ESSAI SUR L'ART DE RESTAURER

LES ESTAMPES ET LES LIVRES

Reproduction et traduction réservées.

———

Paris, impr. Guiraudet et Jouaust, r. Saint-Honoré, 338

ESSAI SUR L'ART DE RESTAURER

LES ESTAMPES ET LES LIVRES

ou

TRAITÉ SUR LES MEILLEURS PROCÉDÉS

POUR BLANCHIR, DÉTACHER, DÉCOLORIER
RÉPARER ET CONSERVER LES ESTAMPES, LIVRES ET DESSINS

PAR A. BONNARDOT

SECONDE ÉDITION, REFONDUE ET AUGMENTÉE

Suivie d'un

EXPOSÉ DES DIVERS SYSTÈMES DE REPRODUCTION

DES ANCIENNES ESTAMPES ET DES LIVRES RARES

PARIS
CHEZ CASTEL, LIBRAIRE-ÉDITEUR
Passage de l'Opéra, Galerie de l'Horloge, 21

1858

AVANT-PROPOS

La première édition de cet ouvrage, publiée en 1846 in-8 et tirée à 400 exemplaires, était épuisée dès 1850. J'en donne enfin une seconde, que j'ai améliorée le plus possible. J'ai mis plus d'ordre dans la suite des chapitres, fondu dans le texte les additions et corrections consignées dans le *supplément*, refait un grand nombre d'alinéas et des chapitres presque entiers, supprimé les redites et les phrases inutiles, enfin remplacé beaucoup d'expressions par d'autres plus claires ou plus techniques. En un mot, j'ai fait tous mes efforts pour douer cette nouvelle édition des deux qualités qui constituent la seule éloquence des ouvrages

de ce genre, fort peu appréciés comme productions littéraires : l'ordre et l'extrême clarté du langage.

D'autre part, mon texte est augmenté de notes inédites, remarques, éclaircissements et indications de nouveaux procédés. J'y ai ajouté, à titre de complément, une liste de plusieurs ouvrages spéciaux bons à consulter, un exposé des divers systèmes de reproduction des vieilles estampes, et des observations sur la possibilité de dédoubler un feuillet simple.

Je n'ai pu, absorbé que je suis dans mes recherches assidues sur la ville de Paris, trouver assez de loisir pour me livrer à de nouvelles expériences au sujet de l'enlèvement des taches et des couleurs. J'aurais notamment essayé de décomposer, à l'aide d'une pile, certaines substances colorantes qui ont pour base un métal, soit à l'état simple, soit à l'état d'oxyde ou de sel, substances que les agents chimiques ne peuvent faire disparaître tout à fait sans quelques

chances de danger, immédiat ou futur, pour la pâte du papier ou pour l'encre d'impression des estampes. Je dois l'avouer : je n'ai jamais eu d'idées bien arrêtées sur la manière dont je ferais agir la pile; je comptais, une fois livré à ces tentatives, rencontrer sur ma route quelques bons expédients. J'ai du reste renoncé à mon projet avec d'autant plus de résignation que je risquais fort, avec ce système de tâtonnement, de n'arriver à aucun résultat positif.

Si plus tard mes propres méditations ou le hasard ne fournissaient de nouveaux documents sur la matière qui va nous occuper, je les consignerais dans un journal artistique, probablement dans la *Revue universelle des arts*, publiée sous la direction de M. Paul Lacroix, revue dont je suis un des collaborateurs.

Sous certains rapports, ce traité s'adresse aux photographes aussi bien qu'aux iconophiles : ainsi, pour reproduire une estampe par un procédé héliographique quelconque,

on doit d'abord en faire disparaître les souillures ou les couleurs, qui déposeraient sur les épreuves des taches noirâtres plus ou moins prononcées.

J'ai cru devoir effacer sur mon titre, légèrement modifié par rapport à celui de la première édition, l'épithète de *Parisien*, que je continuerai (à l'imitation des auteurs des XVIᵉ et XVIIᵉ siècles) d'ajouter à mon nom sur ceux de mes ouvrages relatifs au vieux Paris.

<small>Achevé d'imprimer en mars 1858.</small>

PRÉFACE DE LA I^{re} ÉDITION

(1846)

Je résolus en 1838 de réunir un grand nombre d'estampes relatives aux anciens monuments et aux événements historiques de la ville de Paris. Or, ces estampes, moins remarquables en général sous le rapport de l'art que sous celui de l'intérêt archéologique, se présentaient souvent à moi sous une apparence si pitoyable que je sentis la nécessité de m'exercer dans un art nouveau. Il me répugnait de confier une pièce rare aux mains peu artistiques de messieurs les encadreurs-vitriers, qui ont la prétention d'avoir

réparé une estampe quand ils vous la rendent blanche comme neige avec le noir d'impression tourné au gris (1). C'est un acte de vandalisme emprunté au goût froid et stupide de ces badigeonneurs modernes qui barbouillent de chaux ou de terre à poêle nos vénérables cathédrales. Il faut *désenfumer*, éclaircir au besoin les vieilles estampes, mais leur conserver, s'il est possible, cette légère teinte bistrée qui fait ressortir la beauté de l'épreuve, et donne du ton à l'ensemble de la composition.

Donc, pour échapper aux vitriers, j'entrepris d'appliquer à la restauration des gravures les leçons de physique et de chimie puisées en 1829 aux cours de MM. Thénard et Gay-Lussac. Après avoir souvent, pendant six ans, renouvelé mes expériences, j'en rédigeai par écrit le résultat, afin d'en faire part à mes amis et collègues en collections. Puis l'idée me vint qu'il y aurait

(1) Je ne prétends pas refuser à tous les vitriers-encadreurs le bon goût et l'adresse que réclame la restauration des gravures; mais les plus habiles sur ce point sont, je crois, les artistes, les collectionneurs, les marchands de vieilles estampes, enfin quelques personnes qui ont fait de la réparation des livres, estampes ou tableaux, une industrie spéciale.

plus de générosité, plus d'amour pour l'art et les reliques historiques, à communiquer au public les procédés que m'avaient révélés mes recherches, mes souvenirs ou le hasard.

Cet opuscule semblera encore bien incomplet aux connaisseurs expérimentés ; un habile chimiste pourra le refaire un jour avec un succès qui réduira mes efforts à une simple tentative ; aussi je me borne à réclamer l'honneur du premier pas, et l'indulgence du lecteur en faveur d'une idée utile et désintéressée en ce sens qu'en dévoilant mes procédés à tous mes rivaux, je me prive de l'heureuse chance d'acquérir à bas prix des pièces fort curieuses, mais si dégradées, mais en apparence si hideuses sous les taches, les rides et les lacérations qui les défigurent, que nul n'aurait eu l'idée de me les disputer vivement dans une vente.

Mon but est donc de contribuer, et cela à mon propre désavantage, à retarder, à prévenir la ruine de ces monuments de l'histoire et de l'art si généralement mal appréciés il y a dix ans, et devenus aujourd'hui (1846) rares et recherchés.

J'ai puisé mes procédés chimiques dans les ouvrages les plus modernes, qui les indiquent rarement, mais mettent sur la voie pour les

trouver. Quant à la partie que je nommerai *manipulative*, je la traite uniquement d'après mes propres essais, éclairés quelquefois des conseils de mes amis. Je pense que cet opuscule, tel qu'il est, pourra être jugé neuf et susceptible de quelque utilité.

ESSAI

SUR

L'ART DE RESTAURER LES ESTAMPES

I

DÉDOUBLAGE ET REDRESSAGE DES ESTAMPES.

Quand une estampe est en parfait état sous tous les rapports, on n'a qu'à la conserver sous cadre ou en portefeuille, comme je l'indiquerai au chapitre XII. Je suppose, dans tout le cours de ce traité, une estampe qui a tous les défauts possibles, et je la fais passer successivement par telle ou telle opération capable de

l'amener à figurer sans trop de désavantage à côté des estampes naturellement bien conservées. C'est donc pour prendre les choses dès l'origine que j'ai rédigé d'abord le présent chapitre.

Dédoublage. — Beaucoup d'estampes, celles surtout composées de plusieurs feuilles, telles que les vieux plans de villes, se rencontrent ordinairement doublées, c'est-à-dire renforcées d'une feuille de papier ou de toile; quelquefois même elles sont triplées (1). Quand ce renfort a été mal appliqué, et c'est un cas fort commun, il faut d'abord procéder au *dédoublage*, soit pour le supprimer, soit pour le rétablir plus habilement. On commencera par plonger l'estampe dans un bain d'eau froide, la chaleur,

(1) Beaucoup d'anciens dessins sans inscriptions sont renforcés de plusieurs feuilles superposées, formant un véritable carton. Quand on désire vivement connaître le sujet qu'ils représentent, on peut, si leur nature ne s'y oppose pas, recourir au dédoublage. On trouve quelquefois au verso du dessin l'indication du sujet, une date ou un nom d'artiste. On a reconnu par ce moyen plus d'un ancien portrait d'édifice détruit ou de personnage célèbre.

sauf en certains cas que je signalerai, ne contribuant en rien au succès. Ce bain, dont l'effet est très innocent, doit avoir une durée de 12 à 24 heures, plus ou moins, suivant la ténacité ou l'épaisseur de la couche de colle qui a servi au doublage. Au bout de cet espace de temps, si le dédoublage était difficile à pratiquer, la nature des papiers ou celle de la colle serait, comme je le démontrerai, l'unique cause de cette difficulté.

Bassines. — Les vases les plus commodes pour cette opération sont des bassines en forme de quadrilatère oblong avec des rebords hauts de quelques centimètres. On peut en avoir de plusieurs grandeurs; ce point est une affaire d'emplacement. La dimension moyenne et la plus usuelle comporte 72 centimètres de long sur 56 de large. Il est peu de feuilles d'ancien format qui dépassent cette dimension, ou bien elles se composent de plusieurs morceaux.

Les bassines les plus généralement employées sont de zinc ou de cuivre étamé, matières très convenables tant qu'il s'agit de leur faire contenir de l'eau pure; mais il est souvent

nécessaire de mêler à l'eau un acide ou d'autres agents chimiques qui attaquent ces métaux, surtout si l'on fait chauffer le liquide. Le platine satisferait à toutes les conditions, mais son prix est infiniment trop élevé. Je conseillerai donc aux amateurs de se procurer, en vue de certaines occasions qui seront signalées, une bassine de porcelaine non vernie. On en trouve aujourd'hui de toutes faites dans le commerce, à l'usage des photographes.

Pour vider commodément, sans être obligé de la déplacer, une grande bassine non munie d'un robinet, on peut se servir d'un siphon de verre assez court qu'on remplit, pour l'*amorcer*, du liquide même de la bassine, en l'y posant à plat. Ce tube de verre, en forme d'U à jambages inégaux, une fois amorcé, on bouche avec le pouce l'orifice du jambage le plus long; puis on relève le siphon, on applique l'ouverture de la branche la plus courte au fond du liquide, et l'on maintient l'autre en dehors de la bassine, dont un des côtés doit affleurer le bord de la table qui la porte. Dès qu'on ôte le doigt de l'ouverture bouchée, l'eau aspirée s'écoule dans un récipient quelconque placé au-dessous.

On devra aussi se procurer quatre supports de bois reliés par des traverses ; on y posera d'aplomb la bassine quand il y aura nécessité, comme il arrive souvent, de tenir chaud le liquide qu'on y a versé. En ce cas on place sous le fond de la bassine un réchaud contenant des charbons allumés. Avec quelques briques superposées on obtiendrait au besoin une disposition analogue.

Bien des vases, au reste, peuvent recevoir les estampes de petite dimension. J'ai souvent fait usage de plats oblongs et aussi de cylindres de verre nommés *flûtes*. L'un des bouts de ces gros tubes est ouvert ; l'autre est un fond arrondi en forme de calotte. On le maintient debout en engageant le fond bombé dans du sable que contient une caisse.

J'ai aussi, en certaines occasions, employé, pour les grandes pièces, ces pots de terre hauts et cylindriques qui servent à mettre une ou deux voies d'eau (1). Dans ces sortes de va-

(1) Quand il s'agit de dédoubler ou de désunir d'immenses estampes, composées d'un grand nombre de feuilles, telles que les anciennes cartes géographiques,

ses on roule l'estampe avant de l'y plonger, ce qui n'a aucun inconvénient : l'estampe se déroule d'elle-même, et l'eau tarde peu à s'infiltrer à travers les intervalles des circonvolutions. Mais on conçoit que, dans le cas où le liquide devrait tenir en dissolution quelques substances chimiques assez chères, cette forme de vase entraînerait à un excès de dépense. Une bassine où la gravure est posée à plat exige bien moins de liquide, puisqu'on peut à volonté en diminuer ou en hausser le niveau.

Quand on a laissé tremper pendant vingt-quatre heures une estampe doublée, on remarque que l'eau a pris une couleur jaune, assez foncée quelquefois pour ressembler à une dissolution de réglisse noire : c'est la teinte enfumée du papier qui a été entraînée en grande partie. Il faut retirer la gravure avec beaucoup de soin, crainte de déchirures. Si le papier est solide, on l'enlève soit à plat, soit roulée, sans la moindre difficulté ; on la dépose et on l'étend sur une table, après l'avoir égouttée ; la

on les met tremper dans un tonneau, dans une baignoire, etc.

table ou la planche qui la reçoit doit être bien nette et bien unie.

On étendra l'estampe, en certains cas que j'indiquerai, sur un marbre de commode, une glace polie ou une toile cirée.

Le côté gravé ou *recto* (1) doit toucher la table, de sorte qu'on ait sous les yeux le papier qui adhère au verso. Voici le motif de ce procédé : en règle générale, lorsqu'on dédouble un papier, même à sec, c'est toujours celui de dessus qui est le plus susceptible de se lacérer ; celui de dessous, s'il est solidement maintenu pendant le dédoublage, risque à peine quelques écorchures.

Quand les papiers juxtaposés sont tous deux assez forts et formés d'une pâte bien encollée (absorbant difficilement une goutte d'eau), l'opération marche toute seule ; il suffit de soulever par un coin le papier supérieur ; la colle détrempée reste déposée, à partage à peu près égal, sur les deux surfaces qui adhéraient. Il

(1) J'emploierai toujours le mot *recto* pour désigner l'*endroit* de l'estampe, et le mot *verso* quand il s'agira de l'*envers* ou côté blanc.

faut néanmoins agir toujours lentement : car, si la gravure était trouée ou lacérée en certains endroits, un dédoublage trop prompt élargirait les trous ou prolongerait les déchirures.

Si la feuille qui double une estampe tirée sur papier encollé était au contraire formée d'une pâte absorbante, elle ne se détacherait pas toujours d'une seule pièce ; il faudrait, l'estampe étant bien maintenue, l'enlever par lambeaux, ou même la réduire en une sorte de bouillie pour obtenir le dédoublage (1).

Pour cette opération comme pour beaucoup d'autres, je ne connais qu'un bon outil, le seul, pour ainsi dire, indispensable à l'amateur : c'est une de ces lames flexibles, amincies et arrondies à l'extrémité, dont les peintres font

(1) Une gravure tirée sur papier non encollé unie à un papier qui l'est au contraire beaucoup grimace toujours ; le dédoublage est difficile et exige beaucoup de patience. Dans le cas, heureusement fort rare, où l'on aurait à séparer deux estampes adossées, également précieuses, on devrait agir lentement et prendre toutes les précautions possibles pour que ni l'une ni l'autre ne fût perdue. On les laisserait tremper dans de l'eau maintenue chaude et légèrement acidulée.

usage pour ramasser leurs couleurs sur la palette, et les vitriers pour appliquer le mastic. Quand on s'est habitué à la manier, on s'en sert pour décoller, couper le papier, relever et aplanir les plis, etc.

Quand le papier qui doublait l'estampe est enlevé sur toute la surface, on entraîne au moyen de la lame la majeure partie de la colle qui est adhérente au verso, et, si l'estampe se compose de plusieurs morceaux, on les isole en glissant avec précaution l'extrémité de la lame entre les deux parties qui se touchent ; mais cette dernière opération serait inutile si on voulait doubler de nouveau l'estampe.

La raison de la difficulté du dédoublage peut tenir quelquefois à la composition même de la colle employée, par exemple quand elle contient de l'alun ; mais le plus souvent elle provient de la nature du papier. Supposons une gravure tirée sur un papier mince et non encollé ; admettons que précédemment elle a été lavée au moyen d'un liquide dangereux par un réparateur ignorant ; enfin qu'elle a été *contrecollée* sur un papier qui réunit les mêmes désavantages, de sorte que la colle aura pénétré

assez profondément dans l'épaisseur des deux feuilles superposées ; ajoutons, si l'on veut, des trous, des lacérations, des plis très compliqués en tous sens : voilà le cas le plus critique où se puisse trouver une estampe au sortir de la bassine. Si l'on avait plongé dans l'eau, sans précautions préalables, un pareil assemblage, on courrait grand risque de ne plus étaler sur la table qu'une masse informe, tournant en bouillie à chaque mouvement de la main, et presque aussi difficile à manier que les anciens *papiri* d'Herculanum, ces rouleaux de mince écorce réduits en paquets de cendre.

J'ai deux ou trois fois été aux prises avec un pareil embarras ; le vif désir de conserver l'estampe m'a seul inspiré le moyen de triompher. Ce n'est qu'après l'avoir laissée sécher à moitié, et à force de patience et d'adresse, que j'ai pu réussir miraculeusement à la sauver ; mais, au lieu de détailler les moyens de sortir d'un si mauvais pas, j'indiquerai plutôt celui de le prévenir.

Au lieu de tremper l'estampe, on étendra à sec le recto sur un marbre, ou sur une toile cirée, bien à plat, autant que les plis le per-

mettront; puis sur la feuille doublante collée au verso on passera doucement une éponge fine légèrement humectée, de manière que le papier contrecollé seul absorbe l'eau; au bout de quelques minutes on l'enlèvera par parcelles, en raclant, au moyen de la lame, avec beaucoup de précaution, de peur d'écorcher le fond de l'estampe; à l'approche d'une lacération ou d'un trou, on redoublera de soins.

J'ai souvent employé ce moyen pour dédoubler ou décartonner les dessins à la gouache ou au pastel, qui ne peuvent être humectés au recto. Mais ce procédé est extrêmement long quand la surface est large; j'en vais signaler un plus expéditif. Il consiste à laisser tremper l'estampe pendant douze ou vingt-quatre heures avec les précautions suivantes : soit qu'on la mette à plat dans une bassine ou qu'on la plonge roulée dans un vase cylindrique, on applique le recto, avant le mouillage, sur une forte toile ou sur un papier épais et bien encollé. Cette toile ou cette feuille auxiliaire doit outrepasser les bords de l'estampe, car cette partie excédante servira à la retirer de l'eau sans inconvénients. On étale le tout à plat sur

une table, et, après en avoir ôté l'excès d'humidité avec un linge ou du papier buvard, on détache avec légèreté, au moyen de la lame, le papier qui double, le seul qu'on ait sous les yeux.

Il est rare, lorsqu'on a affaire à une estampe de grande dimension, qu'on n'en écorche pas un peu çà et là le verso, ce qui forme des éclaircies quelquefois si minces que l'encre d'impression semble n'avoir plus de papier pour appui. Ces éclaircies occasionneraient au recto des points disparates et désagréables dans le cas où l'estampe ne serait pas de nouveau doublée. On verra plus tard les procédés à suivre pour renforcer les éclaircies; mais le mieux est de tâcher d'éviter qu'il ne s'en forme.

Quand après un long et pénible travail le papier de l'estampe a été réduit à l'état simple, on enlève de la superficie du verso le gros de la colle au moyen de la lame; opération qu'il faut renouveler une ou deux fois: car, une couche de colle détachée, une autre semble sortir des pores du papier. Pour enlever le tout complétement, le moyen le plus prompt, c'est de plonger l'estampe (bien entendu avec un papier

de soutien) dans de l'eau maintenue bouillante, qui entraînera toute la partie visqueuse de la colle, nommée *gluten*.

On gagnerait du temps à jeter de suite une estampe doublée dans l'eau bouillante. Pour moi, je préfère l'eau froide, qui réussit le plus souvent. L'excès de chaleur humide dispose certains papiers très fins et non encollés à se réduire en bouillie au sortir de la bassine.

On conçoit que, si on a le dessein de doubler l'estampe, il est inutile d'ôter toute la colle, puisqu'il faudra en ajouter une nouvelle couche : on se borne en ce cas à racler les parties saillantes que pourrait former l'ancienne.

Quand on veut conserver à l'état simple l'estampe dédoublée, on en écrase les plis avec le plat de la lame ; on remanie à plusieurs reprises le papier, l'étirant comme font les tapissiers pour tendre un tapis ; on remouille au besoin à l'éponge humide ; enfin, s'il n'y a ni écorchure, ni trous, ni éclaircies, on met en presse comme je vais l'indiquer.

Redressage, ou *Mise en presse*. — L'estampe étant encore à l'état de moiteur, on en applique le verso sur une table (je parle dans la suppo-

sition où toute la colle aurait été enlevée) (1);
puis on étend sur le recto, qu'on a sous les
yeux, vingt ou vingt-cinq feuilles de papier bu-
vard d'une dimension assez grande pour dé-
border l'estampe. Par dessus on pose à plat
soit un carton épais et bien sec, soit une ta-
blette de bois bien unie qu'on surcharge de
cinq poids, un au milieu et un à chaque coin.
Ces poids doivent peser environ deux kilos
chacun ; on peut les remplacer par des cubes
de marbre, par des flacons de verre contenant
du plomb de chasse, etc. J'ai redressé plus de
quatre cents estampes de cette manière. Pour
accélérer le séchage, je renouvelais quelquefois
le papier buvard au bout de quelques heures.

Repassage. — Ce procédé est applicable
surtout aux pièces de petite dimension, pourvu
que l'épaisseur du papier soit bien homogène
et qu'elles ne conservent au verso aucune trace

(1) S'il restait au verso quelques parcelles de colle,
l'estampe, lorsqu'elle serait sèche, adhérerait au bois
sur certains points. On peut l'étendre sur un marbre ;
mais la dessiccation sera plus lente, puisque le marbre
n'absorbe aucune portion d'humidité.

de colle. Dans ces conditions, on peut repasser au fer chaud. Il faut, pour éviter un degré de chaleur qui roussirait l'estampe, essayer le fer sur un papier sec et bien l'essuyer. On ne l'applique qu'au verso, et cette simple opération suffit pour enlever les rides. Si les plis sont très prononcés et rebelles, on les humecte légèrement, en les exposant à la vapeur d'eau avant d'y appuyer le fer. Si l'on juge à propos de repasser au recto, il est important d'interposer entre le fer et l'estampe un papier Joseph, sinon la gravure risquerait de contracter une sorte de poli assez disgracieux.

Lorsque ces deux systèmes de redressage ne suffisent pas, on a recours à un troisième plus parfait, mais qui n'est pas toujours applicable. Quand l'estampe a une grande marge, on l'humecte, et on la colle, par les bords seulement, sur un fond de carton. A mesure qu'elle sèche, les moindres plis s'effacent, et elle se tend comme la peau d'un tambour. Si le papier était trop fin, ou d'une pâte peu tenace, il faudrait s'abstenir, car il risquerait de se déchirer en séchant, retenu par cette énergique tension. Quand la marge manque à l'estampe, on colle

tout autour (au verso) des bandes, dont une portion y restera adhérente losqu'on l'aura détachée du carton. Pour les détails de cette opération, je renvoie au chap. VIII, où il est traité du doublage des estampes *à fond tendu*.

Les procédés indiqués dans ce chapitre sont infaillibles quand on les exécute bien. Je recommande aux amateurs de ne point se dépiter dans le cas où, encore peu exercés, ils n'auraient pu obtenir du premier coup des résultats satisfaisants. En attendant une veine de patience, je dirai plus, un moment d'inspiration, ils devront resserrer l'estampe telle quelle, sans négliger surtout de bien s'assurer de la présence de tous les morceaux qui la composent. L'eau de lavage peut quelquefois détacher et entraîner des fragments d'un grand intérêt ; en certains cas, on fera bien, avant de la jeter, de la passer à travers un tamis de toile métallique.

II

BLANCHIMENT DES ESTAMPES.

Un simple bain à l'eau froide de vingt-quatre heures suffit le plus souvent pour éclaircir une vieille estampe, de sorte que celle que l'on a mouillée, dans le but d'en opérer le dédoublage, acquière en même temps un degré de blanchiment convenable; mais si, après deux ou trois jours de mouillure, elle paraît encore d'une teinte trop foncée et nuisible aux effets du burin, on peut, pour la blanchir davantage, avoir recours aux substances chimiques qui ont la propriété de désenfumer les estampes les plus

bistrées, pourvu que cette teinte ait pour origine, comme il arrive ordinairement, l'action de l'hydrogène sulfuré qui se rencontre dans l'air. Ces liquides sont : le *deutoxyde d'hydrogène* ou *eau oxygénée*, le gaze chlore dissout dans l'eau, enfin les composés de chlore et de bases alcalines. Je pourrais ajouter l'action du soleil sur le papier mouillé, procédé mis en usage pour le blanchiment des toiles, et qui réussirait également sur le papier ; mais il est fort lent : j'en reparlerai dans une autre occasion. (Voyez chap. IV, *Taches d'huile*.)

Deutoxyde d'hydrogène. — C'est un liquide dont la préparation est très compliquée et la conservation difficile. M. Thénard, qui l'a découvert, en parle au long dans le second volume de son Cours de chimie. On ne le trouve jamais tout préparé chez les plus fameux fabricants de produits chimiques, vu son altération rapide, de sorte que le prix pour une petite quantité reviendrait fort cher. J'en aurais cependant fait l'essai, si je n'étais convaincu que ce liquide peut être remplacé, pour le but que nous nous proposons, par des substances moins coûteuses et plus faciles à conserver.

Gaz chlore dissout dans l'eau. — Les propriétés du chlore en dissolution sont aujourd'hui très connues. On verra à l'article *Décoloriage* de quelle manière il agit sur les couleurs végétales et autres. Un célèbre collectionneur (M. Hennin) se sert depuis quarante ans du chlore liquide pour blanchir ses estampes. Or, comme elles sont dans un parfait état de conservation, son système doit faire autorité. Le fait est que le chlore blanchit au degré qu'on veut les estampes, sans altérer le moins du monde l'encre d'impression, même à l'état de concentration, même au bout de vingt-quatre heures.

Je n'oserais en conseiller l'usage à l'état gazeux qu'avec beaucoup de réserve, car on lit à ce sujet dans le Cours de chimie du professeur Dumas (tome IV, p. 44), à propos de la fabrication du papier : « Les chiffons fins
« doivent être blanchis au chlorure de chaux
« liquide, et non au chlore gazeux : ils sont
« bien moins altérés et donnent un papier plus
« nerveux et moins cassant. Il faut laver les
« papiers avec attention, car le chlore qu'ils
« retiennent se convertit bientôt en acide

« *chlorhydrique*, qui détruit peu à peu la fibre
« du papier. »

Il faut user avec la même circonspection de la dissolution concentrée de chlore (1). Quand on l'emploie mêlée à dix ou douze fois son volume d'eau, il ne peut y avoir aucun danger, surtout si on trempe ensuite l'estampe pendant douze heures dans l'eau pure. Le chlore étendu d'eau dans ces proportions décompose assez rapidement à froid la teinte foncée des estampes, à moins que cette teinte ne provienne d'une substance huileuse ou de certaines couleurs à base métallique.

La préparation, chez soi, du chlore liquide, est très facile, mais fort désagréable, à cause de son odeur pénétrante, qui prend à la gorge, altère les papiers de tenture et dépolit plusieurs métaux. Le mieux est de se le procurer tout fait, à raison de 50 cent. environ le litre, chez les marchands de produits chimiques. On

(1) Une dissolution (ou solution) est *concentrée* quand l'eau qui dissout un gaz, un sel, ou une matière quelconque, en est *saturée*, c'est-à-dire n'en peut plus dissoudre aucune parcelle.

doit le conserver dans un flacon à bouchon de verre qui ferme hermétiquement, et coller sur le flacon une feuille d'étain, car le chlore liquide se décompose rapidement par le contact de la lumière, même très faible.

Quand on verse le chlore dans la bassine, il faut opérer près d'une cheminée allumée ou en plein air. On peut couvrir la bassine d'une plaque de zinc pour retarder l'évaporation du gaz ; ou encore imiter l'opération usitée pour le blanchiment des toiles : jeter dans le bain quelques morceaux de craie (carbonate de chaux), qui absorberont la vapeur libre du chlore ; ou enfin, ce qui revient à peu près au même, et supprime toute complication, on emploiera le liquide suivant.

Chlorure de chaux. — Les Anglais blanchissent depuis longtemps leurs toiles au chlorure de chaux liquide. On blanchit chez nous, par le même procédé, des papiers dont on n'a pas toujours lieu de se féliciter, sans doute parce qu'il y a abus. Le chlorure de chaux s'achète en poudre fine et sèche ; quand il est en masse pâteuse, c'est qu'il a absorbé l'humidité de l'air. Du reste, le prix en est peu élevé ;

avec un demi-kilogramme on a de quoi éclaircir bien des gravures.

Voici la manière de l'employer : on jette environ cinquante grammes de cette poudre dans une bouteille remplie d'eau aux deux tiers; on agite fortement, et, quand le liquide est éclairci et l'excédant de la matière déposé au fond du vase, on en verse dans l'eau pure que contient la bassine, ayant soin de s'arrêter quand la dissolution commence à se troubler. On délaie le résidu dans une nouvelle quantité d'eau, qu'on réserve pour une autre occasion. On recommencera ce délayage jusqu'à ce que le chlorure ait perdu toute sa puissance (1). Les premières eaux chargées de chlorure sont naturellement les plus concentrées : aussi les faut-il mêler à quinze ou vingt fois leur volume d'eau pure dans la bassine. Il vaut mieux risquer d'être obligé d'en ajouter que d'en mettre un

(1) Une dissolution de chlorure de chaux doit nécessairement s'altérer à la longue si le vase qui la contient est mal bouché; elle attire à elle les miasmes de l'air, et perd, en les décomposant, une partie de sa force.

excès ; observation qui s'applique à toutes les autres substances chimiques dont j'indiquerai l'emploi.

L'eau tenant en dissolution cette quantité de chlorure n'altère nullement, même après un assez long séjour, le noir d'impression ; mais, selon l'opinion d'un habile préparateur de chimie, trop concentrée, elle prédisposerait le papier à devenir cassant. Il faut surveiller de près l'opération, et retirer l'estampe dès qu'on la trouve suffisamment éclaircie.

On se méfiera donc du chlorure, ainsi que du chlore, comme d'un ennemi perfide, et on l'emploiera à l'état le plus faible possible, mais assez fort pour obtenir l'effet désiré. Je ne saurais trop recommander de ne jamais l'employer à chaud : car, à cet état, mélangé même de beaucoup d'eau, il attaquerait le tissu du papier et la partie grasse du noir d'impression.

Cependant il est des cas, que je citerai à l'article *Décoloriage*, où il faut le faire agir à l'état assez concentré ; mais en même temps j'indiquerai les moyens de prévenir ses ravages ultérieurs, supposé que le fait soit positif. On doit absolument, si l'on ne préfère essayer l'eau

oxygénée, recourir au chlorure de chaux pour les estampes enfumées au point d'être presque indéchiffrables. En tout cas, on se contentera de les éclaircir, et non de les rendre blanches comme la porcelaine; puis on leur fera perdre dans un bain légèrement acidulé le chlore qu'elles pourraient retenir, et qui plus tard se convertirait en acide chlorhydrique.

Par *bain acidulé, eau acidulée*, je veux dire une portion d'acide chlorhydrique (dit autrefois muriatique, puis hydro-chlorique) mêlée à 25 ou 30 fois son volume d'eau. On pourrait ici me faire une objection. Je prétends prévenir la formation d'une substance par l'emploi de cette substance elle-même. Voici l'explication : si l'on trempe un papier imprégné de chlorure de chaux dans une dissolution très faible d'acide chlorhydrique, tout le chlore qui était uni à la chaux se dégage, et la chaux libre, en contact avec l'acide, se combine avec lui pour former un sel soluble dans l'eau. Ainsi l'on n'a plus à redouter la formation ultérieure de l'acide en question, dont le séjour attaquerait le tissu du papier, puisque l'un des deux principes qui le constituent, le chlore, a com-

plétement disparu. Toutes les estampes que j'ai ainsi traitées, il y a plus de dix ans, sont dans un bon état de conservation. J'avais eu soin, au reste, de les retremper pendant quelques heures dans l'eau pure au sortir du bain acidulé.

Pour annuler les restes du chlorure de chaux dont l'estampe a été imprégnée, on réussit, je crois, également par l'usage du vinaigre, acide faible par lui-même, mais capable de décomposer ce chlorure, c'est-à-dire de mettre le chlore en liberté, et de s'unir à la chaux pour former avec elle un sel calcaire.

Un préparateur de produits chimiques m'a conseillé l'ammoniaque étendue d'eau comme moyen de prévenir la formation ultérieure de l'acide chlorhydrique dont parle M. Dumas. Sans aucun doute l'ammoniaque (alcali volatil) annule l'effet de tout acide; mais, puisque celui-ci ne se forme que plus tard, je ne comprends pas l'action de l'alcali, à moins de supposer qu'il reste, comme le chlore, dans le tissu du papier, et ne s'évapore pas. L'emploi de l'eau acidulée me semble plus immédiatement efficace; elle ne combat pas un dommage, mais elle le prévient.

Eau de Javelle. — Nommée chimiquement *chlorure* (ou *hypochlorite*) *de potasse* (1), cette eau se vend à bas prix chez tous les marchands de couleurs. La potasse qu'elle contient, outre le chlore, doit avoir une certaine action sur le noir d'impression : c'est ce qui a lieu, en effet, même quand l'eau de Javelle est étendue de six à huit fois son volume d'eau.

J'ai à plusieurs reprises fait une expérience assez intéressante sur les trois liquides chloreux destinés au blanchiment. Je les employais à un degré approximativement égal de concentration, et laissais tremper dans chacun d'eux, pendant douze heures, des fragments de lithographies et de gravures anciennes ou modernes, sur bois ou sur cuivre.

Voici le résultat : dans le chlore liquide et le chlorure de chaux, nulle altération du noir ; papier très blanc, mais peut-être portant en lui un germe de destruction qu'un bain acidulé

(1) La teinte rosée qui la colore quelquefois est, dit-on, due à un sel de manganèse. L'eau de Javelle incolore n'en est que plus pure. Le même nom désigne, je crois, dans le commerce, le *chlorure de soude*.

peut prévenir. Quant à l'effet de l'eau de Javelle, il était déplorable. Les fragments de vieilles estampes sur bois ou sur cuivre, au burin ou à l'eau-forte, étaient très altérés. Le noir était devenu grisâtre, terne, sans cohérence; entraîné par le liquide, il maculait les intervalles des tailles. J'ai vu un jour un feuillet de livre (impression de 1561) réduit à une trace à peine visible; une belle épreuve d'Israël Silvestre a subi le même sort.

Quant aux fragments de lithographie et d'imprimerie modernes, ils sont sortis de l'eau de Javelle avec le noir aussi brillant qu'avant l'immersion. Ce résultat fait l'éloge de l'encre de nos graveurs et de nos imprimeurs (1); les fabricants de papiers mécaniques me semblent seuls avoir fait des progrès désespérants.

La teinte grisâtre que l'eau de Javelle com-

(1) Cette encre est un composé d'huile de lin cuite et de résine, sorte de vernis dans lequel on délaie un sixième de son poids de noir de fumée. J'ignore la composition précise de l'ancienne encre d'impression. Abraham Bosse, dans son *Traité de la gravure*, cite le noir de lie de vin et l'huile de noix comme éléments de son encre à graver.

munique au noir d'impression se ravive peut-être un peu dans de l'eau légèrement imprégnée d'acide chlorhydrique; le noir que le chlorure de chaux a terni y recouvre à l'instant même son éclat primitif. C'est qu'ici il n'y a aucune altération de l'encre; elle est voilée simplement par un dépôt calcaire blanchâtre, que l'acide décompose à l'instant.

Conséquence naturelle de cette expérience : je n'emploie jamais l'eau de Javelle, mais le chlorure de chaux, sauf en certains cas de décoloriage dont il sera question en leur lieu.

Le chlorure de chaux liquide (je ne saurais trop le répéter) ne devra jamais s'employer, surtout à l'état concentré, autrement qu'à froid, sinon l'on risquerait de communiquer au papier de l'estampe un germe de destruction plus ou moins prochaine. Si l'estampe, malgré son immersion prolongée dans ce liquide, conservait encore des places jaunâtres, ce seraient des taches d'une autre nature que la teinte générale. (Voyez l'article *Taches*, ci-après.)

Blanchiment partiel. — Souvent une estampe n'exige qu'un blanchiment partiel. Dans celles composées de deux morceaux, c'est quelquefois

le milieu qui a jauni, peut-être parce qu'on les avait réunis avec de la colle de graine de lin, usitée au XVII° siècle ; le plus souvent c'est un des coins, ou un des côtés, qui, débordant un livre ou un carton, a reçu l'impression de l'air.

Pour éviter de blanchir toute la surface, on peut s'arranger pour ne tremper dans la bassine que la portion enfumée. Si l'enfumage n'avait atteint qu'une place fort restreinte et rapprochée du centre de l'estampe, on ferait agir le chlore sur cette sorte de tache isolée par l'un des procédés indiqués plus loin (page 42).

Après un blanchiment partiel par le chlore ou le chlorure de chaux, il faut toujours, bien entendu, retremper cette partie de l'estampe dans de l'eau acidulée, puis la laisser plusieurs heures dans l'eau pure, afin de prévenir ou au moins d'atténuer l'effet des substances employées.

On se trouve quelquefois dans la nécessité de raccorder les endroits trop éclaircis avec la teinte jaune générale. On se sert, pour atteindre ce but, de réglisse noire ou d'une couleur bistre quelconque en dissolution plus ou moins

concentrée, mêlée en certains cas d'un peu d'encre commune. On raccorde au pinceau, ou avec une éponge trempée dans la dissolution, ou autrement, en ayant soin de ne pas dépasser la limite de la place à raccorder.

On pourrait peut-être rétablir la teinte en exposant la portion trop blanchie de l'estampe à la vapeur (formée d'une manière factice) de l'hydrogène sulfuré; mais les exhalaisons de ce gaz sont si désagréables et si dangereuses que je n'ose en conseiller l'emploi dans une chambre, à moins qu'il n'y ait une cheminée bien chauffée et d'un tirage parfait.

III

**CONSIDÉRATIONS GÉNÉRALES SUR L'ENLÈVEMENT
DES TACHES.**

Avant d'aborder les moyens de faire disparaître ou d'atténuer les taches qui déshonorent un livre ou une précieuse estampe, je dois dire qu'il convient en certains cas, fort rares au reste, de les conserver. Par exemple, si je possédais une missive adressée à Charles IX pendant la nuit de la Saint-Barthélemy et imprégnée de traces de doigts sanglants, je me garderais bien d'enlever ces traces qui, leur authenticité supposée bien établie, décupleraient le prix de

l'autographe. Si le conservateur de la bibliothèque Saint-Laurent, à Florence, faisait effacer sur le manuscrit de Longus la flaque d'encre de Paul-Louis Courier, il commettrait presque un acte de vandalisme, parce que cette tache est une célébrité littéraire.

Choisissons des exemples plus vulgaires. On trouve souvent sur une estampe, sur un bouquin, une signature ou une inscription quelconque qui peut être un autographe bon à conserver. J'ai rarement effacé ces signatures ou ces notes d'anciens possesseurs inconnus ; je trouvais je ne sais quel plaisir à respecter ces souvenirs du passé.

C'est ainsi que divers objets de curiosité offrent certaines défectuosités, qui complètent, à mon avis, l'intérêt qu'ils inspirent : telle est une statuette de la Vierge (d'argent ou d'ivoire) dont le visage et les mains ont été à demi effacés par le contact répété de lèvres pieuses. Faire restaurer ces parties frustes, c'est dépoétiser un débris du moyen âge. J'aime mieux lui laisser ces cicatrices de la ferveur, ce cachet de l'antique piété du cloître. Un livre d'heures sur vélin du XVe siècle, usé, sali par la prière,

a, selon moi, acquis une *patine* vénérable. Ici une tache de cire jaune ; là une tête de saint maculée par l'empreinte étoilée d'une larme dévote : ne sont-ce pas là des taches à respecter ? Au contraire, un pâté d'encre, une souillure huileuse, attestent uniquement la négligence, et doivent être enlevés.

Peu de temps après la publication du présent ouvrage (1846), je reçus la visite d'un fort adroit réparateur de vieux livres, celle de M. A. Farrenc. Il m'invita à venir voir en son atelier, rue Taitbout, une *Dance macabre* in-4°, imprimée sur papier, à Paris, vers la fin du XV° siècle, livre rarissime, qu'il était en train de restaurer pour M. Techener.

Les portions déjà nettoyées et rétablies, comparées à celles encore en mauvais état, excitèrent mon admiration. Les nombreuses piqûres de vers, les déchirures du papier, etc., avaient disparu grâce à une application de pâte de papier, si bien raccordée, si bien fondue dans la masse, qu'à peine pouvait-on, en transparent, saisir quelques traces de soudure. Les lettres et les tailles sur bois, qu'avaient emportées les lacunes, avaient été refaites sur un fond nou-

veau avec une grande habileté. Quant aux portions tout encrassées (c'est-à-dire à peu près toute la surface de chaque page), elles avaient complétement cédé à je ne sais quel procédé de grattage ou de décomposition chimique. En un mot, M. Farrenc avait mis en jeu tous ses secrets de réparation pour rendre à ce précieux livre son premier lustre (1).

Eh bien! aujourd'hui, je l'avoue, si je possédais cet exemplaire dans l'état délabré où je l'ai vu, je voudrais le laisser tel quel et me borner aux réparations indispensables à la solidité d'une nouvelle reliure. Ses défectuosités et son encrassement étaient dus, c'est fort probable, à un fréquent et pieux feuilletage du livre, à une persévérance monacale dans la prière, que notre siècle ne connaît plus. Son aspect hideux et décrépit serait à mes yeux un cachet en harmonie avec le contenu d'un pareil livre, qui, à chaque page, nous rappelle notre néant.

Tous les amateurs, sans aucun doute, ne seront pas de mon avis à cet égard; quelques-

(1) Secrets dont le présent ouvrage, je l'espère, révélera au moins une partie.

uns, peut-être, me déclareront parvenu à un monstrueux degré de cynisme en fait de bibliophilie. Du reste, je vais tenter de leur fournir les moyens de rendre au moins une partie de leur fraîcheur primitive aux bouquins et aux vieilles estampes maltraités par le temps ou par l'incurie de leurs anciens possesseurs.

Quand une estampe est souillée de taches ou d'un inepte coloris, surtout aux endroits les plus intéressants, on ne peut se décider à la mettre en portefeuille sans avoir tenté de faire disparaître ou tout au moins d'affaiblir ces teintes étrangères qui la déparent. C'est là, je l'avoue, la partie de cet opuscule la plus difficile à traiter, celle aussi qui laissera le plus à désirer. Mes simples notions de chimie ne pourront suffire à tous les cas, et, un jour, un homme de l'art, très exercé dans l'analyse et la décomposition des corps, pourra refaire avec avantage cette portion de mon livre. Je signalerai néanmoins un assez grand nombre de résultats satisfaisants, que des expériences répétées avec soin sur des fragments d'épreuves tirées sur papier non encollé (circonstance la plus défavorable) m'ont fait obtenir.

La première difficulté consiste à ne pouvoir aisément reconnaître sur-le-champ la nature des taches. Telle tache jaune qui a résisté au lavage et au blanchiment peut être formée par un corps gras ou un oxyde métallique quelconque ; il faut donc avoir recours aux hypothèses, aux tâtonnements. Dans cette obligation où l'on se trouve de faire des essais, il serait important de savoir quelle substance chimique doit être employée en premier lieu, afin que, si la tache persiste, cette vaine tentative du moins ne s'oppose pas à celle subséquente d'un autre agent.

Il m'est impossible d'établir à cet égard des règles bien positives, sauf certains cas qui seront mentionnés à leur place. J'essaye indifféremment l'action d'un acide avant celle d'un alcali, *et vice versa*. Seulement j'ai soin, avant de préluder à une nouvelle expérience, de tremper assez longtemps dans l'eau froide ou chaude l'endroit qui a subi l'action du liquide, afin d'en effacer les traces et d'en annuler l'effet rétroactif.

Quand une estampe a exigé pour s'éclaircir le secours du chlore ou de liquides dont il for-

me la base, on conçoit que ces substances ont pu enlever, en même temps que la teinte enfumée, plus d'une tache sur laquelle elles avaient de l'action. On verra, quand je traiterai en détail de chacune de ces taches, quelles sont celles qui cèdent à leur emploi.

Ma série d'expériences a surtout eu pour objet les taches les plus communes. Quant à celles que je ne signalerais pas, par oubli, on pourra, par analogie, trouver les moyens de les faire disparaître, en demandant, ainsi que je l'ai fait, des conseils aux meilleurs livres de chimie modernes.

La première tentative à faire sur une tache dont on ignore l'origine, c'est de tremper pendant quelques heures l'estampe dans l'eau froide; puis, sans la retirer de la bassine, on frotte soit avec le doigt, soit avec une éponge ou un blaireau, à l'endroit de la souillure. Il arrive quelquefois, surtout quand le papier est formé d'une pâte bien encollée et bien lisse, que la tache, cédant à ce simple frôlement, glisse et disparaît. Quand la tache est épaisse et empâtée, elle est au moins très atténuée, si elle ne

s'efface tout à fait. C'est donc, en tout cas, une première opération indispensable. Mais il faut agir avec beaucoup de légèreté, de peur d'excorier la superficie de la gravure.

On donne de l'énergie à ce système de *détachage*, qu'on peut appeler *par entraînement* (car il n'y a là aucune action chimique), au moyen de matières onctueuses, gluantes, ou agissant par frottement, telles que le savon en gelée, les colles, la mie de pain, la râpure de bois, etc. J'indiquerai à chaque article spécial les taches qui cèdent à ces procédés détersifs. Quand l'estampe a résisté à cet essai préliminaire, on a recours à diverses substances que je ferai connaître.

Enlèvement des taches sur un seul point. — Je vais indiquer les moyens les plus simples à employer, quand il s'agit d'attaquer une tache, sans être obligé, pour un seul point à nettoyer, de soumettre toute la surface de l'estampe à l'action d'un liquide dont l'emploi excessif augmenterait inutilement la dépense. D'ailleurs, s'il devait en résulter une altération ultérieure, il vaut mieux qu'une seule place

en coure la chance que l'estampe tout entière (1).

Mes expériences ont en général été faites en petit; aussi je ménageais peu la matière. Je déposais dans une fiole de verre arrondie, nommée *matras*, de petits échantillons d'épreuve, opérant en plein liquide à froid ou à chaud; l'effet était prompt et n'offrait aucune difficulté manipulative. Mais, quand on procède en grand, les obstacles se présentent; il faut s'exercer à les vaincre.

Une tache qui souille un des coins de l'estampe n'offre aucun embarras; on maintient cette partie d'une manière quelconque au fond d'une soucoupe ou d'une assiette, et l'on verse le liquide froid ou chaud qui doit agir. Mais, si la tache est isolée au milieu d'une grande pièce, à quel expédient avoir recours pour l'attaquer particulièrement?

(1) Il me serait impossible de prévoir les effets éloignés des agents mis en action dans toutes ces opérations. Je ne puis prendre d'autre responsabilité que celle des effets positifs et actuels. Mon amour pour les arts et pour la conservation des monuments gravés qui nous en restent me fait un devoir de cette franchise.

Je me suis servi quelquefois d'un godet de porcelaine, tel qu'on en fabrique pour l'aquarelle, ayant une pente inclinée de la circonférence au centre. La portion tachée de l'estampe s'appliquait, à l'état humide, sur ce fond concave, de manière à en prendre la forme; puis j'assujettissais d'une façon convenable les portions du papier qui débordaient la porcelaine. Le liquide n'agissait ainsi qu'au centre où était le point à détacher.

Quand l'agent employé produit son effet sur-le-champ, on peut l'appliquer sur la tache au moyen d'un pinceau, d'un fragment d'éponge, d'un tampon de coton, ou, en certains cas, d'une mèche d'amiante qui en est imbibée.

Voici un procédé plus parfait que ceux indiqués au supplément de la première édition. On fera percer dans un morceau de glace épais plusieurs trous cylindriques de divers diamètres et largement espacés. On posera à plat la glace sur l'estampe humide, étendue sur deux ou trois feuilles de papier buvard que supportera un fond bien uni. A l'endroit maculé correspondra une des ouvertures, celle dont le diamètre concordera le mieux avec la dimension de la

tache ; puis on versera dans la cavité une petite quantité du liquide nécessaire, à l'aide d'une *pipette* (1) qui servira également à l'en retirer par voie d'aspiration.

On pourra placer quelques poids sur la glace trouée afin que l'estampe, pressée plus fortement, retienne mieux le liquide à l'endroit même où il doit agir, au lieu de l'absorber bien au delà de la limite de la tache. Du reste, en recouvrant l'orifice supérieur d'une sorte de couvercle qui ferme hermétiquement (telle serait une rondelle de verre ou de métal enduite d'une matière onctueuse, comme le savon en gelée), on préviendrait complétement la dispersion du liquide, ainsi soustrait à la pression de la colonne d'air.

J'ai façonné pour le même usage une plaque en étain, dont la cavité recevait de l'acide oxalique qui agissait sur une tache de rouille ; mais, dans la plupart des cas, le verre, matière

(1) Une pipette est un tube de verre coudé, effilé à l'une de ses extrémités, et muni d'une boule où se loge, sans danger pour l'opérateur, le liquide aspiré.

inattaquable à tous les agents employés, est bien préférable.

Quand on se servira d'un liquide bouillant, on fera bien de faire chauffer graduellement le bloc de cristal avant de le poser sur l'estampe, car à froid il risquerait de s'éclater. Au besoin, on maintiendrait la chaleur du liquide par l'approche d'un fer rouge ou autrement.

Quand on fait usage d'acides à froid, on peut remplacer le cristal par la résine ou la cire; mais il faut éviter l'emploi de substances qui attaquent ces matières, telles que l'alcool, la térébenthine, la potasse, etc.

Je citerai encore ici un moyen indiqué par M. de Fontenelle, dans son *Manuel du blanchiment*, II, p. 138. Il conseille de pratiquer dans un cahier de papier buvard un trou un peu plus grand que la tache, et d'y verser goutte à goutte le liquide convenable. Les parois de la cavité, absorbant l'excédant du liquide, l'empêcheraient de s'étaler bien au delà de la tache; on peut essayer.

Enfin, si, vu le nombre ou la grande dimension des taches, tous les procédés ci-dessus ne

pouvaient être mis en usage, il faudrait prendre le parti d'étendre l'estampe au fond d'une bassine proportionnée à sa dimension.

Pour économiser le liquide employé, voici ce qu'on ferait : on appliquerait sur l'estampe une forte toile, percée à l'endroit des taches à enlever, et l'on remplirait la bassine (hors aux endroits troués) d'une couche de petits cailloux siliceux ou de toute autre matière très divisée et non susceptible de décomposition, puis on verserait le liquide dans ces sortes de petites cuves ménagées aux endroits tachés. L'action chimique terminée, on enlèverait, en même temps que la toile, la plus grande partie de ces matériaux de remplissage. On comprend l'économie qu'offre un tel procédé, quand il s'agit d'une substance assez chère (1).

Tout ce que je viens de dire s'applique également aux cas de blanchiment partiel et de décoloriage sur des points isolés. Dans toutes ces opérations pratiquées sur un seul point,

(1) En tout cas, on peut conserver son liquide pour une autre occasion, à moins qu'il n'ait perdu dans l'opération sa force ou sa pureté.

48 TACHES. — CONSIDÉRATIONS GÉNÉRALES.

l'action de la substance chimique, dépassant toujours un peu, quoi qu'on fasse, la limite des taches, laisse autour des places que ces taches occupaient des lignes blanchâtres qui forment un contraste désagréable avec les parties intactes de l'estampe. On les raccordera avec la teinte générale, comme je l'ai indiqué page 33.

IV

DES TACHES D'HUILE ET DE GRAISSE.

Je commence de suite par le genre de taches qui intéresse le plus les amateurs de livres et d'estampes, et je confesserai tout d'abord que je ne suis point parvenu à résoudre ce difficile problème : faire disparaître entièrement les taches d'huile ou de graisse, quelles que soient leur nature et leur date, sans altération du papier ni de l'encre d'impression.

Les matières huileuses ou adipeuses qui souillent les estampes sont de diverses espèces. Il y a des huiles grasses, des huiles sicca-

tives, des huiles cuites. Ces dernières, qui forment des vernis, sont les plus redoutables de toutes, et malheureusement elles sont assez communes, car il est rare qu'une bonne estampe ancienne, avant de passer aux mains d'un iconophile, n'ait pas traversé des ateliers de peintres. Les autres taches ont le plus ordinairement pour origine les matières grasses usitées dans la vie domestique : le suif, le beurre, le sain-doux, l'huile d'olive, etc.

Il n'est point aisé, il est même souvent impossible, de deviner du premier coup d'œil le genre du corps gras qui a produit sur une estampe une souillure jaunâtre et plus ou moins transparente. La question de la date est peut-être plus difficile encore à résoudre. Parmi ces taches, en apparence de même nature, les unes sont bien plus rebelles que les autres, et on ne les enlèvera jamais radicalement sans altérer le noir de l'estampe. Tels sont les vernis gras formés d'huiles qu'on a fait bouillir avec la litharge.

Je ne connais aucun indice propre à éclairer sur l'espèce ou sur la date d'une tache jaunâtre ou verdâtre qui perce toute l'épaisseur

d'un papier. Presque toutes les expériences que j'ai tentées avaient pour objet des taches factices dont je connaissais l'origine. J'ai mis à l'essai toutes les matières signalées comme s'unissant aux corps gras pour les dissoudre, les entraîner ou se combiner avec eux. J'ai tantôt réussi, tantôt échoué, sans avoir pu, le plus souvent, saisir le motif de ma réussite ou de mon insuccès.

Taches d'huile ou de graisse récentes. — J'entends par récentes celles qui datent d'un jour ou au plus d'une semaine; passé ce dernier terme, j'admets qu'elles commencent à former avec la pâte du papier une sorte de combinaison qui les rend bien plus tenaces, de sorte que la difficulté de les enlever augmente en raison directe de leur date. Les taches récentes de suif, d'huile d'olive et autres non cuites, cèdent assez facilement à plusieurs substances que je vais indiquer.

Les remèdes consignés dans quelques anciens livres de pharmacie ou de recettes ont peu de chances de succès; s'ils agissent, ce n'est guère que par le peu de chaux, de soude ou de potasse, que renferme la matière. J'en

citerai un exemple tiré du *Dictionnaire économique* de Chomel, tome II, page 1162 : « Pre-
« nez des *pieds de mouton* calcinés, appliquez
« chaudement cette poudre aux deux côtés du
« papier, à l'endroit de la tache ; vous la lais-
« serez une nuit, et mettrez quelque chose de
« pesant sur le livre (il s'agit ici d'un feuillet
« à nettoyer) ; que si elle n'était pas entière-
« ment ôtée, il en faudrait mettre une seconde
« fois ; mais il faut que la tache ne soit pas
« *vieille*. »

Toutes les anciennes recettes sont analogues à celle-ci ; les os calcinés et pulvérisés, c'est-à-dire le phosphate de chaux, en sont toujours la base. La préférence accordée aux os de pieds de mouton me semble une pure naïveté.

Les teinturiers font usage, pour enlever des taches récentes sur les étoffes, de poudres qui agissent sans aucun doute autant par la vertu absorbante, inhérente aux poussières fines et sèches, que par leurs propriétés chimiques. J'en signalerai une qui se vend assez cher chez quelques parfumeurs, sous le nom de *Poudre minérale infaillible*. Cette poudre, d'une teinte jaune-rosée, peu sapide, happant

à la langue comme l'argile, m'a paru provenir, par voie de pulvérisation, de l'un de ces savons secs et durs, à base de chaux ou de soude, connus depuis longtemps pour ôter les taches sur le drap.

La pierre dite à détacher est, selon M. Le Normand (*Manuel de l'art du dégraisseur*, p. 97), de la glaise mêlée de soude et de savon dissous dans du jaune d'œuf.

Au besoin, la cendre de bois (bien tamisée et purgée de toute parcelle de charbon) pourrait, je crois, suffire, voire la craie ou carbonate de chaux. Si l'on chauffe, avant de l'appliquer, une poudre absorbante, son action, quelle qu'elle soit, doit être plus vive, et l'opération n'en marche que plus vite.

Ces poudres s'emploient avec succès, surtout pour les livres, dont on ne peut mouiller les feuillets sans nuire à la reliure. On isole le feuillet maculé entre deux feuilles d'étain ; on étale des deux côtés de la tache quelques pincées de poudre, et l'on ferme le livre. Au bout de quelques heures, une tache d'huile grasse récente est presque entièrement absorbée. Le suif céderait avec plus de lenteur, et sous la

condition de le maintenir à l'état fluide sur un poêle chaud ou sur une chaufferette. Bien entendu, on enlève le gros de la tache avant d'étaler la poudre. Je doute qu'un vernis gras puisse être sensible à ce remède, comme une huile très fluide. Quand il y a une longue suite de feuillets souillés, il faut se décider à découdre le livre et appliquer les remèdes liquides dont je vais parler.

Plusieurs substances s'emparent des taches récentes d'huile ou de graisse, en qualité soit de dissolvants, soit de saponifiants. Les hydrates de potasse, de chaux et de soude, forment avec ces corps des savons solubles dans l'eau; il en est de même de l'ammoniaque; mais l'alcool, l'éther, l'essence de térébenthine pure, etc., n'agissent qu'à titre de dissolvants. « Plusieurs acides puissants, dit M. Thénard, s'unissent *à chaud* à certaines huiles pour former une espèce de cire. » Ce procédé est dangereux pour les estampes, par conséquent impraticable. Le chlore, et les chlorures à base de chaux, de soude ou de potasse, attaquent aussi les taches récentes, mais seulement à l'état concentré.

On essaiera d'abord de l'un des trois liquides dissolvants mentionnés ci-dessus (1). Ces matières agissant surtout à chaud, on les chauffera au bain-marie, c'est-à-dire dans un vase qu'on maintient pendant quelque temps dans une casserole contenant de l'eau bouillante; il faut procéder avec précaution, surtout avec l'essence, qui s'enflamme spontanément à une certaine température. Pour ôter à l'estampe l'odeur de térébenthine, on la passera à l'alcool, ou on la placera entre deux couches de plâtre très fin, qui finira par l'absorber.

Quand la tache résiste aux dissolvants, on a recours aux alcalis, mais avec réserve.

Une dissolution faible de potasse pure ou *caustique* (deux ou trois grammes dans un verre d'eau) agit sur la tache assez rapidement. Si le noir de l'estampe, après l'opération, paraît

(1) On peut aujourd'hui ajouter la *benzine*, liquide dont je parlerai ci-après. L'alcool à froid dissout bien peu d'huile, puisqu'il en faut mille gouttes pour en dissoudre six d'huile de lin ou trois d'huile d'olive. J'ai lu quelque part que l'alcool camphré avait une propriété dissolvante beaucoup plus forte. Si l'on emploie la térébenthine, elle devra être très pure.

grisâtre, voilé, on y dépose un peu d'eau légèrement acidulée, et il reprend son éclat, à moins que l'impression ne soit très fraîche.

On signale encore comme entraînant ou décomposant les taches (de date récente) plusieurs matières, notamment le fiel de bœuf, que les teinturiers emploient sur les étoffes ; je n'en ai pas fait l'essai (1). J'ai quelquefois, avant d'attaquer une tache huileuse, imbibé du même corps gras qui l'avait souillée la surface entière de l'estampe ; le tout disparaissait en même temps. On est sûr par ce moyen qu'il ne restera aucune trace au contour de la tache ; mais cette méthode n'est applicable qu'aux petites pièces.

Taches d'huile ou de graisse anciennes. — Ces sortes de souillures ont fait de tout temps le désespoir des amateurs. Elles sont très dif-

(1) Les teinturiers, pour enlever les taches de graisse sur la *laine*, se servent d'un liquide ainsi composé : eau, un demi-litre ; potasse du commerce, une once ; un demi-fiel de bœuf frais et bouilli, et un peu de jus de citron. Ils emploient ce liquide à chaud ou à froid. (*Manuel du Teinturier* de la Collection Roret.) Selon M. Le Normand, on y mêle aussi du jaune d'œuf.

ficiles à détruire sans altérer le noir d'impression. En effet, tout ce qui peut agir sur elles agit nécessairement sur ce noir, qu'on doit considérer lui-même comme une tache ancienne formée par un vernis gras. Rappelons que le noir employé aujourd'hui est bien plus tenace que celui des estampes des quatre siècles précédents, comme je l'ai dit à propos de l'effet de l'eau de Javelle.

J'ai fait quelquefois disparaître des taches huileuses, évidemment anciennes (telles sont celles, par exemple, qui souillent des estampes provenant de la vente d'un amateur qui les possédait en cet état depuis environ un demi-siècle), au moyen des liquides indiqués ci-dessus pour les taches récentes. Mais, je l'avoue, j'ignorais complétement la nature précise du corps huileux.

L'emploi d'une dissolution de potasse assez concentrée et versée chaude produit toujours, au bout d'une heure ou deux, la disparition des taches les plus opiniâtres; mais, si l'on agit sur un point gravé, le remède est pire que le mal. L'encre d'impression perd son éclat et devient pulvérulente; le noir de fumée qu'elle

contient, entraîné par le liquide, s'étale sur les blancs que forme l'intervalle des hachures ; la tache serait encore préférable. Ajoutons que plus tard le papier peut subir, par suite d'un remède si violent, un commencement de désorganisation. Il faut tenter ce remède, mais sans cesser d'en observer les effets, afin de l'arrêter à temps.

Quand l'action trop prolongée de la potasse a rendu l'encre d'impression pulvérulente par suite de la décomposition de sa partie grasse, on parvient peut-être à atténuer le dommage en encollant légèrement le papier comme s'il s'agissait de fixer un dessin au crayon tendre. (Voyez la fin du chap. X.)

On voit quelquefois exposés aux vitres des encadreurs des échantillons de taches d'huile enlevées, en apparence, avec bonheur ; généralement c'est sur des dessins à la mine de plomb, à la sanguine ou autres crayons d'une composition inaltérable. On y voit pareillement des gravures (quelquefois divisées en deux morceaux) dont une portion, d'une blancheur parfaite, contraste avec l'autre portion, horriblement encrassée d'une huile épaisse. Mais

quelle était la nature, la date de cette tache ? Et d'ailleurs ne pourrait-on pas supposer que ce spécimen a été formé d'une manière factice ? Prenez une estampe fort saine ; tachez une partie de sa surface, et vous obtenez un superbe échantillon. Pour moi, je crois sincèrement qu'il est encore impossible d'enlever, sans altération aucune, une vieille tache d'huile sur une gravure ; je me bornerai donc à indiquer des moyens atténuants (1).

Mais d'abord, pour ne pas désespérer les amateurs, je leur communiquerai une recette que je tiens d'un de nos collectionneurs les plus intelligents, de M. Hennin. La plupart des taches huileuses ou graisseuses finiraient par céder au procédé naturel qui sert à blanchir les toiles : exposer l'estampe à la rosée de la nuit, en un lieu favorable, puis l'étaler en plein so-

(1) Je citerai, seulement pour mémoire, la recette qu'indique Chomel (*Dict. économique*, tome II) pour ôter les taches d'huile *anciennes* ; prendre une demi-livre de savon, quatre onces d'argile, une once de chaux vive ; mêler le tout avec de l'eau et l'appliquer sur la tache. Je n'ai pas mis la recette en pratique.

leil, et continuer l'opération pendant huit ou quinze jours.

J'ai vu un résultat assez satisfaisant obtenu au bout d'une semaine sur un portrait en partie couvert d'huile depuis au moins plusieurs années. La trace paraissait encore, mais seulement au verso. Reste à savoir si toutes les taches huileuses céderaient à cet expédient. J'ai vu plusieurs autres échantillons détachés par ce remède naturel; les gravures n'avaient pas une netteté parfaite, mais on devinait qu'elles avaient dû gagner beaucoup. Je ne sais si l'eau distillée pourrait au besoin produire le même effet que la rosée.

En général, on devra soumettre les taches anciennes successivement à tous les agents chimiques conseillés pour les taches récentes. Si on ne réussit pas, on est sûr au moins de trouver dans ces essais des palliatifs. L'alcool, l'essence, la potasse faible, ôtent à toutes les taches leur transparence, et les réduisent à une légère trace, tantôt d'un jaune faible, tantôt d'un vert très clair (1).

(1) Toutes les huiles anciennes laissent sur le papier

Sur une petite estampe, on peut dissimuler cette trace en donnant (au moyen de réglisse ou de bistre en dissolution) une teinte semblable au reste de l'estampe; la couleur générale sera d'un ton léger et chaud, qui, loin de nuire à la gravure, avantagera quelquefois les tailles du burin. Il m'est arrivé souvent de préférer une épreuve à une autre d'un tirage identique, uniquement parce que sa teinte jaunâtre lui donnait plus d'ensemble au premier coup d'œil.

Il ne faut pas que la teinte ajoutée empiète sur le contour de la tache, qui, devenant plus foncé, en dessinerait la forme avec trop de vigueur. On réussit à donner une couche bien uniforme en lavant vivement au pinceau sur le

cette trace jaunâtre. C'est, je crois, véritablement la seule partie de la tache qui résiste avec opiniâtreté. Cette matière, selon M. Thénard, n'est pas bien connue des chimistes. Elle colore toute l'épaisseur du papier : de là la difficulté de l'enlever. Sur une étoffe elle disparaît mieux, parce que, ce tissu pouvant se tordre, elle est entraînée mécaniquement. Les taches d'huile récentes ne laissent pas cette trace, que l'action de l'air et de la dessiccation contribue sans doute à fixer si fortement.

papier à l'état de moiteur. On redresse ensuite, soit au fer chaud, soit à la presse. (Voyez page 18.)

Un professeur de chimie m'a communiqué le procédé suivant : On se procure un long cylindre de verre à fond arrondi, nommé *flûte* (voyez p. 9), d'une longueur et d'un diamètre proportionnés aux dimensions de l'estampe. On l'y introduit roulée, puis on la déroule, ayant soin de ménager un espace entre chaque circonvolution du papier. Le cylindre dépassera de plusieurs centimètres l'estampe, qui ne doit pas toucher le fond arrondi, destiné à recevoir quelques grammes d'éther.

Le tout disposé, on maintient le vase suspendu, par un appareil quelconque, au dessus d'une lampe à alcool ou de quelques charbons incandescents; puis on pose sur l'orifice du cylindre une légère rondelle de verre ou de fer-blanc, qu'on remplacera quand elle sera trop échauffée. La vapeur de l'éther se produit bientôt, passe à travers les spirales, et va en grande partie se condenser en gouttelettes sur la rondelle, d'où elle retombe liquéfiée au fond du vase; une faible partie se répand dans l'air

en soulevant le couvercle, qui oppose une légère résistance.

Cette vapeur, au bout d'un certain temps, rendrait aux taches huileuses leur fluidité et les ferait disparaître en les dissolvant ou plutôt en les étalant sur toute la surface du papier. Je crois qu'il y a quelques chances de succès dans cette opération. Du reste, j'en reviens toujours à un raisonnement qui me paraît péremptoire : si la tache d'huile est ancienne et de même nature que celle qui entre dans la composition du noir de l'estampe, l'action de l'éther doit enlever également à ce noir sa partie grasse et le réduire à une trace pulvérulente de noir de fumée.

On m'a signalé aussi de bons résultats obtenus par la soude ou par le carbonate du même alcali. Ces effets sont analogues à ceux de la potasse pure ou caustique ; seulement ils sont moins rapides, moins actifs. Je préfère donc, pour simplifier, la dissolution de potasse, plus ou moins affaiblie.

Un marchand d'estampes que j'ai eu occasion de voir à Munich en 1843 enlève, m'a-t-on dit, les taches d'huile en opérant au verso

seulement de la gravure ; mais la substance employée doit, ce me semble, attaquer également le noir d'impression, car elle pénètre bientôt tout le papier. La plupart des taches d'huile traversant le papier du recto au verso, ne serait-il pas plus naturel que le remède suivit la même marche, à moins d'admettre que la partie la plus tenace de la tache s'est précipitée et concentrée sur la surface opposée à celle qui l'a reçue, c'est-à-dire au verso ? Je suppose qu'on imbibe la tache d'un liquide quelconque, versé goutte à goutte, et qu'on maintient l'estampe dans une position telle que le liquide ne séjourne pas du côté de l'impression.

On pourra essayer de ce système. Je me fais un devoir de citer tous ceux qu'on me signale, mais sans en assumer la responsabilité. Si je possédais assez d'habileté, assez de temps aussi, pour les éprouver tous avec soin, ce livre renfermerait moins d'hypothèses.

Après la publication de ma première édition, je reçus un jour la visite de deux personnes qui me priaient de leur confier une estampe tachée d'huile, sur laquelle j'aurais épuisé mes tentatives. Elles me promettaient d'en enlever

la tache sans aucune altération de la gravure, mais ne consentaient pas à opérer devant moi. Que m'importait, dès lors, leur réussite? Mon but n'est pas de savoir si quelqu'un possède réellement un remède dans les cas les plus difficiles, mais en quoi consiste ce remède, afin de le révéler à tous, car j'ai en vue uniquement l'intérêt des gravures précieuses, en quelques mains qu'elles se trouvent.

Je dois consacrer quelques lignes à une nouvelle substance, inconnue, ou du moins peu connue encore en 1846. Il s'agit de la *benzine*, sorte d'essence qui exhale une odeur d'hydrogène carboné, et que prépare en grand M. Collas, pharmacien de la rue Dauphine. Je vais citer un extrait du prospectus qui accompagne chaque flacon :

« Pour enlever les taches de graisse sur les
« gravures, dessins, etc., on place le point
« graissé de la gravure, ou même la gravure
« entière, sur un papier joseph en dix ou vingt
« feuilles ; on trempe un morceau de coton
« cardé dans la *benzine* et on le place sur la
« tache, où on le maintient pendant quelques
« minutes ; on l'enlève et on éponge la place

« rapidement avec un papier joseph. On change
« le papier de dessous la gravure pour en met-
« tre un nouveau. Alors on trempe un nouveau
« morceau de coton dans la benzine et on le
« passe légèrement sur la tache, du centre aux
« extrémités, en formant des rayons pour fon-
« dre la nuance et éviter un cercle qui se for-
« merait sans cela. En raison de la grande vo-
« latilité de la benzine, cette opération doit
« être faite rapidement. Cependant, si, après
« la complète évaporation de la benzine, qui a
« lieu en un quart d'heure au plus, la tache re-
« paraissait encore, il faudrait recommencer.
« Il est important de savoir que la benzine est
« un corps tout à fait neutre et sans aucune
« action sur aucune espèce de tissus ni cou-
« leurs. Elle ne dissout que la cire et les
« *corps gras* : il n'y a donc aucune espèce de
« danger à la laisser en contact avec les pa-
« piers, si précieux qu'ils soient »

Nous retombons toujours, on le comprend, dans l'inconvénient qu'offrent toutes les substances qui agissent sur les taches huileuses. Du moment que la benzine dissout les corps gras, son action ne peut être prolongée impu-

nément que sur des dessins tracés aux crayons, à l'encre de Chine ou à l'encre ordinaire.

Je vais ici réimprimer un fragment de texte, provenant de je ne sais plus quel traité moderne de physique. Le procédé qu'on y indique pour la décomposition de l'huile ne pourrait, fort probablement, s'appliquer à de l'huile desséchée depuis longtemps; quoi qu'il en soit, je le citerai pour acquit de conscience. « Plu-
« sieurs matières organiques peuvent être dé-
« composées par une série d'étincelles électri-
« ques. On remplit, par exemple, d'*huile*, une
« petite cloche reposant sur du mercure, et dont
« la partie supérieure est traversée par un fil
« de platine qui descend jusqu'à une petite di-
« stance de la surface du mercure. En mettant
« le fil en communication avec le conducteur
« d'une machine, et le mercure en contact avec
« le sol, les étincelles qui passent de l'extré-
« mité du fil au mercure *décomposent le li-*
« *quide.* »

Enfin, pour ne rien omettre, je rappellerai le souvenir d'une substance signalée page 22. L'eau oxygénée décomposerait-elle, moyennant certaines conditions (par exemple, sous

l'influence électro-chimique), une vieille tache d'huile, en s'emparant de son hydrogène ? Je l'ignore complétement, mais l'expérience pourrait être tentée.

En résumé, on peut conclure de tout ce qui a été dit sur la question des taches d'huile et de graisse qu'il est impossible d'enlever complétement les taches évidemment anciennes *sans altérer plus ou moins* le papier ou le noir d'impression, et qu'il n'existe que des moyens plus ou moins atténuants. On peut espérer pourtant, vu les progrès incessants de la chimie, que la question sera quelque jour résolue d'une manière plus satisfaisante.

V

ENLÈVEMENT DE TACHES DE DIVERSES NATURES.

Taches de cire blanche ou jaune. — Les cires se dissolvent promptement dans l'essence de térébenthine, surtout chauffée au bain-marie, comme je l'ai dit page 55. Quand ces taches sont épaisses, on en enlève le gros au moyen d'un grattoir ou d'un papier buvard appliqué contre la cire, sur lequel on appuie une cuiller d'argent contenant un charbon allumé.

La cire jaune macule assez souvent les anciennes estampes, car nos pères s'éclairaient

avec moins de raffinement que nous. La trace qui peut en rester ne disparaît pas toujours dans le chlore ou ses composés. Peut-être la benzine, substance mentionnée au précédent chapitre, entraînerait-elle la tache tout entière. Quant aux traces que peut laisser sur le papier la térébenthine impure, elles disparaissent le plus souvent dans l'alcool.

Taches de stéarine. — La bougie de cire, jadis si usitée, est aujourd'hui remplacée en général par une sorte de graisse saponifiée, la stéarine, dont les taches traversent le papier d'outre en outre et lui communiquent une transparence cornée désagréable; elles disparaissent dans l'eau bouillante, et mieux encore dans l'alcool chaud, mais le papier reste toujours assez raide à cet endroit, et le noir d'impression perd une partie notable de son brillant, sans que j'en sache la cause. Le gros de la tache s'enlève par le procédé indiqué à l'alinéa qui précède.

Cire à cacheter, résine et vernis résineux. —Toutes les résines sèches se dissolvent dans l'alcool chauffé au bain-marie. On ôte la partie épaisse, comme je l'ai dit ci-dessus. Les cires

à cacheter colorées en rouge, bleu, etc., laissent une teinte d'une nature quelquefois très tenace. Ces diverses couleurs disparaîtraient peut-être, du moins pour la plupart, grâce aux procédés indiqués au chapitre suivant

Taches de goudron, de poix, etc. — Ces taches se rencontrent rarement. Elles cèdent, en qualité de résines grasses, à l'action de la térébenthine chaude ou de la benzine à froid. S'il restait une trace noirâtre, elle résisterait opiniâtrement, dans le cas où elle serait du noir de fumée. Si cette trace était de l'oxyde de fer, on ferait usage de l'acide oxalique.

La glu est, je le suppose, une substance analogue à la poix.

Une tache provenant d'une goutte de caoutchouc (ou de gutta percha) liquéfié par la chaleur s'enlèverait par l'essence de térébenthine bien épurée, ou mieux encore par l'huile essentielle que fournit la distillation du caoutchouc lui-même. La benzine, je pense, produirait un effet semblable.

Jaune d'œuf. — Ce jaune est toujours mêlé à un peu d'albumine, matière qui s'épaissit dans l'eau bouillante et quitte le papier en en-

traînant la matière jaune. Si le papier est lisse et de pâte bien encollée, tout glisse et disparaît sous l'éponge dans un bain d'eau chaude.

Il reste, en certains cas, une trace jaunâtre dont le principe est peu connu des chimistes ; bien qu'il y ait du soufre dans le jaune d'œuf, elle est d'une nature non sulfureuse. On l'affaiblit beaucoup en l'imbibant au pinceau, à plusieurs reprises, de chlorure de chaux, et l'imprégnant ensuite d'acide chlorhydrique très faible, qui l'entraîne en partie avec la chaux du chlorure, dont le chlore se dégage avec effervescence. La légère teinte qui peut survivre se confond, du reste, avec la teinte générale d'une estampe un peu enfumée.

Taches de boue. — Une tache de boue provenant d'une simple éclaboussure s'enlève, le plus souvent, à l'aide d'une éponge humide qu'on promène sur l'estampe soit sèche, soit maintenue dans l'eau, au fond d'une bassine ; quand le papier est bien encollé, il n'en conserve aucun vestige. Mais il en est autrement si la tache a été appliquée par une forte pression, par exemple si l'on avait marché sur l'estampe.

Sur un papier absorbant et peu lisse, la

boue ne glisse pas aisément, et l'éponge en écorche la surface. En ce cas, on étalera sur la place maculée du savon en gelée, de la colle d'amidon, ou toute autre matière gluante et mucilagineuse susceptible d'entraîner la boue et de se délayer elle-même ensuite dans l'eau à chaud ou à froid.

Si après cette opération quelques traces opiniâtres persistaient, il faudrait essayer successivement le chlorure de chaux, les alcalis et les acides étendus d'eau. Une tache de boue se complique de tant de matières hétérogènes qu'on ne peut agir que par tâtonnement. Celle de Paris contient un peu d'oxyde de fer (ou rouille) qui provient de l'usure continuelle des roues de mille voitures. La rouille disparaît dans l'acide oxalique chaud. (Voyez ci-après.) M. Le Normand indique la crème de tartre (bitartrate de potasse) en poudre très fine pour enlever la partie ferrugineuse de la boue.

Taches d'encre. — L'encre à écrire ordinaire (gallate de fer) se décompose avec assez de facilité, car son principe constituant est une matière végétale, la noix de galle, unie à un peu d'oxyde de fer. Ce noir cède assez promp-

tement à une application de sel d'oseille (sur-
oxalate de potasse), qu'on arrose d'eau *bouillante* ; cette dernière condition est essentielle, si l'on veut opérer avec promptitude.

Les chimistes signalent la propriété que possède l'étain d'accélérer la décomposition, et conseillent de faire bouillir la dissolution du sel d'oseille dans une cuiller d'étain, ou de mettre au revers de l'endroit taché une feuille de ce métal au moment où l'on verse l'eau bouillante. On réussit encore mieux avec une solution chaude et assez concentrée d'acide oxalique pur. C'est un sel extrait de celui de l'oseille, dont il est le principe (1).

(1) L'acide *oxalique*, de nature végétale, paraît faible appliqué sur la langue ; néanmoins, il faut s'en méfier ; il est vénéneux et peut altérer le tissu du papier (de celui surtout fabriqué avec du coton). Une estampe que j'avais laissée séjourner pendant quelques heures dans une solution assez concentrée d'acide oxalique est devenue par la suite si cassante qu'elle s'écaillait sous la pression du doigt. Quand on sera obligé d'employer cet acide, on devra, l'opération terminée, plonger l'estampe dans un bain légèrement alcalin, puis ensuite la laisser tremper pendant douze heures au moins dans l'eau pure ; encore n'oserais-je répondre des suites.

Un liquide en vente chez quelques papetiers sous le nom ronflant d'*encrivore* est tout simplement de l'eau tenant en dissolution quelques centimes d'acide oxalique ou de sel d'oseille. On a bien plus d'avantage à se procurer ces matières sèches.

Le chlore, ainsi que les chlorures alcalins, les acides chlorhydrique, nitrique (étendus d'eau), l'acide citrique pur, etc., décomposent l'encre, mais sans enlever la tache de rouille, qui survit à la teinte noire. Pour éviter une double opération, il vaut mieux recourir tout de suite à l'acide oxalique chaud. (Voir plus loin : *Taches de rouille.*

Avis aux bibliophiles. — Les taches d'encre sont assez communes sur les anciens livres. Quand un grand nombre de feuillets en est pénétré, le livre doit être décousu, pour être ensuite relié de nouveau. Si pourtant on ne voulait pas se résoudre à ce parti extrême, voici le procédé assez long à mettre en usage.

On attaque isolément chaque feuillet ; on dispose au dessous une feuille d'étain ; on humecte la tache d'eau imprégnée de sel d'oseille ou d'acide oxalique ; puis on procède de

la même manière à l'égard des feuillets suivants. Quand l'encre a disparu, on remplace l'étain par du papier buvard. Comme on applique la dissolution sur la tache d'encre seulement, il se forme presque toujours au delà de ses limites une zone jaunâtre, qui exige, pour s'enlever, un mouillage général de la page à l'eau pure. En tout cas, ce mouillage est nécessaire pour prévenir l'effet ultérieur de l'acide. (Voyez à ce sujet l'article *Mouillures* à la fin du présent chapitre.)

Si l'on opérait sans précaution, une partie du liquide acidulé, s'infiltrant à travers le dos des cahiers, irait former des traces de couleur fauve sur d'autres feuillets voisins qu'il envahirait par l'effet de la capillarité. Le livre décousu se nettoierait assurément beaucoup mieux ; mais par malheur le plus habile relieur ne saurait le recoudre sans qu'une nouvelle rognure fût nécessaire.

S'il s'agissait non de plusieurs cahiers, mais de quelques pages isolées, on pourrait les séparer du livre, et, l'encre effacée, les recoller à leur place. Il existe, pour extraire nettement les feuillets d'un livre, un expédient fort

simple, employé quand on veut remédier à une transposition de pages peu compliquée. Le livre tenu ouvert, on passe, entre la base du feuillet à isoler et celle du feuillet contigu, un long fil bien sec, qu'on maintient serré le plus près possible du dos du volume; on mouille la partie du fil qui dépasse, et, le tirant doucement, on substitue peu à peu cette portion humide à celle qui ne l'est pas, puis on ferme le livre.

Deux ou trois minutes après, plus ou moins, selon l'épaisseur et le degré d'encollage du feuillet, le papier est humecté sur toute la ligne, et cède à une légère traction. La tache d'encre enlevée, on laisse tremper le feuillet, puis on le met en presse, ou on le repasse au fer (voir page 18), et on le recolle à la gomme (voyez fin du chap. VII) au moyen d'un onglet ou bande étroite de papier mince, qui a pour appui la naissance du feuillet voisin. Cet onglet est même souvent inutile. Ce procédé peut être également suivi dans tous les cas où quelques pages isolées d'un livre sont tachées d'une matière quelconque.

J'ai parlé de l'encre dont on fait communé-

ment usage. Mais il en est qui ont pour base une autre substance que le gallate de fer, ou sont mélangées de matières de diverses natures. Ces encres, pour s'effacer, peuvent exiger d'autres remèdes que ceux indiqués ci-dessus. Si l'acide oxalique ne réussit pas, il faut avoir recours successivement au chlore, à l'eau de Javelle, ou à divers acides étendus d'eau, etc. Au reste, les détails que je donnerai au chapitre *Décoloriage* pourront mettre l'amateur sur la voie.

Encre de Chine. — Cette encre a pour base non pas le liquide noirâtre que secrète le mollusque nommé *sèche*, comme on l'a supposé longtemps, mais bien le noir de fumée délayé et agglutiné par une colle quelconque. Elle a été jugée par tous les chimistes complétement indécomposable. (Voir l'article suivant.) Fraîchement appliquée sur un papier très lisse et bien encollé, elle peut s'effacer avec une éponge humide ; dans ce cas, elle glisse, elle est entraînée mécaniquement ; mais aucun agent ne peut la décomposer ni la dissoudre. On doit même la regarder comme plus tenace que l'ancienne encre d'imprimerie, qui, en cer-

tains cas, est en partie entraînée avec la matière huileuse qui lui donne de la fixité.

J'ai fait au sujet de l'encre de Chine bien des tentatives sans résultats ; on peut tout au plus, à force de lavages, atténuer un peu la vivacité de son noir (1). Il n'y a plus, si l'on veut absolument s'en délivrer, qu'à gratter le papier. C'est au reste le meilleur parti à prendre quand elle macule une partie blanche ; mais, si la tache s'étend sur les tailles de la gravure, il faut ou la laisser, ou découper et remplacer le morceau. (Voy., chap. VII, l'article *Lacunes*.)

Cette impossibilité de détruire et même d'affaiblir des taches si apparentes impose aux bibliophiles l'obligation de suivre ce double conseil : n'avoir jamais d'encre de Chine délayée à proximité de leurs livres, et ne s'en jamais

(1) Je signalerai l'essai suivant : imbibez une tache d'encre de Chine d'une huile grasse purifiée ; douze heures après, saponifiez cette huile avec de l'ammoniaque ou une solution alcaline. Le noir s'est comme ramolli ; appliquez-y à plusieurs reprises du papier buvard, vous finissez par déloger une quantité notable des parcelles carboneuses nichées dans les pores de cette sorte de feutre qu'on nomme papier.

servir pour y tracer des notes. Il devront se garder aussi d'en mêler la moindre parcelle à l'encre commune, puisqu'elle laisserait une trace ineffaçable.

D'autre part, cette vertu indélébile peut être utilisée toutes les fois qu'on veut obtenir des caractères inaltérables : aussi en indiquerai-je l'usage au sujet de la réparation des traits de burin. Si l'on veut tracer un écrit dont le plus rusé faussaire ne puisse retrancher une lettre, on n'a qu'à employer l'encre de Chine liquide sur un papier peu encollé qui se laisse pénétrer à demi.

Taches de noir de fumée. — Ce noir est du carbone très divisé retenant de l'hydrogène, qui lui donne sans doute cette nature onctueuse qui le fait adhérer à la surface du papier. Bien que considéré comme une sorte de résine, il ne se dissout ni dans l'alcool ni dans la benzine, où il reste simplement en suspension. L'eau oxygénée ne peut l'oxyder, autrement dit le réduire à l'état gazeux d'acide carbonique ; il est inaccessible à l'action de toutes les substances chimiques, et n'est gazéifiable qu'au fond d'un creuset, à une température élevée.

Quand le noir de fumée n'a pas été frotté sur le papier de manière à s'y incruster, la mie de pain rassis ou le savon en gelée l'enlève assez facilement; mais la trace noire qu'il laisserait est, je le répète, chimiquement inattaquable.

Taches de crayons. (*Plombagine*, *sanguine*, *crayon noir*, *etc.*) — Les traces récentes que laissent sur le papier ces divers crayons s'effacent au contact du caoutchouc ou de la mie de pain; mais, quand elles sont trop anciennes, elles résistent à ces moyens; on a recours alors à l'application du savon en gelée ou de la colle de pâte. On frotte ensuite avec une éponge douce ou un blaireau, et l'on trempe dans l'eau chaude. S'il restait, après cette opération, des traces opiniâtres sur le papier, il faudrait désespérer de les enlever.

La *plombagine* ou *mine de plomb* (deux dénominations inexactes) est un composé inaltérable de fer mêlé de charbon (carbure de fer) dont une excessive température peut seule opérer la décomposition. Les autres crayons de diverses couleurs (espèces d'argile siliceuse retenant du charbon ou des oxydes métalliques)

sont également irréductibles (1), et ne peuvent s'effacer, dans certains cas, que par voie d'entraînement.

Les traces produites sur le papier par un métal simple, tel que le plomb, le cuivre, etc., se dissolvent dans la plupart des acides étendus. Quant à celles du fusin, elles cèdent presque toujours, si elles n'ont pas été fixées, à la mie de pain ou à l'action du savon.

Comme il est des cas où les crayons peuvent laisser des traces indélébiles, on doit éviter d'appuyer trop fortement quand on charge de notes les marges d'un livre rare à l'aide de ceux signalés comme indécomposables.

On a indiqué le saindoux pour effacer les

(1) Je ne parle pas ici des pastels, à base calcaire, qui se décomposent dans les acides faibles. Les crayons argileux qui adhèrent simplement au papier finissent avec le temps par se combiner en quelque sorte avec sa surface; aussi les traces de la sanguine, au bout d'un certain nombre d'années, sont-elles *inentraînables*. La triple combinaison de l'air, de l'humidité et de la lumière, est un véritable agent chimique, lent, mais plein de puissance. C'est peut-être à cet agent qu'est due la ténacité du ciment romain.

traces anciennes de crayons; après un séjour de quelques heures, on enlèverait cette graisse en la saponifiant par la potasse. La graisse, en ce cas, se mêle à la plombagine, mais ne la dissout pas. Essayer dans les cas désespérés.

Encre à marquer. — Ce liquide noirâtre, qui est un azotate (nitrate) d'argent dissout dans l'eau, est très solide en ce sens que la potasse ou la chaux des lessives ne fait que lui donner de la vigueur. Cependant, sur le papier, il cède à l'action de l'eau de Javelle ou du chlorure de chaux appliqué au pinceau (1). Du reste, il est rare que l'azotate d'argent souille une estampe, sinon dans l'atelier d'un photographe.

Une tache de cette nature s'effacerait moins facilement sur du parchemin, qui est une matière animale.

Selon M. Thénard, la tache produite sur la main par le nitrate d'argent ne disparaîtrait que par le renouvellement de l'épiderme. D'autre part, j'ai lu, dans je ne sais plus quel

(1) Il faut éviter de se servir d'une éponge avec le chlore et les chlorures : elle serait bientôt réduite en une sorte de bouillie.

traité de chimie, qu'elle céderait au cyanure de potassium. Ce réactif produirait probablement sur le parchemin le même effet que sur la peau humaine ; reste à savoir si son emploi est sans danger.

Taches de thé, tabac, réglisse, etc.—Parmi ces taches de nature végétale, les unes disparaissent dans l'eau chaude, les autres exigent l'application du chlorure de chaux. Il en est qui sont plus rebelles : telle est celle provenant du chocolat, qui contient une huile particulière. M. L. Séb. Le Normand remarque que l'infusion de café torréfié laisse sur le linge une tache composée ; il conseille pour l'enlever la vapeur sulfureuse.

Taches de fruits.—M. Thénard avance, dans son *Cours de chimie*, à l'article *Acide sulfureux* (ne pas confondre avec celui dit *sulfurique*), que cet acide enlève, spécialement sur le linge, toutes les taches de fruits. Son action est sans doute la même sur le papier. Je crois, au reste, qu'on doit obtenir du chlore le même effet, et qu'en certains cas l'eau chaude est même suffisante. On signale aussi l'efficacité de la crème de tartre.

M. Le Normand, dans son *Manuel de l'art du dégraisseur*, assure que les taches de vin, de mûres, de cassis et de liqueurs, cèdent à une fumigation de gaz acide sulfureux. Le même (ou un autre chimiste) avance que les manuscrits à l'encre ordinaire, encre que le chlore détruirait, peuvent se blanchir par le soufrage, avec la précaution d'éloigner le papier de la flamme sulfureuse.

Taches de sang. — Le sang, ce composé de tant d'éléments divers, disparaît assez vite, par entraînement, sur le linge; mais le papier, ne pouvant se tordre, offre plus de difficultés. La tache est décolorée par le chlorure de chaux; mais il faut que ce chlorure agisse au moins pendant vingt minutes. Le plus simple est de l'appliquer en pâte sur la tache. Il reste ensuite une trace d'un jaune pâle, qui cède à un faible acide.

La couleur rouge du sang passe pour contenir de l'oxyde de fer; néanmoins je n'ai pu rien obtenir de l'emploi direct de l'acide oxalique, qui décompose cet oxyde.

Fientes de mouches, d'oiseaux, etc. — Les taches occasionnées par les mouches sont très

communes, principalement sur les estampes qui ont été longtemps étalées à nu sur une muraille. Les unes glissent sous l'ongle ou s'effacent dans l'eau, au simple frottement d'une éponge; mais d'autres pénètrent le papier dans toute son épaisseur, et sont très difficiles à enlever. Cette différence provient de l'espèce de mouches, et sans doute aussi de la nature de leurs aliments. Elles disparaissent en général dans un bain de chlorure de chaux assez concentré; il vaudrait mieux peut-être les laisser, quand elles nuisent peu à l'effet de la gravure. L'eau acidulée n'a sur elles aucune influence; peut-être la solution de potasse en détruirait-elle le principe gras, qui s'oppose à leur disparition; mais le remède serait trop dangereux pour le noir de l'estampe.

Les taches que les punaises déposent sur le papier doivent différer de celles produites par les mouches, puisque ces insectes s'alimentent surtout de sang. Je n'ai fait aucune expérience à ce sujet; on essayera des remèdes indiqués ci-dessus.

Quant à la fiente des oiseaux, qui souille quelquefois les estampes exposées en plein

air, elle a pour base l'acide urique; on l'écroûte d'abord et on enlève la trace jaunâtre par le chlorure de chaux faible.

Matières fécales et urines. — Les souillures provenant de cette source peuvent se rencontrer sur une estampe, ne fût-ce que dans une tache de boue. Je n'ai fait aucun essai sur les matières fécales, fort compliquées dans leur composition; on essayera d'abord l'eau de savon. Si ce système par entraînement ne réussit pas, on emploiera successivement le chlorure, les alcalis, puis les acides oxalique ou chlorhydrique, ayant soin de faire retremper l'estampe pendant au moins une heure entre chaque opération. Les taches *anciennes d'urine* se décomposent, selon M. Le Normand, par l'acide oxalique.

Taches de colle de pâte. — Ces taches, quand elles sont très récentes, disparaissent sous une éponge humide. Quand elles sont sèches, on a recours à l'eau bouillante, qui dissout de même et sur-le-champ toutes les colles gélatineuses.

Taches de rousseur isolées. — Ces taches se rencontrent surtout sur les estampes qui ont été longtemps sous cadre; elles sont dues à la

saleté ou à l'humidité du carton, souvent aussi à la nature du papier (1). Le chlore les enlève au bout d'un certain temps; mais quelquefois elles laissent une trace qui provient, je crois, d'une décomposition partielle du papier, ou bien elles s'effacent momentanément et reparaissent plus tard.

Taches de rouille. — Voy. ci-dessus (page 28) ce que j'en dis au sujet des taches d'encre. J'ajouterai ici ce passage extrait du *Manuel du blanchiment*, par M. de Fontenelle, tome II, p. 139 :

« La rouille qu'on remarque sur le linge ou
« sur le papier est due à un tritoxyde de fer
« sous-carbonaté qui, pour se dissoudre dans
« la plupart des acides, doit passer à un de-
« gré d'oxydation moindre; on y parvient en
« mouillant les taches avec un hydrosulfure
« alcalin; on éponge ensuite la partie, et l'on y
« met, au moyen d'une pipette ou d'une pincée
« de coton, quelques gouttes d'acide oxalique

(1) Quelques-unes doivent avoir pour origine de la rouille provenant de parcelles de fer oxydé que contient leur papier ou le carton du cadre.

« ou de sel d'oseille en poudre. On peut em-
« ployer aussi à cet usage l'acide hydrochlo-
« rique ou l'acide nitrique affaiblis ; le premier
« est cependant préférable. »

Taches de moisissure. — On voit quelquefois le noir des estampes encadrées se couvrir de petits points blanchâtres formés par l'humidité (1); ils cèdent au frottement de la mie de pain. Mais ces larges taches qu'a produites une longue action de l'air humide, et dont la couleur est d'un jaune fauve ou violacé, parsemé de points noirs, étant une véritable pourriture, ne peuvent guère que pâlir dans le chlore ; et, comme le papier très altéré n'a plus de consistance en cet endroit, il est nécessaire de le renforcer au verso.

M. de Fontenelle, dans son ouvrage cité ci-dessus (tome II, p. 137), désigne l'acide tartrique comme remède aux *avaries* du papier. Or, il comprend parmi ces avaries les taches de moisissure. A mon avis, l'acide tar-

(1) Un marchand d'estampes m'a assuré que la nature de certaines vitres n'était pas étrangère à la formation des taches blanchâtres en question.

trique ou tout autre, appliqué à une moisissure avancée qui a désorganisé le tissu du papier, doit produire, pour employer une expression populaire, « l'effet d'un cautère sur une jambe de bois ».

Taches jaunâtres de diverses natures. — Il existe quelquefois sur le papier, certaines taches jaunâtres, dont le principe est inconnu et qu'on ne sait comment attaquer. Comme il est impossible d'en saisir la nature, il faut tâtonner; on commencera ses essais par les liquides les plus innocents, et l'on remouillera l'estampe pour en annuler l'action, avant de procéder à de nouvelles tentatives. (Voyez, au chapitre *Décoloriage*, l'article *Couleurs jaunes.*)

Taches fauves et noirâtres provenant de brûlures. — On conçoit que celles-ci sont irréparables, puisque le papier est décomposé et presque charbonné; il faut les conserver telles quelles, les soutenir par une pièce appliquée au verso, ou remplacer toute la partie brûlée. (Voir chapitre VII, article *Lacunes.*)

Je vais citer à tout hasard ce paragraphe de M. de Fontenelle (t. II, p. 182): « Composi-

« tion pour réparer le *linge* roussi par un
« commencement de brûlure. — On fait bouil-
« lir dans une pinte de vinaigre, avec quatre
« onces de terre à foulon, deux onces de
« fiente de poule, une once de savon en pain
« et le jus de quatre oignons, jusqu'à ce que
« le tout ait acquis quelque consistance. On
« verse de cette composition sur toutes les
« parties endommagées; et, si elles ne sont
« pas *tout à fait* brûlées, après l'avoir laissée
« sécher dessus et l'avoir bien lavée une ou
« deux fois, elles paraissent aussi blanches
« et en aussi bon état que le reste du linge. »
Voilà un remède bien compliqué dont je ne
voudrais pas répondre sur ma tête.

Encrassement des estampes. — Un livre
ou un recueil de gravures souvent feuilleté
finit par se couvrir d'une crasse plus ou moins
épaisse. Quelques in-folios de notre cabinet
des estampes offrent en ce genre de curieux
échantillons, surtout sur les marges. Si la
gomme élastique ou la mie de pain n'agissent
pas, on mouille chaque estampe (ou chaque
feuillet); on la recouvre, aux endroits encras-
sés, d'une couche de savon blanc en gelée, et

on la laisse en cet état pendant quelques heures. Il est rare qu'en la frottant ensuite avec un blaireau très doux ou une éponge trempée dans l'eau chaude, toute la crasse ne soit pas entraînée, surtout quand le papier est lisse et sans écorchures.

Si le savon en gelée est impuissant, on le remplacera par du savon noir; mais on le laissera séjourner peu de temps sur le noir d'impression. On peut enfin recourir au chlorure de chaux (appliqué en bouillie) ou aux solutions alcalines affaiblies. En tout cas, après ces tentatives, on trempera l'estampe (ou le feuillet) dans l'eau acidulée, puis on la laissera quelques heures dans un bain d'eau pure.

Taches noires carboneuses (provenant de l'encre d'impression). — Souvent les caractères d'un livre, relié avant le séchage complet du noir d'impression, se déchargent, pendant l'opération du battage ou de la mise en presse, sur les pages opposées ou sur les estampes intercalées dans le volume. Ces contre épreuves bavochées, qu'on nomme, je crois, *maculage,* offrent une légère couche de noir de fumée,

quelquefois adhérente à peine à la surface du feuillet. En ce cas, elle cède à la mie de pain ou au savon en gelée. Si elle n'est pas entraînée par l'un de ces deux moyens, il n'y a aucun espoir de remède, puisque, ainsi que nous l'avons vu plus haut, le noir de fumée ne peut se décomposer qu'à l'aide d'un feu très ardent.

Mouillures. — On appelle ainsi des taches d'une teinte jaunâtre plus foncée vers les bords, formées sur du papier par le séjour de l'eau ordinaire. Les livres des bouquinistes en plein air offrent de superbes échantillons de mouillures dues à l'infiltration de la pluie à travers les tranches du livre.

Quand une goutte d'eau tombe à plat sur une estampe, elle conserve une forme plus ou moins sphérique. Or, cette eau dissout une certaine quantité du jaune qui enfume l'estampe, et la matière colorante, entraînée par la pente qui résulte de cette forme bombée, s'accumule sur les bords de manière à produire des taches annulaires. Au lieu d'une goutte, supposons une flaque d'eau de forme inégale; la tache ressemblera à une portion de carte géographique.

Toutes ces taches, quand il n'y a point de

moisissures, sont fort innocentes; un bain de quelques heures dans l'eau pure suffit pour les effacer. Si la disparition tarde trop à s'effectuer, on ajoute un peu de chlorure de chaux.

On peut enlever les mouillures sur les livres en posant à plusieurs reprises un linge humide de chaque côté du feuillet taché, et isolant cet appareil au moyen de feuilles d'étain. L'effet produit, on retire le tout et on ferme le livre après avoir placé le feuillet, pour le sécher, entre deux papiers buvards. Quand le livre est à demi envahi par les mouillures, il faut se décider à le découdre et à le laisser tremper une nuit dans l'eau; puis on fait sécher chaque feuillet à califourchon sur une corde tendue, et on donne au relieur.

J'ai sans doute oublié de décrire plus d'une tache qui s'offrira à l'amateur en certaines circonstances. En raisonnant par analogie, il trouvera tout aussi bien que moi des remèdes ou des palliatifs. S'il croit la tache de nature végétale ou animale, il appliquera le chlore et l'acide sulfureux; métallique, l'acide chlorhydrique (ou autre) étendu d'eau; huileuse ou

graisseuse, l'essence de térébenthine, l'éther, les solutions alcalines, la benzine, etc. Au surplus, le chapitre suivant n'est, pour ainsi dire, que la continuation de celui-ci : ne sont-ce pas en effet de véritables taches que ce hideux coloris dont une main malavisée a barbouillé une estampe quelquefois de grand prix ?

VI

DÉCOLORIAGE DES ESTAMPES.

Considérations préliminaires. — S'il est des estampes que le coloriage, le coloriage grossier surtout, déprécie, il en est d'autres auxquelles il communique au contraire un surcroît d'intérêt : je citerai les cartes à jouer, les planches d'histoire naturelle, les anciennes gravures de mode, etc. En ce cas, la couleur doit être conservée à titre de complément nécessaire.

Dans les livres d'heures imprimés au commencement du XVIe siècle, on voit des sujets sur bois miniaturés, qu'on prendrait au pre-

mier coup d'œil pour des gouaches. Ce genre de coloris est un type, et ce serait maladresse de le supprimer à grand'peine.

Choisissons un autre exemple. Les costumes gravés par Bonnard sont quelquefois couverts de couleurs contemporaines, assez criardes, il est vrai, mais néanmoins dignes d'être respectées, puisqu'elles ajoutent aux diverses parties de l'habillement des détails que le burin serait impuissant à rendre. Ce serait folie de passer son temps à décolorier ces estampes, d'autant plus que certains noirs résisteraient à tous les efforts, et que, d'ailleurs, ces costumes ne peuvent être considérés comme estampes d'art.

Mais il est d'autres pièces auxquelles le coloriage ôterait toute leur valeur : telles seraient des nudités, dues au burin de Marc-Antoine, qu'un enfant aurait barbouillées de carmin. Quel prix aurait un paysage à l'eau forte de Claude le Lorrain si le ciel était souillé d'une couche de bleu de Prusse, si les arbres chargés d'un vert uniforme offraient une tartine d'épinards ? En ce cas, tenter le décoloriage, c'est courir la chance de rendre à cette estampe,

7

surtout si l'épreuve est de premier état, une valeur, pour ainsi dire, inappréciable.

Je vais traiter de mon mieux cette matière difficile. D'abord, je dirai qu'il serait inutile de s'adresser à certaines estampes contemporaines de Louis XVI, et coloriées par *impression*; leurs couleurs, étant délayées à l'huile de lin cuite, à la manière du noir des graveurs, ne pourraient disparaître. Avec un peu d'attention, on en reconnaît facilement la nature.

Il peut se rencontrer par hasard une vieille estampe qu'on se serait avisé de colorier à l'aide d'un procédé qui avait la prétention, il y a vingt-cinq ans environ, de faire des tableaux à l'huile avec des lithographies couvertes de couleurs grasses et d'un vernis. Je ne m'occupe qu'en passant de cette espèce de vandalisme, dans le cas où il aurait pris pour victime une pièce rare (1).

(1) J'ai vu, en 1855, chez un bric-à-brac de Batignolles, une curieuse estampe accommodée à cette sauce peu artistique. C'était une remarquable épreuve de la procession de la Ligue, en deux feuilles et demie, gravée par Léonard Gaultier. Le fond du coloris paraissait

Comme il n'est question en ce chapitre que du coloris à la gomme, je me bornerai à dire qu'en cette circonstance on pourrait essayer d'enlever d'abord le vernis avec l'alcool chaud, ensuite de détacher ces couleurs, broyées à l'huile de lin, par une faible dissolution alcaline. La matière grasse, en se saponifiant, entraînerait-elle les couleurs ? Je l'ignore. Peut-être les couleurs mises à nu et isolées de l'huile céderaient-elles aux agents chimiques que je vais appliquer à l'aquarelle.

Cette observation, du reste, concerne en général toute matière grasse unie à une substance colorante : tel est le cambouis, vieux oing noirâtre, qui contient de l'oxyde de fer. Noel Chomel, dans son *Dictionnaire économique*, t. II, prétend ôter les taches de cambouis « avec du beurre, qui s'enlève ensuite au « moyen d'une cuiller contenant du feu ». Je doute que les iconophiles aient la velléité d'essayer du remède.

contemporain. L'estampe avait été tendue sur un châssis, puis recouverte d'un vernis qui en avait rendu le papier sec et cassant sous la pression du doigt.

Parlons maintenant du coloriage à l'eau, et prenons pour exemple une vue d'optique chargée de toutes sortes de couleurs. Si le papier était lisse comme du vélin et d'une pâte bien encollée, l'opération serait facile, à ce point que j'ai vu sur un tel papier toutes les couleurs glisser sous l'éponge après une heure d'immersion dans l'eau, sans laisser aucune trace (1). Mais souvent le coloris, appliqué sur un papier plus ou moins absorbant, s'est comme incorporé à sa surface; alors le système par *entraînement* ne réussit plus ; il faut recourir à la décomposition chimique. Du reste, comme je tenais à étudier les cas les plus complexes, toutes mes expériences au sujet du décoloriage ont été pratiquées sur des gravures dont le papier absorbait l'eau au dernier degré; de sorte que le succès était, en raison de la circonstance, le plus difficile possible.

Il n'est pas toujours aisé de reconnaître du premier coup la nature de la matière colo-

(1) Ce fait a lieu, je crois, surtout quand les couleurs appliquées contiennent beaucoup de gomme.

rante; un artiste peintre a sur ce point beaucoup plus d'habileté qu'un amateur. Quant à la date du coloris, elle ne peut se constater à la simple vue. J'ai rencontré des couleurs anciennes ineffaçables, du violet notamment. Étaient-ce des couleurs d'une composition inconnue, ou le temps les avait-il fixées, incorporées au papier? Pour moi, je pense que les couleurs décomposables, qu'elles soient appliquées récemment ou depuis deux siècles, cèdent avec une égale facilité aux mêmes agents; néanmoins il peut y avoir à cet égard des exceptions.

Je dois avertir d'abord que la moitié au moins des couleurs usuelles ne s'enlèvent pas sans risque d'altérer légèrement soit le noir d'impression, soit la surface du papier; du reste j'aurai soin, quand il existera plusieurs moyens d'effacer une couleur, d'indiquer le moins nuisible, le moins dispendieux et le plus rapide.

1° DES COULEURS BLANCHES. — Ces couleurs se rencontrent rarement à l'état simple sur les estampes coloriées. Appliquées sur les tailles du burin, elles y produisent presque

toutes, vu leur opacité (qui est un avantage dans la peinture à l'huile), un effet détestable. Les blancs à base calcaire, comme la *craie*, se décomposent facilement dans l'eau acidulée. L'*argile* blanche et non cuite se délaye dans l'eau simple.

Blanc de plomb ou *Céruse*. — C'est un carbonate de ce métal; sa teinte est un peu grisâtre; il disparaît au contact de l'acide chlorhydrique affaibli et de quelques autres; mais il en reste quelquefois une trace opiniâtre qui ternit un peu le noir brillant des hachures.

Le *blanc* dit *d'argent* est identiquement la même matière, mais plus pure; de là le nom qu'il porte. Il ne retient pas, comme le blanc de céruse, des traces d'hydrogène sulfuré, mais il est plus tenace, parce que peut-être on y mêle du sulfate de baryte, sel insoluble. Le *blanc* dit *léger* aurait-il également la même base? Un chimiste m'a dit que c'était un oxyde d'antimoine, ou qu'il en contenait.

Ces blancs doivent aux divers procédés de préparation la variété légère de leurs nuances. Le chlorure de chaux fait passer le carbonate de plomb (en deux ou trois heures) au rouge-

brique foncé; l'acide chlorhydrique étendu d'eau enlève le tout. C'est peut-être le moyen le plus efficace à employer pour s'en délivrer complétement.

Il arrive que le blanc de plomb, quand il rencontre dans l'air quelques parties de gaz hydrogène sulfuré, ou quand il est mêlé à certaines couleurs, se change en une matière noire qui est un *sulfure*. M. Thénard, à propos de l'eau oxygénée, dont il a fait la découverte, signale l'action soudaine de ce liquide sur le sulfure de plomb.

Blanc de zinc. — Cette couleur moderne est un protoxyde de ce métal; elle n'a pas, comme le blanc à base de plomb, l'inconvénient de noircir au contact des émanations hydrosulfureuses, ni celui d'altérer la santé de ceux qui la préparent. Elle doit céder à la plupart des acides affaiblis par l'eau.

Argent en coquille. — Cette couleur, sans cohésion, s'écoule d'ordinaire dans l'eau au moindre frottement. Si elle résistait, on y appliquerait un peu de mercure. Quelquefois cet cet argent contracte une teinte noirâtre, due, je crois, au contact du gaz hydrogène sulfuré.

Cette teinte est détruite par l'ammoniaque.

2° DES COULEURS NOIRES. — La plupart des noirs, de nature végétale ou animale, se décomposent aisément. Il n'en est pas de même de ceux, malheureusement très usités, qui ont pour base le charbon. J'ai déjà parlé plus haut (pages 73 et 78) de l'encre ordinaire et de l'encre de Chine.

Noir d'ivoire. — Formé d'ivoire calciné et carbonisé, ce noir offre-t-il plus de chances d'être un jour décomposé que l'encre de Chine, dont le principal élément, le noir de fumée, résiste à toute action chimique? Je n'oserais l'affirmer : je n'ai jamais pu parvenir qu'à lui ôter, à l'aide du chlore, une partie de son brillant.

Cette inaltérabilité est d'autant plus affligeante que cette couleur se rencontre assez fréquemment sur les estampes coloriées, à l'état simple ou mélangée de blanc.

Noir de sèche. — Il est tiré du liquide noir que sécrète le mollusque nommé *sèche*, substance qu'on a regardée longtemps à tort comme la base de l'encre de Chine, et dont on ne connaît encore qu'imparfaitement la com-

position. Cette matière, de nature animale, doit se décomposer dans le chlore ou le chlorure de chaux (1).

Teinte neutre. — Ce noir, assez employé dans l'aquarelle, est composé de gallate de fer ou de la liqueur fournie par la sèche unie au bleu de Prusse. L'eau de Javelle ou le chlorure de chaux enlève le noir ; mais il reste une teinte bleuâtre qui cède à une dissolution très faible de potasse.

Teintes grises. — Elles laissent une trace noirâtre ou s'effacent complétement, suivant le noir qui entre dans la composition. Quant aux couleurs blanches qu'elles contiennent, elles cèdent aux moyens indiqués plus haut, comme si elles étaient isolées.

3° DES COULEURS ROUGES. — Ces couleurs s'effacent toutes plus ou moins complétement par divers procédés que je vais signaler.

Vermillon (deuto-sulfure de mercure). — M. Thénard dit, à l'article *Sulfure de mercure*, que le vermillon résiste à presque tous les

(1) Voy. plus loin le paragraphe *Sepia* et la note qui s'y rapporte.

agents. Cet adverbe *presque* est fort contrariant ; j'aurais voulu connaître les agents qui font exception.

J'ai vu le vermillon disparaître en une demi-heure dans l'eau de Javelle mêlée à deux volumes d'eau, mais le remède est violent. Quelques puissants acides, tels que l'eau régale, le décomposeraient, mais en désorganisant le papier. En attendant un procédé plus convenable, je couvre cette couleur de chlorure de chaux à l'état de bouillie, tel qu'on le trouve au fond du vase où l'on a préparé le chlorure liquide (page 12). Quelques heures après cette pâte est sèche ; j'en enlève le gros au grattoir, et j'en dissous le résidu en l'arrosant de quelques gouttes d'eau acidulée. Comme le vermillon est une des teintes les plus usitées dans le coloriage, j'ai fait mille efforts pour trouver un autre remède, mais sans succès (1).

(1) Réussirait-on à isoler le soufre du mercure avec une pile agissant d'une certaine manière? L'électricité ne décompose, je crois, que des oxydes et des sels métalliques, à l'état libre, et non mêlés à la gomme arabique ou autres substances qui servent à fixer les cou-

Carmin. — Cette couleur végétale est extraite de la cochenille. Pure, elle se décolore sur-le-champ, sans laisser aucune trace, au contact d'un pinceau imbibé d'eau de Javelle faible ou de chlore. La *laque carminée* se comporte de même, mais avec plus de lenteur, sans doute à cause de l'alumine qu'on y a mêlée, et qui lui donne de la fixité (1). Le carmin *fixe* de garance cède immédiatement, en dépit de son nom, au chlorure de chaux appliqué au pinceau, puis humecté avec de l'acide chlorhydrique très affaibli. L'acide sulfureux liquide fait également disparaître, à froid, le carmin de garance.

Il existe un *rose de cobalt* qui résisterait sans doute à tous les agents chimiques, comme l'oxyde du même métal (voy. plus loin l'article *Couleurs bleues*); heureusement cette couleur

leurs destinées à l'aquarelle. M. Dumas signale le protochlorure d'étain comme ramenant à l'état métallique presque tous les composés de mercure. Sans doute cette réduction ne s'opère qu'à la chaleur rouge.

(1) Je n'ai pas étudié les autres laques, diversement colorées, qui sont des couleurs du même genre.

est peu employée, vu l'élévation de son prix. Elle a pour élément l'oxyde de cobalt calciné avec de la magnésie.

Un sel de cobalt, soit dit en passant (le chlorhydrate, je crois), est la base d'une encre sympathique curieuse. Elle est, sur le papier, d'un rose clair ; chauffée, elle tourne au bleu ; éloignée du feu, elle pâlit et reprend bientôt, surtout si l'air est humide, sa teinte rose et son invisibilité. On doit naturellement écrire sur un papier de même nuance.

Rouge pourpre de Cassius. — Mélange de protoxyde d'or et de deutoxyde d'étain ; couleur fort éclatante qu'emploient les peintres en miniature et sur porcelaine. Comme elle est fort chère, on doit la rencontrer rarement sur des estampes. Je ne l'ai ni essayée ni même vue ; mais je la crois facile à décomposer par plusieurs acides. Il existe aussi un autre rouge pourpre à base de mercure.

Carthamine. — C'est un rouge végétal provenant de la fleur du carthame, et qui disparaît probablement tout de suite dans les chlorures.

Minium (deutoxyde de plomb). — Cette couleur rouge-orangé s'emploie dans le coloris

à la gomme, sous le nom de *rouge de Saturne* Elle cède sur-le-champ à l'acide chlorhydrique faible et à quelques autres.

Rouge-brique, dit *Colcothar* ou *Rouge d'Angleterre*. — C'est un sesquioxyde de fer d'une teinte très solide, qui forme la base de la sépia de Rome et de plusieurs autres couleurs d'ombre. Il ne disparaît qu'après un séjour d'au moins vingt-cinq minutes dans une solution d'acide oxalique assez concentrée, et maintenue bouillante (voy. la note de la page 28). Les chimistes prétendent, comme je l'ai déjà dit à l'article *Taches d'encre* (ibid.), que le contact de l'étain favorise la décomposition des oxydes de fer par l'acide oxalique ; on jettera, à tout hasard, dans le liquide, quelques morceaux d'étain en feuilles. On pourra essayer aussi des procédés signalés pages 73 et 88.

Un rouge-brique analogue, dit *Fleur d'Orléans*, disparaît de la même manière.

Il existe encore d'autres rouges de nuances très vives, tels que le *réalgar* ou bi-sulfure rouge d'arsenic, le *bi-iodure* de *mercure*, espèce de vermillon. J'ignore si on emploie ces matières pour l'aquarelle. En tout cas, on les

décomposerait, je pense, par le chlorure de chaux, l'acide nitrique, ou autres acides plus ou moins étendus.

L'*écarlate* dit *anglais*, d'un ton fort éclatant, s'efface au bout d'une heure environ dans le chorure de chaux.

J'ai quelquefois enlevé, à l'aide du même chlorure, les traces de certaines teintes rouge-brique que l'acide oxalique n'avait pu dissoudre. C'était peut-être une teinte mélangée de vermillon, car les couleurs ne sont pas toujours à l'état de pureté. Cette remarque, au reste, s'applique à toutes celles que je signale.

4° DES COULEURS JAUNES. — Je me suis déjà occupé, au chapitre *Taches*, de cette teinte considérée comme tache très commune, et due à bien des causes différentes ; je n'en parlerai plus ici qu'à titre de matière colorante. Les couleurs jaunes s'effacent aisément, hors celles à base d'oxyde de fer.

Jaune de chrome. — C'est un chromate de plomb, d'une nuance plus ou moins orangée selon le degré de calcination. Cette couleur se décompose rapidement au contact d'un grand nombre d'acides. Je citerai, comme toujours,

le moins cher de tous, l'acide chlorhydrique, mêlé à dix ou douze fois son volume d'eau. L'eau de Javelle et la dissolution de potasse très affaiblies la font également disparaître.

Jaune de Naples. — C'est un protoxyde de plomb uni à l'oxyde d'antimoine et mêlé d'argile. Il se décompose par l'acide chlorhydrique.

Gomme-gutte. — L'eau chaude ou même froide enlève, sur un papier encollé et bien lisse, cette couleur végétale. Le chlorure de chaux faible ou l'alcool effaceront les traces, s'il en reste.

Jaune dit *Indien.* — Disparaît presque dans l'eau simple; ajouter au besoin à l'eau quelques gouttes d'acide chlorhydrique. C'est une matière animale provenant de l'urine du buffle ou du chameau.

Jaune de Sienne. — Cette couleur, à base d'oxyde de fer, cède à une dissolution d'acide oxalique maintenue chaude pendant un quart d'heure. Je l'ai vue, je crois, s'effacer aussi à froid dans plusieurs autres acides étendus d'eau. La solution chaude d'acide phosphorique la réduit à une trace noirâtre que le chlorure de chaux enlève.

Ocre jaune. — Cette couleur, à base d'oxyde de fer hydraté mêlé ou combiné avec l'argile, est plus ou moins rougeâtre suivant son degré de calcination. C'est de tous les jaunes le plus tenace. On peut l'affaiblir en l'arrosant de chlorure de chaux, puis ensuite d'eau acidulée, laquelle emporte une portion de la couleur, en même temps qu'elle décompose le chlorure. S'il s'agissait d'une petite estampe, on pourrait garder cette trace jaunâtre et raccorder avec sa teinte les autres portions du papier.

Pour décomposer complétement l'ocre jaune, il faut avoir recours encore à cet acide oxalique dont je redoute les conséquences; l'estampe doit rester environ une demi-heure dans une dissolution de cet acide maintenue bouillante. Peut-être la décomposition serait-elle beaucoup plus rapide si l'on pouvait faire intervenir dans cette opération l'influence électrique sous une forme quelconque (1).

(1) Le protochlorure d'étain, sorte de sel cristallisé en aiguilles, a la propriété d'enlever l'oxygène à beaucoup de corps; mais c'est probablement dans un creu-

Massicot ou *litharge* (protoxyde de plomb).
— C'est un jaune peu usité, je crois, dans l'aquarelle, et que dissolvent probablement la plupart des acides affaiblis.

Safran. — Couleur de nature végétale qui cède au chlore. L'acide sulfurique lui communique une teinte bleue, et l'acide azotique une teinte verte.

Orpiment. — Cette couleur d'un jaune citron très vif est, comme le réalgar, un sulfure d'arsenic, ou naturel, ou préparé artificiellement. L'orpiment naturel, selon M. Lefort (*Chimie des couleurs*), se décompose par l'acide nitrique. Celui que j'ai essayé était détruit par le chlorure de chaux. Je crois qu'il se dissolvait également dans l'ammoniaque.

Jaune de Cadmium. — Cette couleur, dite aussi *jaune brillant*, est un proto-sulfure de ce métal. L'acide chlorhydrique affaibli la décompose avec dégagement d'hydrogène sulfuré. Si on la mélangeait à la céruse, elle la

set, à une haute température. A l'état de solution chaude, ce sel ne peut décomposer les taches de rouille, autrement dit, désoxyder le fer.

ferait peu à peu tourner au noir, vu qu'il se formerait un sulfure de plomb.

Il existe plusieurs autres couleurs jaunes ou orangées que je n'ai pas essayées, telles que l'iodure de plomb, l'iodure de mercure, le jaune dit de Hall, etc. Au reste, quand je citerais tous ces produits chimiques, le lecteur n'en serait guères plus avancé que moi même. Comment distinguer sur le papier qu'il recouvre tel jaune de tel autre? Il me suffit d'avoir cité les plus usuels.

Or en coquille. — C'est de l'or pur à l'état de division extrême, tenu en suspension dans de la gomme arabique. Ce métal ne peut être dissout que par l'*eau régale* (dite chimiquement acide chlorazotique), mais cet agent très énergique détruirait le papier. Par bonheur, cette poussière d'or disparaît dans un bain d'eau pure; on en opère l'entraînement complet à l'aide d'une éponge douce ou d'un blaireau. Au besoin on y appliquerait du mercure chauffé à 50 degrés.

Jaunes orangés. — J'ai peu de choses à dire sur les teintes orangées, couleurs mixtes, intermédiaires entre le jaune et le rouge. Rap-

pelons ici que plusieurs jaunes francs (couleur citron) contractent par la calcination prolongée la teinte orange au point de se rapprocher beaucoup du rouge. Les nuances orangées les plus vives, sinon les plus solides, résultent, je crois, du mélange des rouges et des jaunes les plus éclatants. Pour les effacer, on aura recours aux agents qui attaquent isolément les couleurs qui les constituent ; le point difficile est de les bien reconnaître.

Toute couleur qui acquiert par la calcination ou par l'oxygénation un ton plus prononcé, plus grave, doit se décomposer moins aisément que la nuance plus claire d'où elle dérive. La nuance orangée des jaunes de mars, de chrome, etc., se trouve dans cette condition.

Des couleurs brunes. — La plupart des teintes brunes ont pour base le fer plus ou moins oxydé mélangé à d'autres substances noirâtres de nature végétale, animale ou carboneuse. Dans le coloriage des estampes entrent souvent des teintes brunes composées de divers éléments ; si une partie de ces éléments ne peut se dissoudre, on ne saurait les effacer tout entières. Ainsi celle qui contiendrait un

noir carboneux laisserait nécessairement sur le papier une tache noirâtre indélébile, supposé que les autres couleurs qui s'y mêlent fussent détruites. Si au contraire l'encre ordinaire entre dans sa composition, elle pourra s'effacer. Cette observation, du reste, s'applique à toutes les couleurs factices résultant du mélange de plusieurs autres (voir, plus loin, *Couleurs mixtes*).

Je vais maintenant parler en détail de quelques teintes brunes, simples ou composées.

Sépia (en italien *seppia*). — Dans ma première édition je n'ai, au sujet de cette substance, exposé que des idées assez vagues. La question était pour moi fort obscure, parce qu'on a donné à la même matière des noms divers, selon sa teinte plus ou moins foncée, provenant de mélanges, ou du degré de calcination. Il y a la sépia anglaise et française, et la sépia de Rome. M. J. Lefort, dans sa *Chimie des couleurs*, p. 210, n'en mentionne qu'une sorte : la sépia naturelle. Je vais citer quelques passages de son livre : « La sèche, « mollusque céphalopode très commun dans « la Méditerranée, l'océan Atlantique, etc.,

« possède près du cœur une vessie remplie
« d'une liqueur brune ou noire qui, desséchée,
« fournit la couleur brune connue sous le nom
« de *sépia*. »

Il nous apprend ensuite que les pêcheurs font sécher ces vessies au soleil et les livrent à l'industrie, qui réduit la matière en poudre impalpable, la broie et en forme des *pains* à l'usage de l'aquarelle. « La sépia, ajoute-t-il,
« contient de la gélatine, du phosphate de
« chaux et quelques autres terres. De Blain-
« ville croit qu'elle doit sa couleur à une ma-
« tière animale qui a quelque analogie avec la
« matière urinaire. » Il dit plus loin : « Il est
« rare que les tons bruns s'obtiennent sans
« mélange. » Puis il cite les substances qui y sont mêlées, telles que l'ocre jaune calcinée, le noir de fumée ou le noir d'ivoire, et le bioxyde de manganèse.

Voilà des mixtures qui doivent rendre certaines sépias indécomposables. Il faut nécessairement tâtonner, quand on veut enlever cette couleur sur une estampe : car personne, je pense, n'en saurait, à la simple vue, deviner au juste la composition. Tout ce que je sais,

c'est que j'ai réduit, par le chlorure de chaux, une sépia dite de Rome, à une légère tache rougeâtre et ferrugineuse qu'a enlevée à chaud l'acide oxalique en dissolution.

Autres couleurs brunes. — M. Lefort signale les suivantes : — *Brun de manganèse* (bioxyde de ce métal), teinte fort riche, encore peu employée. — *Brun Van Dyck*, mélange d'ocre jaune, de colcothar et de sulfate de fer, toutes substances fortement calcinées, réductibles seulement par des dissolutions acides maintenues bouillantes. — *Brun doré de plomb* (bioxyde de ce métal), encore très peu connu, et qui, je le suppose, serait décomposé par les acides affaiblis. — *Terre d'Ombre* (ainsi nommée parce qu'elle provient de l'Ombrie, province des États-Romains); elle a pour base de l'oxyde de fer et de l'oxyde de manganèse unis à l'alumine. — *Terre de Sienne*, composition chimique inconnue, à base d'oxyde de fer, d'une teinte brune-rougeâtre. — *Terre de Cologne* (ou *de Cassel*), lignite ferrugineux et pulvérulent, de teinte foncée, où domine le charbon. — *Brun de Prusse* (bleu de Prusse calciné). Le fer que contient ce bleu a passé

à l'état d'oxyde; cette couleur est légère et transparente, comme celle d'où elle provient.
— *Bistre*, couleur extraite de la suie de certains bois, spécialement du hêtre, et employée seulement dans l'aquarelle. Sa composition n'est pas indiquée. J'ai détruit par l'acide oxalique une couleur ainsi nommée sur l'étiquette.
— *Ulmine*, couleur diversement composée et encore peu usitée. — *Brun de chicorée*, employé très rarement.

6° DES COULEURS BLEUES. — Ces couleurs se détruisent avec plus ou moins de rapidité, une seule exceptée : celle dont je vais parler immédiatement.

Bleu de cobalt. — Ce bleu éclatant est, selon M. Thénard, qui en a fait la découverte, un composé d'alumine et d'oxyde de cobalt. M. Dumas le nomme *aluminate de cobalt*, parce qu'il suppose que l'alun forme ici non un mélange, mais un sel inaltérable (1). Plus

(1) Quand l'alumine constitue un mélange, et non une combinaison, comme il arrive dans les laques bleue, verte, carminée, etc., elle ne s'oppose nullement à la décomposition de l'oxyde métallique.

d'un acide peut-être dissoudrait cet oxyde métallique, si l'alumine ne lui donnait de la fixité. Je n'ai pu réussir à le décomposer chimiquement; il a résisté à tous les réactifs, à toutes les combinaisons. Je ne sais si quelque chimiste possède le secret de le réduire sur le papier; pour moi, je ne puis qu'en affaiblir la teinte éclatante par le procédé suivant. L'estampe étant placée dans une bassine, on verse goutte à goutte sur la partie coloriée une dissolution, concentrée et chaude, de savon blanc. Au bout de deux heures le savon a pénétré toute l'épaisseur du bleu et s'est pris en gelée. On passe alors avec légèreté une éponge sur la tache bleue. Le savon, en se dissolvant, entraîne une portion notable de la couleur, même sur un papier très absorbant (1); mais une faible teinte azurée survit toujours. Je n'oserais conseiller aux amateurs, pour dissimuler cette tache indélébile, de donner à toute la surface de l'estampe une teinte pareille, car

(1) D'autres substances mucilagineuses, telles que la gomme arabique, la colle d'amidon, etc., produiraient sans doute un effet analogue.

je doute que cette nuance soit propice à l'effet du burin. Par bonheur les estampes anciennement coloriées ne peuvent offrir aucune trace de bleu de cobalt, puisque cette couleur ne fut signalée qu'en 1804, par M. Thénard.

Bleu de Prusse. — Composé d'oxyde de fer et d'acide cyanhydrique (cyanure de fer), ce bleu se décolore dans l'eau contenant en dissolution une très petite quantité de soude ou de potasse. Il y disparaît sur-le-champ, laissant une trace jaunâtre qui, n'étant, je crois, qu'un peu d'oxyde de fer, doit céder à l'acide oxalique; du reste cette trace est très faible et s'efface même quelquefois dans l'eau chaude.

Après l'emploi de la potasse, ou de tout autre alcali, on passera l'estampe à l'eau légèrement acidulée, et on la laissera retremper longtemps dans de l'eau pure.

Indigo. — Couleur végétale peu employée en aquarelle; elle cède au chlore et aux chlorures, et peut-être aussi à l'acide sulfureux.

Cendres bleues. — C'est une couleur due à un sel de cuivre. L'acide chlorhydrique très étendu d'eau la dissout, malgré l'argile qu'elle contient. En général, les bleus à base de

cuivre cèdent à tous les acides affaiblis.

Outremer. — Bleu d'une teinte éclatante, qu'on extrayait jadis du lapis lazuli, et qu'on tire aujourd'hui d'autres substances. L'outremer que j'ai essayé s'est effacé sur-le-champ dans la plupart des acides mêlés d'eau, notamment dans l'acide chlorhydrique.

Violets. — La plupart des violets sont des teintes obtenues par le mélange d'un rouge et d'un bleu. Leur décomposition est plus ou moins facile, selon la nature des deux éléments colorés qui les constituent (voy., plus loin, *Couleurs mixtes*).

Le jaune dit de *Mars*, qui a pour base le peroxyde de fer, donne, étant calciné (par des procédés tenus secrets), un violet naturel, probablement très difficile à détruire. Quant au violet végétal qu'on obtient de la décoction du bois de Campêche, mêlée à un sel de plomb, il doit disparaître sur-le-champ dans les chlorures, puisque, selon M. Lefort, les rayons du soleil suffisent à l'altérer.

7° DES COULEURS VERTES. — Beaucoup de teintes vertes résultant du mélange d'un bleu et d'un jaune quelconques, on attaque isolé-

ment chacune des couleurs qui entrent dans la composition. Il est un cas qui serait difficile à résoudre : celui d'un vert formé de bleu de cobalt, matière indécomposable ; heureusement cette composition doit se rencontrer rarement, car le bleu de cobalt produit des nuances vertes peu agréables.

Verts à base de cuivre. — La plupart des verts éclatants ont pour base un sel de cuivre ; tels sont : la *cendre* et la *laque verte*; le *verdet* (acétate de cuivre, vert-de-gris); le *vert anglais* ou *de Scheele*, qui se compose d'oxyde de cuivre et d'oxyde d'arsenic ; le *vert de Vienne* ou *de Mittis* (nom de l'inventeur), qui est très vif et d'une composition à peu près analogue.

Ces couleurs s'effacent en général sur-le-champ dans une dissolution très faible d'acide chlorhydrique. Ceux qui suivent ont une autre base que le cuivre.

Vert de Rinnmann. — On le nomme aussi *vert de cobalt*, parce qu'il est un zincate de ce métal. Le *vert* dit *de zinc* est, selon M. Lefort, la même matière, mais préparée par d'autres procédés. Cette couleur est fort chère. J'ignore si elle cède ou non à l'action des acides.

Vert de vessie. — Ce vert, léger (peu opaque) et d'une teinte assez foncée, est extrait du nerprun, arbrisseau qui fournit aussi un sirop purgatif. Son nom provient de l'usage où l'on est de le faire sécher dans des vessies. Cette matière, de nature végétale, doit être décomposée par les chlorures.

J'ai constaté dans la première édition de ce livre des essais faits sur un *vert de vessie*, ainsi étiqueté sur la tablette ; il avait une odeur semblable à celle du fiel de bœuf. Plusieurs acides, ainsi que les chlorures, l'ont fait tourner au bleu, et ce bleu, analogue à celui dit de Prusse, a disparu dans une faible dissolution de potasse. Avais-je affaire à un vert de nerprun mélangé ? Je l'ignore.

Vert d'Iris. — C'est encore une couleur végétale, extraite de la fleur que porte la plante de ce nom ; elle doit céder aux chlorures, et sans doute aussi à l'acide sulfureux liquide.

Vert émeraude. — Cette couleur, qui doit sa désignation à sa nuance et se vend fort cher, est précieuse par sa solidité : elle résiste à tous les agents chimiques. Quand elle est récemment appliquée sur un papier bien encollé, on

peut l'entraîner avec le savon ; mais, quand elle s'est incorporée à sa surface, elle est tout à fait indécomposable.

M. Lefort (*Chimie des couleurs*, p. 300) nous apprend que ce vert, inventé par M. Pannetier, dont il porte quelquefois le nom, s'obtient par des procédés tenus secrets ; il lui donne pour base l'oxyde de chrome, et assure qu'il ne se réduit que calciné avec le chlorate de potasse. Il distingue ce vert de celui dit vulgairement *vert de chrome* (sesquioxyde de ce métal), qui vaut 1 fr. 50 c. le kilogr., tandis que le vert d'émeraude se vend 140 fr. J'ai essayé un *vert de chrome* qui cédait à l'eau acidulée. Il est vrai que le nom inscrit sur la tablette pouvait être une fausse étiquette.

Cette source d'erreur, soit dit en passant, m'a peut-être plus d'une fois, dans le cours du présent chapitre, entraîné dans des méprises.

M. Lefort signale encore d'autres verts dont il est inutile de nous occuper.

8° DES COULEURS MIXTES. — J'ai parlé, en passant, du gris, de l'orange, etc. Les couleurs peuvent, en se mêlant, former mille combinaisons de nuances et de teintes. Un amateur un

peu exercé dans l'aquarelle discernera promptement les diverses matières primitives qui ont concouru à former telle ou telle nuance. Il faudra souvent, pour les dissoudre, autant d'opérations qu'il y a de couleurs mélangées. Supposons, par exemple, une teinte d'ombre formée de carmin, de bleu de Prusse et de sépia : on devra successivement employer le chlorure de chaux pour effacer le carmin et la teinte noire de la sépia; la dissolution de potasse pour le bleu de Prusse; puis l'acide oxalique pour le peroxyde de fer, résidu de la sépia.

Je l'avoue, je ne saurais trop décider par quel liquide on devrait commencer à attaquer une teinte si compliquée. Je crois que l'ordre des substances indiqué ici est le plus convenable. En tout cas, il sera bon, entre chaque opération, de faire tremper l'estampe assez longtemps, afin que les traces du premier liquide employé ne nuisent pas à l'effet du second.

Quand plusieurs couleurs ont été superposées seulement, la décomposition de celle qui adhère au papier entraîne les autres. Appliquez du carmin sur du papier; couvrez-le,

quand il est bien sec, et avec légèreté, d'une couche de bleu de cobalt : le chlorure de chaux enlèvera le carmin, et entraînera en même temps ce bleu indécomposable, parce qu'il est comme isolé et se trouve tout à coup privé de son soutien.

Dernières réflexions sur le décoloriage. — Je n'ai pu parvenir, dans cette seconde édition, à résoudre plus complétement que dans la première la question du décoloriage. Il y a au moins trois couleurs positivement indécomposables : — les noirs à base carboneuse, le bleu de cobalt et le vert émeraude. Plusieurs autres ne s'enlèvent que difficilement et non sans quelque danger futur pour le papier ou le noir d'impression ; tels sont : le vermillon, les peroxydes de fer à base d'alumine, et autres qui exigent l'emploi de substances assez concentrées et chaudes. J'espère néanmoins qu'on évitera toute mauvaise conséquence en agissant prudemment et ayant soin, après chaque opération dangereuse, de laisser longtemps l'estampe dans un bain d'eau pure, ou légère-

ment mélangée d'une matière capable de prévenir les ravages de celle employée.

Les estampes que j'ai, depuis plus de treize ans, décoloriées, n'ont pas souffert sensiblement. Cependant le noir de quelques vues d'optiques soumises à mes procédés est loin d'offrir le brillant et la netteté d'une épreuve qui n'aurait jamais été coloriée. Il est vrai qu'à titre de pièces à peu près sans valeur, je les avais traitées assez cavalièrement, tandis que j'aurais eu mille égards pour les estampes rares ou précieuses.

Je ne saurais trop le répéter : le point difficile pour l'amateur qui a sous les yeux une estampe à décolorier, c'est de savoir au juste : 1° à quelles sortes de couleurs il va avoir affaire, difficulté qui oblige à des tâtonnements ; 2° si ces couleurs ont une teinte franche et ne sont pas falsifiées ou mélangées ; 3° si la substance indiquée qu'il leur applique est d'une pureté convenable.

On ne saurait satisfaire à cette dernière condition en certaines localités ; de là des déceptions. Ainsi, tel liquide impur ou mal préparé déposera de nouvelles taches sur le papier ou

consolidera au lieu d'enlever celles qui s'y trouvent.

Quand le décoloriage compliqué d'une gravure a exigé l'emploi d'un grand nombre de dissolvants, on fera bien, pour plus de sûreté, de la doubler d'un papier assez mince qui lui servira de soutien; on pourrait même avertir (par une note au bas de la marge ou au verso) les amateurs de l'avenir de se garder de la dédoubler, de crainte de la perdre. Au reste ce n'est là qu'un avis de précaution, et je déclare ne raisonner que par hypothèse.

Chaque branche de l'arbre de science croît en ce siècle avec une rapidité merveilleuse. Il est à espérer qu'un jour un habile chimiste, qui daignera refaire mon livre, perfectionnera mes procédés de décoloriage, sans perdre de vue les deux conditions essentielles du problème à résoudre : conserver intacts le papier et l'encre d'impression, et les garantir de tout dommage présent ou futur.

Un amateur ne doit jamais, dans un moment de dépit, détruire une précieuse estampe ou un livre rare flétris de taches réputées aujourd'hui indestructibles. Pourquoi ne décou-

vrirait-on pas un jour une nouvelle substance capable d'isoler, de dissoudre, d'entraîner cet amas de parcelles carboneuses agglutinées, qu'on nomme encre de Chine, noir d'ivoire, etc.? J'ai fort superficiellement étudié l'art d'enlever les couleurs par voie d'entraînement mécanique ; cet art est susceptible de notables progrès. Qui sait si bientôt on ne trouvera pas un agent inespéré de décomposition dans la puissance, appliquée d'une certaine manière, du fluide électrique? L'étude de la photographie nous réserve aussi sans doute la révélation de plus d'un secret. L'action de la lumière sur la formation ou la destruction des couleurs n'a pas encore été bien approfondie. Il est avéré que le soleil, sous l'influence de plusieurs circonstances mystérieuses, décolore ou métamorphose quelques nuances. Pourquoi un savant ne devinerait-il pas le moyen de décomposer, à l'aide des rayons solaires, par l'intermédiaire d'un agent encore inconnu, les couleurs réputées les plus solides? Les ouvrages de chimie signalent dans le charbon une propriété décolorante (Voir le *Journal de Pharmacie*, t. VIII, et les *Annales de Chimie*,

t. XXIX); pourquoi ne parviendrait-on pas à tirer parti de cette propriété, pour résoudre en partie les difficultés de la question qui nous occupe?

Je conseille une fois encore au lecteur de bien méditer tout ce que j'ai dit çà et là relativement à l'action des divers liquides appliqués au décoloriage. Il pourra lui-même en tirer de nouvelles conséquences pour le perfectionnement de mes procédés. Je termine en le renvoyant à l'article (imprimé à la fin du livre) intitulé : *Note sur l'emploi des substances chimiques indiquées*.

VII

RÉPARATION DES DÉCHIRURES, LACUNES, ETC.

Revenons à la manipulation. Ici les règles sont certaines : c'est pour ainsi dire la partie chirurgicale de ce livre, c'est-à-dire la plus claire, la plus palpable; il n'y a plus ni science ni tâtonnements; il s'agit d'apporter un peu d'industrie et du coup d'œil.

Supposons donc une estampe dédoublée, éclaircie, détachée et décoloriée. Si le papier est intact sur toute sa surface, il ne reste plus qu'à procéder à la mise en presse, telle que

je l'ai décrite page 18. Mais supposons-la très grièvement blessée ; trous, éclaircis, déchirures, plis obstinés, piqûres de vers, etc , rien n'y manque. Voilà une série de réparations qui réclament du goût, de l'adresse, et surtout de la patience. Il faut, avant de se mettre au travail, se demander si l'on est bien dans un jour de bonne disposition, d'inspiration, si l'on veut.

Eclaircis ou *Ecorchures*. — J'ai déjà dit que ces avaries se réparent en collant au verso de l'estampe des fragments de papier minces, encollés au même degré (1), et de la même teinte que toute la surface. Ces pièces rapportées imiteront aussi exactement que possible la forme des éclaircies, mais en dépasseront un peu la limite. Au lieu de les couper net, on en amincira, on en dentellera les bords au grattoir ; leur contour ainsi préparé n'en adhérera que mieux et sera moins apparent. Il est indispensable que la colle soit blanche et très pure,

(1) Si l'on a trempé l'estampe dans l'eau bouillante, elle a perdu l'encollage qu'elle avait à sec ; le papier de réparation, en ce cas, doit être également non encollé.

sinon elle formerait au recto une sorte de tache jaunâtre.

Les meilleurs grattoirs sont, à mon avis, ceux légèrement recourbés qu'emploient les pédicures. Pour façonner les bords d'une pièce avec une certaine régularité, il est essentiel que le papier repose sur un corps lisse et dur, par exemple sur un verre de montre légèrement bombé ; cette forme seconde efficacement l'action du grattoir.

Déchirures. — Le papier étant un tissu filandreux, une sorte de feutre, ses déchirures offrent une multitude de bavures en forme de dents de scie frangées. Quand il en manque quelques portions, elles se retrouvent assez souvent dans l'eau de lavage de la bassine, eau qu'on ne doit jeter qu'après un minutieux examen.

La déchirure simple, en ligne droite, est facile à réparer. Le recto de la gravure humide étant posé à plat sur une table bien unie, on rapproche les deux rangs de dentelures jusqu'à ce qu'elles se raccordent avec exactitude; puis on applique une bande de papier préparée comme je l'ai dit ci-dessus, et enduite

d'une couche de colle de pâte, ayant soin que ses bords soient à peu près, de part et d'autre, à une égale distance de la ligne que suit la déchirure. L'essentiel, je le répète, c'est qu'elle soit, quant au degré d'encollage, identique au papier de l'estampe ; sinon, à sec, la surface générale grimacerait.

Quand la bande est bien appliquée, on retourne l'estampe du côté du recto ; on réunit de ce côté avec la plus grande précision les bords de la déchirure, qui sont quelquefois fort accidentés ; on ramène au moyen de la lame (décrite page 12) les dentelures vis-à-vis les unes des autres, en les soulevant à plusieurs reprises, jusqu'à ce qu'elles se rejoignent parfaitement ; on relève celles qui sont repliées au-dessus ou au-dessous du papier de l'estampe, et l'on ajoute, s'il est nécessaire, de la colle avec un pinceau très doux.

En définitive, s'il ne manque aucun fragment, on peut parvenir à dissimuler les points de coïncidence ; mais le plus souvent, en dépit de tous les efforts, il reste une trace d'usure, un trait blanchâtre en zigzag qui décèle les sinuosités de la déchirure ; plus tard, à sec,

on le masquera à l'aide de quelques points de raccord tracés à l'encre de Chine (voir chap. IX).

Les déchirures en forme de croix ou de pattes d'oie, etc., se réparent de la même manière, mais exigent plus de soins et de patience. Il faut appliquer un papier de soutien au verso de l'estampe, avant de la tirer de la bassine : c'est le moyen d'éviter que ces déchirures compliquées ne s'agrandissent. Quand on l'aura étendue à plat sur la table et qu'elle y adhérera par tous les points de sa surface, on relèvera les bavures, et l'on collera au verso plusieurs bandes, disposées suivant la forme des ramifications de la déchirure.

Plis et *Rides*. — Il existe souvent sur une estampe des plis antérieurs au tirage et contemporains de la fabrication du papier. On se gardera bien de les aplanir, car les traits du burin se trouveraient déformés ; il faut au contraire les resserrer davantage, puis les maintenir au moyen d'une bande collée au verso. Mais les plis ou rides postérieurs au tirage, qui rompent ou font grimacer les lignes des hachures, doivent être détendus et aplanis. Le simple redressage par la mise en presse au

moyen de poids (voir p. 18) opère le plus souvent cette réparation. On peut encore les faire disparaître avec un fer chaud appliqué sur le verso de l'estampe maintenue à l'état de moiteur.

Enfin, s'ils résistent opiniâtrément à ces deux moyens, on aura recours à un autre procédé. On collera par les bords l'estampe humide sur un carton sec et épais. Il faut, pour réussir, que son papier soit capable de supporter en séchant une forte tension. Si elle n'avait pas de marges, on y suppléerait au moyen de bandes qui adhéreraient d'une part à son verso, d'autre part au carton. On se fera une idée de l'opération en lisant, au chapitre VIII, la manière de disposer la feuille destinée à doubler une estampe par le procédé dit *à fond tendu*.

Les traces blanchâtres que laissent quelquefois les plis anciens proviennent du frottement; on les dissimule le mieux possible en retouchant les hachures, comme je l'indiquerai au chapitre IX.

Trous et *Lacunes*. — Les trous fort petits, comme les piqûres de vers, se rebouchent au moyen de rondelles de papier collées au verso.

Si l'on tient à les combler avec une parfaite netteté, on a recours à un procédé plus long, mais aussi plus parfait : on prépare de la pâte de papier. Je ne sais au juste, je l'avoue, comment on fabrique cette pâte dans les papeteries ; mais on obtient une sorte de mastic assez convenable en faisant longtemps bouillir dans l'eau de la limaille de papier. On se procure cette limaille à l'aide d'une râpe à bois, qu'on promène sur les tranches, bien serrées en presse, d'un livre inutile. On broie ensuite cette bouillie avec de la colle de peau alunée, afin de l'encoller, puis l'on raccorde, s'il est nécessaire, sa teinte avec celle de l'estampe.

La gravure étant humide et appliquée sur un marbre, on colle au verso, à l'endroit des piqûres, un papier très mince ; puis on retourne l'estampe et l'on remplit de pâte toutes ces petites cavités, qu'on aplatit au niveau de la superficie de la gravure, absolument comme s'il s'agissait de mastiquer les lacunes d'une vieille peinture à l'huile. On met en presse, et plus tard on raccorde à sec les tailles du burin.

On pourrait même supprimer le papier des-

tiné à soutenir la pâte, car cette pâte écrasée sous la lame empiète assez sur les bords du trou pour s'y maintenir seule, surtout si ces bords ont été un peu dentelés au grattoir.

Les *lacunes*, ou trous trop larges pour être réparés à la pâte, se comblent au moyen de pièces rapportées, déchiquetées tout à l'entour, et affectant la forme du trou, dont elles doivent dépasser un peu l'orifice du côté du verso, côté où elles s'appliquent. Il est essentiel que ces pièces soient façonnées avec un papier identique, autant que possible, à celui de l'estampe.

Je suppose ici que l'amateur aura fait comme moi provision d'anciens papiers de toute époque et de toute nature, provenant de vieux livres ou de marges de mauvaises estampes sacrifiées. On peut même posséder un assortiment de fragments de ciels et d'ombres diversement hachées; il arrive quelquefois que ces hachures coïncident fort bien avec les traits à raccorder. Plus d'un artiste a eu l'idée de dissimuler ainsi des lacunes par trop choquantes; mais on conçoit que la suprême perfection du système consiste à se procurer le morceau

manquant découpé sur une autre épreuve incomplète. Si l'on possède ce précieux fragment, on y superpose la gravure à sec, afin d'y tracer la forme précise du trou dont on suit les contours, puis on égratigne un peu au grattoir les limites de la pièce à rapporter, à une petite distance du tracé.

Voici comment on colle au verso la pièce ainsi préparée : on glisse sous l'estampe humide, et dont le recto repose sur un marbre, un papier fort à l'endroit troué; on imprègne de colle, avec un pinceau de plume, les bords diversement accidentés de la lacune; on retire le papier qui a reçu l'excédant de la colle, et l'on pose la pièce, humectée comme l'estampe elle-même. On regarde en transparent pour s'assurer si l'application est exacte; puis on retourne l'estampe; on rapproche les bavures de l'orifice du trou, en appuyant avec la lame pour les bien fixer; on enlève avec du papier buvard l'excès d'humidité, puis l'on met en presse.

J'ai vu chez un peintre en miniature (1),

(1) Feu M. Ch. Fr. Muller, qui recherchait surtout

habile en ces sortes de réparations, des lacunes si adroitement comblées qu'à peine distinguait-on en transparent l'endroit précis de l'application de la pièce. Les bords du trou, ainsi que ceux du morceau rapporté, étaient amincis au grattoir et ajustés avec tant de précision que toutes les dentelures s'engrenaient pour ainsi dire les unes dans les autres sans laisser aucune trace de jonction. D'autres trous plus petits avaient été bouchés au moyen d'une pâte de papier qui, sans soutien au verso, paraissait comme soudée à leur orifice, et s'incorporait tout à fait à la masse, sans former de bourrelet. Je dois ajouter que les traits et les hachures avaient été raccordés avec beaucoup de goût, d'art, de talent et de patience. Cette restauration merveilleuse s'appliquait au reste à une estampe de grand prix.

les anciennes estampes et les dessins relatifs aux fêtes, mœurs populaires ou édifices détruits de la capitale. Après son décès (1855), sa collection, vendue en bloc à M. Danlos, marchand d'estampes, a été dispersée dans les cartons de divers amateurs. La majeure partie de ses dessins a passé dans la collection de M. Destailleurs, architecte.

Quelques artistes comblent les lacunes par un procédé plus expéditif, mais aussi moins parfait : ils posent, avant le mouillage, la gravure, à l'endroit troué, sur un papier identique pour la teinte, le degré d'encollage et le sens des vergeures ; puis ils rasent net toutes les bavures du trou, au moyen d'un canif bien tranchant.

On conçoit que du même coup ils découpent la pièce avec une grande précision. Il n'y a plus qu'à rapporter, qu'à ajuster le morceau, et à boucher exactement le trou, comme on fait dans le travail des mosaïques de rapport. L'opération a lieu à sec et à la gomme (voir l'article ci-après), ou à l'état humide, à l'aide de la colle de pâte. Dans les deux cas, il faut appliquer au verso de l'estampe de petites bandes de papier mince qui maintiennent la pièce dans l'espèce de châssis où elle reste incrustée. Dans ce système, les lignes de raccord sont un peu crues, et ne peuvent guère se dissimuler, surtout si les tailles refaites sont très déliées.

Quand on opérera à l'état humide, on écrasera légèrement les bords de la pièce, de telle sorte que les points de contact soient à peine

apparents; ce dernier procédé est donc plus parfait que l'autre.

Si le papier d'où l'on a tiré la pièce ne paraissait pas, après le séchage à la presse, aussi lisse que celui de l'estampe, on lui donnerait du poli en frottant avec l'ongle, ou, s'il est nécessaire, avec un brunissoir.

Je n'ai pas ici mentionné le cas où il serait question de faire adhérer à une estampe ou à un livre une partie additionnelle, par exemple un angle qui aurait été enlevé. On conçoit que ces réparations sont tout à fait analogues à celles qui concernent les lacunes. S'il s'agit d'un feuillet de livre imprimé des deux côtés, la pièce doit avoir son point d'appui au verso plutôt qu'au recto. Le texte, s'il en manque, se restaure par voie de calque, à l'aide de procédés qui seront indiqués au chapitre IX.

Réparations à sec. — Quand le mouillage de l'estampe n'est pas nécessaire, on peut la réparer d'une manière fort simple et très expéditive, au moyen de la gomme dite arabique. Additions de fausses marges, comblement des lacunes, raccord des déchirures, etc., tout cela, grâce à ce procédé, s'exécute sans

qu'on ait recours à l'humidité ni à la mise en presse.

La meilleure gomme est la plus blanche et la plus pure. Cette substance, imbibée d'eau à un certain degré, retient cette eau, et ne dilate ni ne fait goder le papier, même le plus fin et le plus absorbant; mais le degré de viscosité de la gomme est une condition essentielle : trop épaisse, la dissolution ne peut s'étaler au pinceau; trop fluide, elle traverse le papier, lui donne une transparence huileuse et le fait grimacer; il faut un juste milieu.

Un morceau de gomme jeté dans une quantité d'eau égale à deux ou trois fois son volume acquiert, au bout de douze heures, une consistance visqueuse satisfaisante. Cette colle doit couler lentement du pinceau, à peu près comme la pâte dont on fait des beignets. Au reste, l'expérience apprendra bientôt à juger du point favorable de fluidité.

Pour prévenir l'épaississement, par évaporation, de la dissolution de gomme, on devra, l'été surtout, la conserver dans un de ces encriers à réservoir de verre posé sur un ressort en spirale, au fond d'une boîte qui ferme au

caoutchouc. On aura soin d'ajouter quelques gouttes d'eau toutes les fois que le vase sera resté longtemps ouvert. On évitera les atteintes de la moisissure en y jetant gros comme une tête d'épingle de camphre. Inutile de préparer beaucoup de gomme à la fois ; lorsque le vase est trop plein, on perd beaucoup de temps à décharger le pinceau de l'excès de matière qu'il a entraîné.

Ce pinceau doit être semblable à ceux que les peintres nomment *brosses*, qui servent à peindre à l'huile, et se composent de poils durs fixés par des fils de laiton. Quand il est enduit de gomme desséchée, on le laisse tremper une demi-heure dans l'eau, où il recouvre toute sa souplesse. Les pinceaux à tiges de plume sont beaucoup trop doux et ne valent absolument rien pour cet usage.

Parlons maintenant des réparations à l'état sec. L'estampe sur laquelle on va opérer doit être exempte de taches, plis, rides, etc., et avoir été préalablement redressée, et, s'il en était besoin, nettoyée d'après les procédés indiqués aux chapitres précédents. Cette condition est essentielle : car, après la pose des piè-

ces de soutien appliquées sur les lacunes ou sur les déchirures, on n'a plus la faculté d'humecter l'estampe ; le plus léger mouillage liquéfierait très promptement la gomme et décollerait ces pièces, ou déposerait sur le papier, s'il n'était pas encollé, des taches d'un jaune sale, que le retrempage de l'estampe pourrait seul faire disparaître. C'est assez dire que tout serait à recommencer.

Tous les procédés relatifs au bouchage des lacunes, aux déchirures, etc., exigent des soins et des précautions analogues à celles indiquées à propos des réparations pratiquées à l'état humide ; je m'étendrai donc fort peu sur cet article. Je dirai seulement que les pièces ou les bandes rapportées, quand la gomme est délayée bien à point, n'occasionnent jamais de grimaces ni d'ondulations. Quant à la nature des papiers soumis à ce genre de collage, elle est à peu près indifférente ; la gomme convenablement visqueuse appliquée même sur du papier joseph ne l'humecte pas du côté opposé, pourvu qu'on l'étende légèrement ; le mieux néanmoins est de faire usage de papier à pâte encollée.

Quand on fixe une bande de soutien sur les dentelures d'une lacune, il faut y appuyer à peine la lame, autrement leurs bords frangés s'imprégneraient d'un excès de gomme et contracteraient une transparence cornée fort désagréable. Quand on étalera la gomme sur ces fragiles dentelures, on n'oubliera pas qu'on se sert d'un pinceau à poils durs, et qu'un mouvement trop brusque en entraînerait des portions. Les papiers forts et rugueux exigent au contraire une couche de gomme assez épaisse pour bien adhérer; en cette occasion, on ne trouve jamais au pinceau trop de rigidité.

Le doublage en plein à la gomme ne peut concerner que de très petites pièces, ou plutôt des fragments de gravures rapportés sur un fond. Le système le meilleur et le plus expéditif pour fixer par ce procédé une grande estampe sur un papier de soutien consiste à ne coller que les bords. Ce mode de collage est préférable à tout autre en plusieurs circonstances. Les estampes ainsi fixées, même au moyen d'une couche très légère, adhèrent suffisamment, et pourtant peuvent se décoller au besoin avec une grande facilité, puisqu'il suf-

fit, le plus souvent, de glisser l'extrémité amincie de la lame entre les deux papiers pour les désunir sur-le-champ, sans qu'il en résulte d'autre inconvénient qu'une faible trace de gomme desséchée au verso de l'estampe.

Il est bien entendu que la feuille gravée et celle qui sert de soutien doivent être sèches au même degré, sinon l'une des deux serait plus tard moins tendue que l'autre et grimacerait. Quand donc il s'agit d'appliquer à la gomme, sur un fond bien sec, une estampe récemment redressée à la presse, il faut s'assurer si elle a perdu toute trace d'humidité. On pourrait du reste mettre en presse les deux papiers superposés pendant vingt-quatre heures ; ce temps suffirait, je pense, pour équilibrer parfaitement leur état hygrométrique.

On verra, aux chapitres suivants, figurer assez souvent l'emploi de la gomme.

VIII

DOUBLAGE DES ESTAMPES.

Une ancienne estampe d'art perd toujours à être doublée : l'amateur veut pouvoir examiner en transparent les vergeures et le filigrane du papier, qui attestent souvent l'époque du tirage et l'*état* de la gravure. Cependant, si ce papier avait si peu de consistance qu'il se plissât dans les cartons, ou si le verso était imprimé ou barbouillé d'un noir indécomposable, il serait convenable de le doubler, d'autant mieux qu'on a toujours la fa-

culté de le ramener plus tard à l'état simple. Mais il est un cas de doublage plus urgent : c'est lorsque l'estampe a subi un grand nombre de restaurations de tout genre. Au sortir de la presse, elle grimace souvent sur quelques points ou dans son ensemble ; on appliquera donc au verso un papier qui en consolidera et en redressera toute la surface.

Doublage sur fond libre. — Les feuilles de doublage peuvent sans inconvénient être plus minces ou plus épaisses que les pièces à doubler ; l'essentiel, c'est qu'elles soient encollées au même degré. S'il était impossible de satisfaire à cette condition importante, il vaudrait mieux qu'elles fussent plutôt *plus* que *moins* absorbantes : car, en ce cas, l'estampe à l'état sec bomberait un peu du côté du recto, défaut moins désavantageux que le défaut contraire, soit qu'on l'encadre, soit qu'on la conserve en portefeuille.

On peut constater ainsi que deux papiers sont encollés au même degré : on tire de chacun d'eux une bande d'égale dimension et coupée dans le même sens ; on les humecte dans les mêmes circonstances, puis on les rap-

proche avec précision; il est facile alors de juger si la dilatation est identique. Pour quiconque a un peu d'habitude, il suffit même de jeter une goutte d'eau sur chaque papier, et de suivre les effets de l'absorption, pour savoir à quoi s'en tenir.

Je suppose le papier convenable trouvé. On mouillera les deux feuilles; puis, quand elles seront un peu ressuyées, on étendra sur le verso de l'estampe une couche de colle de pâte. Le pinceau dont on se servira doit être assez dur sans l'être trop, et assez large pour abréger l'opération. Quant à la colle, elle sera blanche, passablement épaisse et surtout bien homogène dans toute sa masse, ce qu'on obtient en l'agitant longtemps et en y ajoutant au besoin un peu d'eau.

Il est aisé de préparer soi-même cette colle : on délaye de l'amidon dans de l'eau pure, à froid, à raison d'environ trente grammes pour un demi-litre; puis on fait bouillir cette eau laiteuse pendant quelques minutes. J'ai ouï dire qu'en délayant l'amidon dans une décoction de riz, on obtenait une colle plus blanche et moins sujette à jaunir avec le temps. Quant

à l'alun qu'on y ajoute quelquefois pour la rendre plus tenace, je n'en vois pas la nécessité : c'est préparer une difficulté à celui qui, dans l'avenir, jugerait convenable d'opérer le décollage. J'ai la bonne habitude aujourd'hui de jeter un petit morceau de camphre au fond du vase qui la contient. Une fois imprégnée de cette odeur, elle peut se dessécher à la surface, mais jamais se corrompre.

On trouve au besoin chez tous les marchands de couleurs pour peintres en bâtiments une colle satisfaisante et bien assez blanche. Il faut la prendre à l'état de gelée ferme, mais éviter celle qui est mêlée de portions avariées, moisies et grumeleuses.

Je reviens maintenant à l'opération du doublage sur fond libre, en avertissant toutefois le lecteur que j'ai rarement recours aujourd'hui à ce système et ne l'applique qu'à de petites pièces qu'il s'agit de doubler légèrement. Quant à celles qui dépassent trente centimètres en longueur, je les double toujours sur fond tendu (voir ci-après).

L'estampe étant appliquée sur un fond net et uni, on étend au verso la colle assez vive-

ment; on promène d'abord le pinceau çà et là, puis on lui donne un mouvement uniforme, ayant soin d'enlever les grains de sable, les grumeaux, les poils échappés au pinceau, etc., tous corps étrangers qui formeraient des boursouflures quand le papier serait sec. On veillera à ce que le pinceau n'enlève ou ne déplace aucune des bandes ou pièces qui auraient été appliquées pour boucher des trous ou rapprocher les bords des déchirures.

On étalera ensuite une couche de colle de la même manière et avec les mêmes précautions sur la feuille de doublage, qui dépassera les limites de l'estampe de deux ou trois centimètres. Alors on posera à plat l'estampe sur cette feuille, dont on rognera aux ciseaux tout ce qui déborde, afin d'éviter de reporter sur la gravure la colle étalée sur cette partie excédante.

Les deux feuilles superposées, il s'agit de les faire adhérer parfaitement sur tous les points de leur surface. On commence par appuyer au milieu de l'estampe avec un tampon de linge fin ou une éponge douce qu'on promène à plusieurs reprises du centre aux extré-

mités. On chasse ainsi les bulles d'air qui formeraient des ampoules. Pour se délivrer complétement de ces bulles, il faut successivement décoller, puis recoller (en soulevant les coins) toutes les portions de l'estampe. On étire tantôt celle-ci, tantôt le papier de renfort, sans pourtant négliger d'agir avec une certaine régularité : car, si l'une des deux feuilles avait été plus allongée que l'autre, elle se retirerait trop en séchant, et ferait onduler la masse. On remouille, s'il est nécessaire, à l'éponge humide; on s'assure qu'aucune des pièces ou bandes de soutien n'a été dérangée; puis enfin, quand l'ensemble paraît bien uni et bien adhérent, on met en presse, comme je l'indique page 18. Le papier qui double touchera le bois de la table, et, sur le recto de l'estampe, on appliquera une main de papier buvard, qu'on couvrira d'une planche (ou d'un carton) chargée de poids.

J'ai conseillé l'application de la colle sur les deux papiers; mais on peut en mettre seulement sur le verso de l'estampe, qu'on posera sur le papier de doublage préalablement mouillé et bien étiré. La couche de colle étant

moins épaisse, l'estampe n'en conservera que plus de souplesse. L'excès de colle prédispose d'ailleurs le papier à devenir cassant, comme il arrive pour le linge trop chargé d'amidon.

Ce dernier procédé serait donc le meilleur et le plus expéditif; mais, en chargeant de colle les deux papiers, on les place ainsi positivement dans les mêmes circonstances, ce qui, en certains cas, peut donner lieu à un collage plus parfait. L'amateur choisira. Il est libre aussi de procéder en sens inverse, c'est-à-dire d'appliquer le papier de doublage sur le verso de l'estampe. Les résultats seront toujours les mêmes.

Quelques personnes auraient peut-être l'idée d'employer, au lieu de colle de pâte, des colles formées de matières animales ou gélatineuses appliquées à l'état de couche très mince. Je préfère la colle de nature végétale; elle est bien assez tenace et moins sujette à attirer les vers, ainsi qu'il arrive pour les reliures anciennes où l'on a prodigué la colle-forte.

Doublage sur fond tendu. — Ce procédé, le seul convenable pour les grandes pièces, est celui que je mets le plus souvent en pratique,

à moins que je ne veuille doubler mon estampe d'un papier mince et léger. Dans ce dernier cas il serait impraticable, car il exige l'emploi d'une feuille de renfort assez épaisse et d'une pâte résistante, vu que, retenue par les bords, elle aura, en séchant, à supporter une tension énergique.

L'identité, sous le rapport du degré d'encollage, des deux feuilles qu'on va réunir, est toujours la condition essentielle, et les préparatifs qui précèdent l'opération sont les mêmes que ceux du doublage sur fond libre. Occupons-nous d'abord de la feuille qui double.

Cette feuille doit nécessairement avoir, en tous sens, une dimension plus grande que celle de l'estampe, surtout si l'on veut qu'elle forme des marges. On l'étend sur une table bien nette, et on l'humecte des deux côtés à l'aide d'une éponge; puis on applique sur ses bords, dans une largeur de deux ou trois centimètres, du côté qui doit former verso, une couche de colle de pâte épaisse, ou, si l'on préfère (pour ce cas seulement), de colle gélatineuse. Il est bon, pour opérer avec régularité, de tracer

d'avance au crayon une limite que ne dépassera pas le pinceau.

Il s'agit maintenant de faire adhérer cette feuille par les bords au fond de bois (ou de fort carton), sur lequel on la laissera se tendre et se sécher. Au lieu de l'y poser à plat, nous l'appliquerons comme une affiche sur un mur, c'est-à-dire que la planche de soutien sera maintenue dans la position verticale contre le dossier d'une chaise ou autrement. Les cartes géographiques se collent sur toile de cette manière, et ce système, quand on a affaire à de grandes pièces, a sur le collage à plat ou horizontal un immense avantage.

Essayons donc de fixer la feuille, par les bords seulement, sans qu'aucune des parties chargées de colle touche une autre place que celle même qu'elle doit occuper. Si, en effet, quand elle séchera, elle était retenue sur certains points plus ou moins rapprochés du centre, elle se déchirerait, ou, au lieu de se tendre avec régularité, contracterait des plis. La planche, d'autre part, sera préalablement examinée avec soin. On s'assurera de sa netteté parfaite, du moins sur toute la portion où la

feuille de doublage devra la toucher, mais rester libre. Si elle retenait la moindre parcelle de colle desséchée, cette parcelle s'amollirait et deviendait visqueuse au contact du papier mouillé, lequel adhérerait à cet endroit; ce qui occasionnerait un accident quelconque, et obligerait à tout recommencer.

Pour coller la feuille dans le sens vertical, à la manière d'une affiche, on la tient par les deux coins supérieurs. Si, au moment où on l'approche de la planche, elle se présente bien parallèlement à sa surface, les quatre côtés s'y appliquent à la fois; mais, pour réussir plus sûrement, voici le moyen que j'indiquerai. Je suppose que l'amateur possède un tableau de bois (ou dessus de table) de 1 mètre de haut sur 75 centimètres de large, formé de planches solidement assemblées et bien unies; on le dressera simplement et à l'état libre sur une tablette fixée à un mur.

Si l'extrémité supérieure de ce tableau reposait sur le mur, il aurait nécessairement un peu de talus, position bien moins favorable que celle verticale. Faites mieux : donnez-lui de l'inclinaison en sens inverse; faites-le pen-

cher en avant comme on dispose un cadre placé en face d'une fenêtre. Sur le profil de votre planche, de chaque côté, vous vissez un piton, et dans les pitons vous passez une corde qui se rattache à un clou. La base de votre planche inclinée appuiera sur le bord de la tablette qui est contigu au mur. Voilà notre appareil prêt à fonctionner.

Si vous approchez le sommet de votre papier de doublage de cette surface qui penche vers vous, cette partie se collera tout aussitôt, tandis que le bas de la feuille restera pendant, s'éloignant peu de la ligne verticale. Alors, tout en maintenant des deux mains le bord supérieur de la feuille, vous repousserez doucement vers le mur le tableau mobile, qui s'y appliquera. La feuille suivra le mouvement et s'ajustera d'elle-même sur le fond qui lui est destiné; vous n'aurez plus qu'à bien l'étirer en tout sens au moyen d'un tampon de linge ou d'une éponge très douce.

On pourrait aussi étaler la colle non sur les bords de la feuille, mais sur la planche contre laquelle on l'appliquera à l'état humide. A mon avis, le procédé inverse est

meilleur et plus expéditif. Quelquefois, employant un papier à doubler d'une dimension suffisante, j'en rabattais les bords sur le profil (préalablement enduit de colle) de la planche, ou même sur son verso. Ce système permet de fixer à plat la feuille de soutien sans crainte qu'elle ne se colle ailleurs que sur les bords. Les encadreurs tendent ainsi les estampes sur des cartons qui leur servent de soutien et restent fixés au cadre. Ce mode d'encadrement, très usité, exige une grande habitude : les coins de l'estampe, repliée au verso du carton, grimacent toujours si on ne rabat les bords avec une parfaite régularité.

Revenons à notre opération. La feuille de doublage étant bien étalée sur le fond de bois, vous la laissez là et vous mettez de la colle au verso de l'estampe, que vous avez eu soin de retirer d'avance de la bassine, afin qu'elle ait le temps de se ressuyer à l'air. Je suppose aussi qu'on aura tracé au crayon, sur la feuille de doublage, avant de la mouiller, la place précise où doit s'adapter le bord supérieur de l'estampe.

Grâce à ces simples précautions, on évite

les tâtonnements. On incline de nouveau la planche que la corde retient; on saisit l'estampe par le haut, et l'on en fixe le bord supérieur sur la ligne de crayon; on relève la planche, et toute la surface de l'estampe se colle d'elle-même.

Si l'estampe avait été tirée sur un papier très fin et sans consistance, son propre poids, à l'état humide, risquerait d'en occasionner la déchirure. En ce cas, on appliquerait préalablement au recto un papier fort, également humide, qui la soutiendrait pendant le collage, et qu'on enlèverait quand ce collage serait effectué.

Le plus difficile est fait. On pose alors la planche à plat sur une table ou sur deux dossiers de chaises, et l'on remanie à son gré et l'estampe et le papier de doublage, qu'il est bon quelquefois de recoller sur les bords, et même de consolider au moyen de bandes.

Grâce à ce procédé, quand l'estampe sera sèche, les rides et les plis seront complétement effacés. Mais il y a un écueil à éviter : les plis antérieurs au tirage de la gravure ne doivent pas disparaître; sinon, certains points

seraient déformés, balafrés de lacunes blanchâtres, plus hideuses que des déchirures, car les tailles ne se raccorderaient plus. Il faut, avant le contre-collage, prendre des mesures pour retenir en place ces plis malencontreux au moyen de colle épaisse et très pure, et les maintenir avec des bandes fixées au verso. On pourrait encore retrancher au canif la partie cachée du pli et traiter la fissure qui en résulterait comme une simple déchirure (voyez p. 134). Si l'on désespérait de réussir à conserver ces plis originels, il vaudrait mieux se contenter du doublage sur fond libre.

L'opération terminée, on n'a plus qu'à laisser sécher le tout pendant quelques jours. On évitera l'action du feu et du soleil, qui, opérant une dessiccation trop brusque, romprait le papier de doublage et quelquefois l'estampe elle-même. A l'ombre, au contraire, et dans une chambre sans feu, tout se passe en bon ordre. J'ai vu des planches de sapin se courber sous cette tension, sans pourtant que le papier se déchirât. Quant aux cartons de moyenne force, ils bombent comme le bois de l'arc sous la corde.

Au bout de quatre à dix jours, suivant l'état hygrométrique de l'atmosphère, on coupera au canif les bords de la feuille de doublage, qui, détachée et chargée de l'estampe, n'offrira nulle part ni plis, ni grimaces, ni ondulations, même sur la partie excédante et formant marge, pourvu qu'on ait observé toutes les précautions prescrites.

Il est permis d'employer ce même procédé pour contre-coller une grande estampe sur un papier assez fin, mais à cette condition : dès que l'opération du doublage sera achevée, au lieu de laisser le tout sécher sur la planche, on détachera le papier qui double, on en rognera les bords au niveau de ceux de l'estampe, et on mettra sous presse comme je l'indique page 18.

On doit s'abstenir de doubler une précieuse estampe, en bon état du reste, dans le seul but de lui donner des marges simulées. Ce doublage inutile lui ôterait une partie de sa valeur. Je conseille le contre-collage uniquement dans le cas où il est nécessaire de soutenir et de consolider une pièce rare, qui a subi de nombreuses réparations. Je repar-

lerai des fausses marges au chapitre suivant.

Je terminerai par une observation assez intéressante pour les iconophiles. Le papier des estampes, en séchant (surtout quand il est fixé par les bords), s'allonge presque toujours un peu plus dans un sens que dans l'autre. Il conviendrait donc, quand la chose est possible, d'employer pour les doubler un papier d'une nature identique et de les contre-coller de telle sorte que le sens de leur plus grande élasticité coïncidât.

Notons que cette irrégularité dans la dessiccation des papiers peut nuire à l'effet de certaines gravures en déformant, en faussant, les proportions des lignes. Les calques sur papier transparent des plans d'architecture sont sujets à cette déformation quand on les double à l'état humide par un procédé quelconque.

Je contre-collai un jour le calque du plan d'un quartier de Paris. Mon dessin s'allongea dans le sens horizontal à tel point qu'en appliquant le compas sur l'échelle, je ne trouvai plus de proportions entre les rues qui s'étendaient dans le sens de la longueur et celles qui les croisaient. Il eût fallu, avant de mouil-

ler les papiers, tracer deux échelles des mesures, une dans chaque sens du papier.

On tire d'ordinaire sur papier humide les épreuves d'un cuivre gravé. Or, quand le papier sèche à l'air, il se retire presque toujours plus en un sens, ce qui entraîne une légère déformation du sujet de l'estampe. Un portrait est tantôt un peu plus large, tantôt un peu plus allongé, sur l'épreuve que sur le cuivre. A la rigueur, deux planches tirées sur papiers qui diffèrent d'épaisseur ou d'encollage n'auraient pas mathématiquement les mêmes proportions. Quand une estampe se compose de deux pièces (telles sont les cartes géographiques), si chaque épreuve a été tirée sur un papier différent ou placée sous la presse dans un sens opposé, il est très probable que le raccord sera imparfait. C'est le défaut de de presque toutes les anciennes gravures en plusieurs pièces représentant des panoramas de villes.

IX

**RACCORD DU NOIR D'IMPRESSION, ETC.
— ENCOLLAGE DU PAPIER.**

Raccord du noir d'impression. — Quand l'estampe doublée est complétement sèche, elle offre souvent, à la suite de restaurations compliquées, une multitude de places blanches formées par les lacunes, les traces de plis, les déchirures à raccords intermittents, les piqûres de vers, etc. En cet état, elle peut être assimilée à un tableau rentoilé et parsemé de taches de mastic qui attendent pour disparaître la touche d'un adroit pinceau.

Pour raccorder, pour remplir ces blancs, il s'agit de dessiner à la plume, de lutter avec la hardiesse du burin; c'est donc une question d'art. Aussi n'indiquerai-je que des moyens artificiels pour venir à l'appui du talent du réparateur. Une tête d'expression réclame une main d'artiste; pour moi, qui le suis un peu uniquement lorsqu'il s'agit de juger, je n'ai jamais entrepris d'autres retouches que celles des lignes architecturales, des draperies, des ciels à lignes droites, des hachures simples ou croisées.

Il faut d'abord s'assurer si le blanc des lacunes est bien de la même teinte que le reste de l'estampe. Au besoin on l'éclaircit à l'aide d'un pinceau imprégné de chlore; on le rejaunit au moyen de bistre ou de réglisse; quelquefois on ajoute, quand la teinte jaunâtre est sèche, un peu de fusin appliqué à l'estompe. Le papier des gravures du XVIIe siècle exige souvent cette addition, vu leur ton gris. Au reste, on a dû s'arranger autant que possible pour ajuster des pièces tirées du papier même de l'estampe, par exemple quand sa marge, d'une largeur inégale, peut,

sans inconvénients, fournir quelques rognures.

On reportera sur la lacune comblée de l'estampe le tracé des contours et des hachures de l'original en s'y prenant ainsi : on calque sur papier transparent la partie manquante, d'après une autre épreuve; puis, fixant le calque sur la lacune au moyen de poids légers, dès que la coïncidence paraît établie, on glisse entre le calque et l'estampe, sans rien déranger, un papier chargé de mine de plomb, et l'on décalque tous les traits du dessin à l'aide d'une pointe assez dure, puis on repasse au noir les contours et les tailles à l'aide d'une plume ou d'un pinceau. Les plumes de corbeau convenablement taillées me paraissent les plus favorables à ce travail de patience.

L'encre de Chine, vu sa propriété indélébile et sa teinte légèrement brillante, se raccorde assez bien avec le noir d'impression : cette encre, délayée d'avance, doit n'être ni trop fluide, ni trop épaisse; on en charge la plume avec un pinceau. Pour les parties où papier n'est pas bien encollé, il faut l'employer assez épaisse pour qu'elle ne puisse être absorbée, sinon les traits seraient bavo-

DU NOIR D'IMPRESSION, ETC. 169

chés, comme l'écriture tracée sur un papier qui boit. Le mieux est de prévoir cette circonstance et d'encoller d'avance les endroits blancs quand l'estampe est encore humide. (Voyez la fin du chapitre, article *Encollage*.)

Toutes les encres d'impression qu'il s'agit ici d'imiter n'ont pas précisément la même nuance : les unes ont plus de brillant que les autres ; il en est de teinte grisâtre ou de couleur de rouille, etc. L'amateur appréciera, devinera ces nuances, et, par l'addition d'une pointe de couleur nécessaire, saura, s'il a du goût et un peu d'entente, approcher le plus près possible d'un raccord parfait.

On peut remplacer l'encre de Chine par le noir d'ivoire, également solide, ou par l'encre même qu'emploient les graveurs ; mais, celle-ci étant peu coulante sous la plume, il faudrait raccorder au pinceau. Un peintre déjà cité (M. Muller) m'a conseillé le fiel de bœuf mêlé de noir de fumée, comme imitant très bien le noir d'impression ; le défaut de cette encre est aussi, sans doute, d'être trop peu fluide pour permettre de se servir d'une plume.

C'est avec l'une ou l'autre des matières que

je viens de signaler qu'on peut convenablement rétablir, si l'on est un peu artiste, les traits absents du burin, comme aussi raviver les endroits où d'anciens plis ont, par suite d'usure et de frottement, laissé une trace blanchâtre.

Fausses marges, etc. — Quand on veut donner à une estampe défectueuse toute l'apparence d'un parfait état, on ne se borne pas à en raccorder les lacunes ; on lui restitue encore sa marge d'une manière factice, en l'incrustant au milieu d'une feuille où l'on a ménagé un vide suivant le tracé exact de son contour. En ce cas, on ajuste au verso, avec de la gomme, des bandes de papier qui la fixent dans cette espèce de châssis. (Voir au chapitre XII, l'article *Collage à jour*.)

On se contente, lorsqu'il s'agit de grandes pièces, d'ajouter sur les quatre sens de larges bandes d'un papier semblable en tout à celui de la gravure, qu'on colle à la gomme aux bords du verso. Le *remmargement* peut également s'exécuter à l'état humide, par le procédé dit *doublage sur fond tendu*, décrit au chapitre précédent. La condition essentielle

dans ces trois systèmes de marges artificielles, c'est que les vergeures et les pontuseaux du papier employé coïncident parfaitement avec ceux du corps de l'estampe, sinon l'effet désiré ne serait pas obtenu.

Pour augmenter encore l'illusion, quelques amateurs ajoutent à la fausse marge une trace simulée de la pression de la planche, trace nommée *témoins* (1). Le procédé le plus parfait consiste à placer sur l'estampe emmargée, et à l'état de moiteur, une planche de métal dépassant d'environ deux millimètres la ligne qui limite le champ de la gravure, et sur laquelle on exerce une forte pression à l'aide, je suppose, d'une presse à copier. On ne peut mieux imiter l'espèce de bourrelet formée par la planche, puisque cette opération est identique à celle même du *tirage*.

Quand une estampe, trop rognée, est privée de sa ligne d'encadrement, on y peut tracer, à l'encre de Chine, une ligne factice qui renferme tous les traits limitrophes. Mais je dois

(1) Quand il s'agit d'un livre, on nomme *témoins* les bords inégaux des feuillets non rognés.

déclarer ici que toutes ces petites supercheries ne sont nullement de mon goût. La franchise, notamment dans les questions d'art, doit être regardée comme un devoir, comme un point d'honneur. Je ne passerais mon temps à fabriquer exactement des marges, des traces de planches et des lignes d'encadrement factices, que dans un seul cas : celui où il s'agirait de mettre de l'harmonie dans une suite précieuse, dont quelques pièces offriraient, relativement à l'ensemble, une choquante disparate.

Je ferai observer ici qu'une estampe véritablement rare mérite seule toutes les opérations minutieuses que j'ai indiquées, car on y emploie beaucoup de temps, et, quelque habileté, quelques soins, que l'on y mette, la mieux restaurée ne peut rivaliser, que par exception, avec une épreuve parfaitement conservée sous tous les rapports.

La condition la plus favorable pour bien réparer les estampes, surtout les grandes pièces, c'est la température humide. Les colles, dans cette circonstance, séchant avec lenteur, donnent plus de temps pour les apprêts préliminaires. Quand l'air est très sec, il faut coller

fort vite, si l'on se sert de gomme ; et, si l'on emploie la colle de pâte, on est souvent dans la nécessité de remouiller les papiers sur lesquels on opère afin de les maintenir à un degré d'humidité convenable.

Encollage du papier. — J'ai signalé plusieurs cas qui entraînent la nécessité d'encoller une estampe, soit entièrement, soit en partie, par exemple lorsqu'elle est couverte d'écorchures sur lesquelles on doit faire des raccords. Le papier d'une estampe qui a été soumise à l'eau bouillante a perdu plus ou moins son encollage; il faut avant tout le rétablir.

Pour encoller le papier, on le trempe dans de l'eau contenant en dissolution un peu de colle de peau, d'alun et de savon blanc. Le savon ne me paraît pas fort utile; l'alun donne à la colle de la fixité.

Plusieurs chimistes ou fabricants de papiers, que j'ai consultés, n'ont pu m'indiquer au juste les proportions du mélange; elles varient suivant la nature et l'épaisseur des papiers. L'excès d'encollage rendrait peut-être le papier cassant; tel est l'effet, je crois, de toute matière qui raidit trop une substance naturel-

lement souple; en tout cas, elle lui communiquerait un brillant défavorable à l'effet de la gravure. La colle de peau, qu'on extrait de vieux gants et de rognures de parchemin, peut être remplacée par celle de poisson, qui est plus blanche.

Dans l'incertitude où je suis, je fixerai les proportions que je crois raisonnables, et qu'on modifiera au besoin après quelques essais. — Eau, demi-litre; alun cristallisé, 3 grammes; colle de poisson à l'état sec, 8 grammes; savon blanc, demi-gramme. On fait bouillir le tout pendant au moins une heure.

On peut, quand l'estampe est sèche, la retremper, s'il est nécessaire, dans la dissolution chaude, une seconde, puis une troisième fois. La chaleur favorise l'opération en ce qu'elle fait mieux pénétrer le liquide.

Quand on veut encoller une écorchure seule, on applique le liquide chaud au moyen d'un pinceau doux, et l'on renouvelle l'opération jusqu'à ce que le papier paraisse ne plus absorber l'encollage qu'avec peine. Si l'estampe grimaçait à cet endroit, et si l'application d'un fer chaud n'y remédiait pas, il

faudrait remouiller toute la surface à l'éponge, la laisser sécher à demi, puis la mettre en presse, le recto posé sur un marbre bien net.

On peut avec ce même liquide (ou plutôt avec l'alun seul) fixer plus solidement qu'à l'eau de gomme les dessins à la plombagine et aux crayons tendres. Il suffit de passer sur la surface, *rapidement* et *légèrement*, un blaireau très doux trempé dans la composition; il faut prendre garde d'écacher le crayon, et éviter de passer plusieurs fois le pinceau sur le même point. On met ensuite en presse, comme je l'ai dit ci-dessus.

J'ai quelquefois encollé des gravures que j'avais soumises à des réactifs qui passent pour disposer le papier à une désorganisation ultérieure plus ou moins éloignée : tels sont les chlorures à l'état concentré. J'ignore si cette opération peut prévenir un dommage que je regarde encore comme tout à fait hypothétique; quoi qu'il en soit, cet encollage de précaution ne saurait nuire.

X

DES ESTAMPES TIRÉES SUR DIVERS TISSUS. — RÉPARATION DU PARCHEMIN.

Tout ce que j'ai dit concernant la réparation des estampes sur papier ordinaire peut, en plus d'un cas, s'appliquer à celles tirées sur papier de Chine, sur satin, sur toile, sur peau blanche, sur parchemin, etc.; néanmoins, j'ai à consigner plusieurs observations au sujet de quelques-unes de ces matières.

Gravures sur soie et calicot. — L'usage de tirer des épreuves sur satin blanc est assez

ancien et remonte au moins au commencement du règne de Louis XIV, peut-être beaucoup plus haut. Ces estampes sont même assez communes ; on imprimait spécialement sur satin les thèses philosophiques et les images de dévotion, quelquefois aussi des portraits dus à d'habiles graveurs. J'en ai traité quelques-unes absolument comme s'il se fût agi de papier ; je les ai blanchies au chlore, détachées et redressées à la presse par les procédés ordinaires. Je ne sais trop le meilleur moyen à employer pour reboucher les lacunes avec netteté, au moyen de morceaux d'une étoffe qui s'effiloque si aisément.

Le mouillage ne fait pas perdre au satin tout son brillant, et bien des taches doivent glisser plus aisément sur sa surface lustrée que sur celle grenue du papier. Quant à celles qui ont assez profondément pénétré ce tissu, on peut essayer les agents chimiques indiqués pour le papier, ou consulter les nombreux ouvrages qui traitent du nettoyage et du dégraissage de la soie. On y verra que la soie blanche enfumée perd en partie sa teinte jaunâtre au contact de la vapeur du soufre. La benzine

doit aussi enlever sur la soie, sans en altérer le tissu, les taches de graisse, de cire, de résine, etc.

Mais je sortirais de mon sujet si je consacrais un long chapitre à un genre d'estampes qui est une exception. Aujourd'hui, en fait de gravures tirées sur soie, je ne connais guère que des foulards, produits *rococos* qu'apprécient certains fashionables américains.

Je ne ferai que mentionner les estampes tirées sur calicot : ce sont des cartes géographiques, des portraits de personnages en vogue, des plans de ville qui servent à la fois de guides et de mouchoirs. Tous les procédés signalés pour le nettoyage des gravures sur papier peuvent s'y appliquer, car c'est la même matière autrement façonnée. Le calicot a sur le papier un avantage : on peut le frotter et le tordre.

Mais je m'arrête : ces chefs-d'œuvres industriels ne sont pas de ma compétence, pas plus que les assiettes lithographiées, leur nettoyage rentrant dans les attributions des blanchisseuses et des laveuses de vaisselle.

Une dernière observation : c'est une idée

peu heureuse et nullement artistique que le tirage d'une remarquable gravure sur des tissus très dilatables, sujets, dès qu'ils ont perdu leur apprêt, à déformer les dessins qu'on leur a confiés. J'ai rencontré des épreuves sur satin de bonnes estampes du XVIIe siècle, qui grimaçaient d'une façon grotesque, étirées qu'elles étaient sur un carton rigide par une main inhabile.

Gravures sur fonds de couleur. — J'ai vu deux ou trois estampes tirées sur satin de couleur; mais le cas d'une vieille gravure sur papier coloré s'est rarement présenté; de nos jours, on ne tire guère sur fond de couleur que des estampes destinées à décorer la couverture d'un livre.

On pourrait croire, au premier coup d'œil, que la variété dans la couleur du fond doit imposer de nombreuses modifications aux procédés ordinaires; mais la question sera bientôt éclaircie. Ou cette couleur céderait tout de suite à un agent qui ramènerait le papier au blanc, ou bien elle serait tout à fait inattaquable, comme le bleu de cobalt. Dans ces deux cas, on n'aurait nullement à s'inquiéter du fond, et les

résultats seraient les mêmes que s'il était blanc. Ce raisonnement peut également s'appliquer à la question des satins ou calicots de toute couleur.

Du reste, si l'on tenait à conserver le papier rose ou vert, etc., qui sert de fond à une gravure, il serait probablement facile de raccorder avec la teinte générale les places blanchies par l'application d'une substance chimique.

Je mentionnerai en passant les estampes ou livres tirés à l'encre rouge, bleue, etc. Elles peuvent subir, tout aussi bien que si l'encre était noire, les procédés indiqués pour le détachage et décoloriage. L'huile qui entre dans la composition de ces encres de couleur les protége contre l'action des substances chimiques, excepté contre celles de nature alcaline, ou autres qui dissolvent les huiles, telles que l'éther, la térébenthine et la benzine.

Gravures sur peaux et parchemins. — J'ai vu plusieurs fois des gravures du siècle dernier tirées sur peaux d'agneau, de daim, etc. De pareils tissus ne seraient pas, je crois, faciles à manier à l'état humide, et ne pourraient jamais reprendre en séchant ni leur état pri-

mitif ni une teinte uniforme. Je ne cite au reste ces exceptions que pour mémoire.

Les gravures et impressions sur divers parchemins (1) sont assez communes. Elles se manient comme celles tirées sur papier, plus aisément même, en ce sens qu'elles ne se déchirent pas quand elles sont mouillées, et qu'il est permis jusqu'à un certain point de les chiffonner et de les tordre; mais les taches de toute sorte ne peuvent pas toujours, il s'en faut de beaucoup, céder aux procédés ordinaires.

Si je trouve un jour le temps nécessaire, j'entreprendrai une série d'expériences sur la restauration des vieux parchemins; cette matière nous a conservé tant de précieux monu-

(1) On doit distinguer au moins trois sortes de parchemins : le parchemin ordinaire, formé de peau de mouton; le vélin, fabriqué avec celle du veau, plus ferme, plus lisse, plus homogène; enfin, la peau de chevreau parcheminée, d'une extrême finesse, destinée, au XIVe siècle, aux bibles compactes et portatives ou aux livres d'heures de très petit format. On fabrique encore aujourd'hui, à des prix très élevés, des vélins et des parchemins de chevreau.

ments historiques qu'elle mérite bien, en retour, qu'on se livre à des essais favorables à sa conservation.

J'ai fait plusieurs tentatives pour ôter sur du parchemin certaines taches ou couleurs qui disparaissent aisément sur le papier ; mes résultats ont été d'autant plus imparfaits que je ne pouvais agir à chaud. Presque tous les agents chimiques, acides ou alcalis, employés à l'état liquide, salissent le parchemin ou lui communiquent une transparence cornée très peu agréable à l'œil ; j'ignore s'ils en altèrent la substance, mais assurément ils détruisent l'apprêt qui en rendait la surface lisse et d'un blanc opaque. Pour faire un travail utile sur ce sujet, il faudrait commencer par se mettre au courant des anciens procédés usités pour la préparation de cette matière animale.

La benzine ne laissant aucune trace sur le parchemin, je la conseillerais pour l'enlèvement des taches d'huile ou de graisse, de préférence à la potasse et à l'ammoniaque, qui en salissent un peu la surface ; je ne sais, au reste, si l'on réussirait à détruire complétement les taches qui ont pénétré l'épaisseur de la peau.

Pour blanchir ou du moins éclaircir le parchemin très enfumé d'une estampe ou d'un feuillet imprimé, on emploiera une dissolution très faible de chlore ou de chlorure de chaux. Peut être suffirait-il, en certains cas, de l'exposer à sec aux vapeurs du chlore. Peut-être aussi parviendrait-on à le désenfumer, comme la laine et la soie, par le contact du gaz sulfureux.

Parlons maintenant de la restauration du parchemin sous le point de vue mécanique. Comme ces peaux, à l'état humide, sont à la fois souples et résistantes, on peut en faire disparaître sans peine toutes les souillures qui cèdent au simple frottement : telles sont les taches de boue, les traits au crayon, etc. En certaines circonstances, je le répète, on a la faculté de les froisser comme des morceaux d'étoffe; mais, sous plusieurs autres rapports, le parchemin est très difficile à manier. On ne parvient pas toujours à le redresser, à le doubler, à le rapiécer, à en raccorder les déchirures. Il n'est donc pas seulement rebelle aux procédés chimiques, il résiste encore aux opérations qu'on pourrait nommer chirurgicales.

D'abord, en qualité de membrane, il est très sensible aux influences hygrométriques; il se dilate inégalement par une température humide, et se recoquille plus ou moins par le temps sec. Ajoutons que la contexture d'une feuille de parchemin ordinaire est peu égale, peu homogène; sa superficie est ici mince, là épaisse; d'un côté elle a presque le poli de la porcelaine, de l'autre elle est rugueuse et comme écorchée. En général la colle de gluten ou la gomme arabique n'y adhère pas avec une ténacité suffisante; les pièces rapportées se détachent quelquefois spontanément (surtout quand la température est très sèche), repoussées par une surface trop onctueuse. Il faut nécessairement recourir, pour les diverses réparations, aux colles gélatineuses (1) appli-

(1) Voici comme on prépare toutes les colles gélatineuses : on en laisse ramollir des morceaux, pendant douze heures, dans deux fois environ leur poids d'eau; ils se présentent alors à l'état de gelée. On liquéfie cette gelée en posant le vase qui la contient au-dessus d'une flamme quelconque ou de quelques charbons. La chaleur ne doit agir que sur le fond du vase, sinon l'on grillerait une portion de la matière, qui formerait des

quées tièdes, car l'excès de chaleur humide sied mal au parchemin.

On ne saurait, bien entendu, soumettre le parchemin aux opérations qui exigent l'emploi prolongé des liquides bouillants ; il perdrait bientôt la gélatine qui lui donne l'élasticité ; il serait désorganisé, métamorphosé en gelée, puisque c'est par l'ébullition des peaux qu'on obtient la colle forte et les autres colles de même nature.

La réparation à l'état humide et à froid des déchirures et lacunes du parchemin est donc pour l'amateur une véritable source de tribulations. S'il met sécher en presse cette membrane revêche, dès qu'elle est libre, souvent elle tarde peu à reprendre ses anciens plis. Ici une pièce se décolle, là une autre fait grimacer la surface générale.

grumeaux. Le procédé le plus parfait est celui du bain-marie. (Voyez page 55.) L'été, la chaleur solaire suffit pour liquéfier la gélatine prise en gelée. En cette saison, on y ajoutera un très petit morceau de camphre pour prévenir la putréfaction. J'ai essayé d'une colle-forte liquide qu'on employait à froid : elle m'a paru détestable autant que fétide.

Pour redresser le parchemin, le mieux est de recourir au système de séchage à fond tendu. Comme il se retire plus dans un sens que dans un autre, on devra, avant d'ajuster des pièces, faire coïncider leur sens élastique avec celui du fond.

Quand on l'aura fixé par les bords, et à la colle-forte, sur une planche ou sur un carton, on le laissera longtemps et très lentement sécher ; on ne saurait prendre trop de précautions pour éviter une dessiccation rapide et artificielle. Mais, en dépit de tous les soins, on ne réussit pas toujours à faire entièrement disparaître ses rides et ses ondulations, à cause, je le répète, du peu d'homogénéité de son tissu. Plus la feuille sera grande, plus elle aura de chances de goder.

Pour mouiller convenablement le parchemin, il n'est pas besoin de le faire tremper dans une bassine. Il suffit d'ordinaire de passer sur chacune de ses faces ou même sur une seule une éponge légèrement imprégnée d'eau. Mais, si l'on devait l'humecter avec la condition de n'exercer aucun frottement sur sa surface (par exemple quand il sert de fond à des ma-

juscules gouachées), il faudrait suspendre le feuillet isolé dans un lieu humide pendant quelques heures, ou encore l'exposer à la vapeur aqueuse, ayant soin de le tenir loin du foyer qui produit l'évaporation, car il se crisperait à l'approche du feu. Au bout de quelques minutes, il aura contracté assez de moiteur et de souplesse pour se prêter à l'opération du redressage.

Nettoyage des manuscrits sur parchemin. — Que le lecteur me passe une digression qui intéresse spécialement les bibliophiles. Il ne sera pas ici question des anciennes gouaches intercalées dans ces manuscrits (j'en parlerai à la fin du chapitre suivant), mais du texte tracé à la main à l'aide de l'encre ordinaire.

Disons d'abord qu'on peut attaquer les taches d'huile ou de graisse qui les souillent sans craindre d'en effacer les caractères, puisqu'ils sont formés en général d'un noir à base de gallate de fer, redoutant peu l'action des alcalis et des huiles essentielles. Malheureusement, c'est le parchemin lui-même qui peut en souffrir, si l'on prolonge trop l'opération. Comme l'application partielle d'une solution al-

caline y laisserait une sorte de tache, il vaut mieux en imprégner le feuillet entier.

La benzine n'altérant sensiblement ni le noir de l'encre ni le parchemin, on emploiera donc d'abord cette substance de préférence à la potasse, qui fait tourner ce noir au rouge-bistre. Néanmoins, si l'usage de cet alcali devient nécessaire, il suffira, je pense, pour rétablir la couleur de l'encre, de jeter sur la portion où il aura agi quelques gouttes d'eau acidulée.

Quand on enlève sur le parchemin des taches ou des couleurs, soit avec le chlore, soit avec l'eau de Javelle (qui ne peut ici nuire comme lorsqu'on l'applique sur le noir d'impression), il est certain que l'encre tournera à la rouille; mais il y a pour la raviver un remède que je signalerai bientôt. J'ai dit plus haut que les acides altèrent l'apprêt, sinon la substance du parchemin; cependant, leur intervention pouvant seule opérer la disparition de certaines taches, on devra les employer. Du reste, je crois qu'en agissant avec discrétion, il n'en résultera qu'un léger mal.

Parviendrait-on à détruire *radicalement* sur un manuscrit les flaques d'encre qui souvent

s'y trouvent par accident et cachent une portion de texte? Radicalement, non, puisqu'il n'est pas permis de tremper le parchemin dans une solution bouillante d'acide oxalique; mais on réussira à atténuer cette tache en l'imbibant de chlorure de chaux ou d'eau de Javelle. Le pâté se réduira à une teinte légère d'un jaune plus ou moins accusé. En même temps, l'encre du texte aura perdu la vivacité de son noir, mais il sera possible le plus souvent de déchiffrer les lettres que couvrait la tache; et, quand le parchemin sera sec, on les rétablira soit à l'encre de Chine, soit même à l'encre ordinaire, supposé que les traces des substances décolorantes employées aient disparu complétement. Quant à la teinte jaunâtre qui aura survécu à la tache, on la laissera telle quelle.

Notons ici que l'indélébilité des traces déposées sur les vieux parchemins par l'oxyde de fer que contient l'encre à base de noix de galle a sauvé la moitié peut-être de nos anciennes chroniques, en ce sens que les tentatives faites pour rendre la blancheur au vélin chargé d'écriture ont toujours échoué. Sans cette circonstance, la spéculation aurait détruit toutes les

pièces curieuses, à ces époques où si peu de personnes en comprenaient la valeur. Comme on n'en pouvait faire du parchemin neuf ni les utiliser comme combustibles, on les laissait vivre ou on les employait à la reliure des livres et à divers autres usages. Ainsi, de nos jours, on a retrouvé presque intacts d'anciens comptes (ou cartulaires) convertis en gargousses. En tout, le mal a son bon côté : je vais en donner une autre preuve.

On peut tirer parti de l'adhérence opiniâtre au parchemin ainsi qu'au papier de l'oxyde de fer. On rencontre fréquemment des manuscrits ou des dessins indéchiffrables parce que l'encre en a pâli à tel point qu'il n'en reste plus de vestiges, du moins en apparence. C'est un effet du temps, ou plutôt de l'action de certains gaz qui se mêlent à l'air sous certaines influences. Or il en subsiste des traces latentes sur la surface ou même à une certaine profondeur de l'épaisseur du parchemin. Pour raviver ces traits insaisissables à l'œil, on a recours à une solution d'acide gallique, acide extrait de la noix de galle, et cristallisé sous forme d'aiguilles soyeuses. Je citerai à ce sujet les pas-

sages suivants extraits des *Recherches chimiques sur l'encre* par C. N. Alex. Haldat, 1802. L'auteur s'exprime ainsi, pages 25 et 26 :

« L'encre moderne, quoique imparfaite d'ailleurs, a cependant l'avantage, dans le plus grand nombre des circonstances, de laisser dans l'épaisseur du papier des traces invisibles qu'on peut ressaisir par des moyens chimiques... Les altérations que l'influence de l'atmosphère et l'humidité produisent sur les écritures, se réparent au moyen de l'acide gallique. En plongeant le titre altéré dans une dissolution *chaude* de cet acide, et l'y laissant *quelque temps*, le fer qui a pénétré le fond, ou qui a pris une couleur faible à sa surface, est de nouveau précipité en noir; et le papier, loin d'en être altéré, reprend une nouvelle solidité. La couleur rouille, donnée aux écritures par les alkalis, soit sur papier soit sur *parchemin*, peut être corrigée par l'acide sulfurique faible; l'acide gallique, rendu libre, se porte de nouveau sur le fer, et rétablit la couleur. » Le même auteur avance que, si l'encre a été altérée par une forte dose d'acide sulfurique, nitrique ou phosphorique,

la restauration est impossible. Il ajoute plus loin (page 29) : « On peut, à l'aide du prus-« siate de potasse, restaurer les écritures alté-« rées par l'acide muriatique-oxygéné (chlor-« hydrique); on doit opérer par immersion. » Page 31, il s'exprime ainsi : « En versant de « l'acide nitrique ou muriatique-oxygéné sur « de l'encre, on la décolore; et en versant de « l'acide gallique sur le mélange, non-seule-« ment on rétablit la couleur, mais on en forme « de véritable encre. »

On comprend que, si l'on tentait de raviver par ce moyen un texte qu'aurait maculé une large flaque d'encre, l'acide gallique ramènerait en même temps cette tache, dont la partie ferrugineuse aurait survécu. Peut-être, si avant d'opérer on imbibait de cire, des deux côtés, la place où s'étalait la tache, parviendrait-on à la soustraire à l'action *recolorante* de cet acide. Le texte du feuillet rétabli, on enlèverait facilement la cire au moyen de la benzine. On agirait de même à l'égard de toute substance qui laisse une trace d'oxyde de fer, telle que le bleu de Prusse, la sépia, etc.

Cette propriété de l'acide gallique, à part

les circonstances exceptionnelles que j'ai signalées, est assurément une précieuse ressource en bien des cas ; mais, par malheur, à l'égard du parchemin, elle me paraît offrir des inconvénients : cet acide, à chaud surtout, peut en attaquer l'apprêt et même le tissu ; au reste, je n'en ai pas fait l'expérience. Quant à son application au papier, elle n'entraînerait aucune conséquence fâcheuse, à moins qu'on n'eût affaire à du papier contenant dans sa pâte des traces d'oxyde de fer.

Un mot sur le blanchiment des vieux manuscrits sur parchemins enfumés. Il est permis d'essayer, comme je l'ai dit plus haut, le chlore, l'eau de Javelle ou le gaz sulfureux. L'emploi de ce gaz, ainsi que celui des chlorures, fera sans aucun doute tourner l'encre au jaune ; mais qu'importe, puisque nous avons, pour en rétablir la couleur, le secours de l'acide gallique et du prussiate de potasse ?

XI

RESTAURATION DES DESSINS DE TOUTES SORTES.

Tout ce qu'on a lu précédemment au sujet du nettoyage des estampes peut, en bien des cas, s'appliquer aux dessins ; mais il y a des exceptions à signaler. Cette matière réclame au moins un chapitre à part.

Dessins à la plume. — Un dessin de ce genre, exécuté soit à l'encre de Chine, soit avec toute autre matière ou couleur ineffaçable, ou du moins très difficile à décomposer, peut se traiter en tout comme une gravure. Il

a même sur la gravure un avantage : on peut, en faisant agir avec énergie la potasse, l'ammoniaque ou la benzine, le délivrer d'une ancienne tache d'huile. Les taches de cette nature disparaissent aussi sur les dessins et autographes tracés à l'encre ordinaire (gallate de fer), que les alcalis n'attaquent pas.

On croirait au premier abord qu'il n'est point possible d'employer, pour les nettoyer, les acides et les chlorures qui décomposent cette encre ; cependant, en certains cas et dans certaines conditions, on en pourra faire usage, puisque, ainsi que nous l'avons vu au chapitre précédent, il y a moyen de rétablir le noir effacé de l'encre à base d'oxyde de fer. Seulement, on ne saurait en enlever complétement une tache ou une couleur ayant pour principe ce même oxyde, car du même coup on détruirait une portion des traits du dessin.

On se gardera bien d'attaquer une tache d'huile par les alcalis sur certains anciens dessins lavés au bleu de Prusse : ce bleu disparaîtrait tout aussitôt.

Pour redresser la surface ondulée d'un dessin à la plume, on le mouillera seulement du

côté du verso. Au bout de quelques minutes, le papier sera uniformément humecté dans toute son épaisseur. On le mettra de suite en presse, ou on le fixera par les bords sur un carton, dont on l'isolera quand il sera bien sec.

Un ancien dessin dont l'encre, appliquée depuis longtemps, est comme incorporée au papier et a perdu son brillant, peut être blanchi, *désenfumé*, sans inconvénient, dans l'eau pure; il n'aura rien à redouter d'un séjour de quelques heures dans une bassine. Néanmoins, par prudence, dans la crainte d'en altérer le trait, on s'abstiendra de l'essuyer au recto avec un linge, pour le priver, avant sa mise en presse, de l'excès d'humidité qu'il contient; on se bornera à poser dessus, sans appuyer, quelques feuilles de papier buvard.

Gouaches, pastels, aquarelles. — La réparation des gouaches et des pastels exige de grandes précautions. Ces deux genres de dessins ne sauraient être trempés dans aucun cas en pleine bassine; le contact de l'eau en disperserait les couleurs mal fixées, et même les détruirait complétement pour peu qu'elle fût acidulée. Quand ils ont été doublés (ce qui

n'a eu lieu qu'avant leur exécution), on ne peut les dédoubler qu'au grattoir et à sec, opération fort longue. Cependant, si le papier qui leur sert de base est bien encollé, on peut recourir au procédé indiqué page 15, avec le soin d'éviter que l'excès d'humidité de la feuille de doublage ne forme des mouillures au recto du dessin.

C'est à l'aide de la colle gommeuse qu'il est permis d'appliquer des pièces aux gouaches et pastels pour en boucher les lacunes ou en rapprocher les déchirures. Lorsqu'on veut les doubler ou plutôt leur donner un papier de soutien, on se borne à les y fixer à sec et à la gomme, non en plein, mais seulement par les bords. Pour les y faire adhérer, on appuiera légèrement la lame sur le recto avec l'intermédiaire de plusieurs feuilles de papier joseph.

J'ai réussi quelquefois à éclaircir sans inconvénient le fond de certaines aquarelles anciennes, sortes de lavis (que n'empâtaient aucunes teintes superposées), à l'aide d'un bain d'eau pure; mais on ne peut traiter ainsi les gouaches, ni surtout les pastels, qui ont pour base un blanc très fragile. Il faut se résigner

à conserver enfumés ces sortes de dessins. On n'a pas même la faculté de recourir aux fumigations de chlore ou de gaz sulfureux : car le contact de ces gaz enlèverait, en même temps que la teinte qui jaunit le fond, toutes les couleurs de nature végétale.

Les taches huileuses et autres ne peuvent être attaquées isolément sur les pastels ou gouaches par les remèdes signalés que sous la condition, assurément très fâcheuse, de refaire les points où ces remèdes auraient agi. Il vaudrait presque mieux enlever au canif la place maculée, combler le vide et rétablir la portion supprimée du dessin, si l'on possède l'habileté nécessaire. Quant aux aquarelles, on parvient, en quelques cas, à les délivrer de certaines taches isolées sans que le fond en souffre. Par exemple, sur un fond d'ocre jaune ou de bleu de cobalt, on effacerait, par l'application d'un alcali, une tache d'huile, sans altérer ce fond. En pareille circonstance, on devra se rappeler tout ce que j'ai dit, page 42, au sujet de l'enlèvement des taches sur un seul point.

La fragilité des dessins au pastel peut se comparer à celles des vives couleurs du papil-

lon. Il faut les manier avec légèreté, et, pour ainsi dire, en retenant son haleine, sinon l'on risque de détruire quelques portions de leurs teintes fugitives. Plusieurs peintres en miniature les réparent habilement; c'est un travail qui exige, outre le talent, une patience presque exceptionnelle. Un artiste m'a dit qu'on réussissait aujourd'hui à fixer les couleurs des pastels en les soumettant à l'action d'un certain gaz dont il ne m'a pas du reste révélé la nature.

Dessins aux divers crayons. — Les dessins tracés au moyen de crayons d'une nature inaltérable peuvent se nettoyer et se réparer plus facilement que les estampes. La plombagine ou mine de plomb (1), et les crayons diversement colorés, à bases siliceuse ou argileuse, tels que la sanguine, le crayon noir, etc., ainsi que les fusins, forment sur le papier une trace indécomposable; ils redoutent le frottement

(1) Ainsi appelée sans doute à cause de sa couleur et de sa tendreté. Ce nom en donne une idée chimiquement fausse : la plombagine, dite aussi *graphite*, est, selon M. Bouchardat, « une variété de carbone mélangé de terre et d'oxyde de fer ».

quelquefois le plus léger, mais défient toute action chimique. On conçoit dès lors qu'il est permis de nettoyer parfaitement les dessins de ce genre toutes les fois que le frottement n'est pas une condition essentielle.

Les plus anciennes taches d'huile ou de vernis gras peuvent être attaquées au moyen de dissolutions alcalines assez concentrées, impunément pour le dessin, mais non pour le papier, si on ne prend la précaution de le laisser retremper dans un bain acidulé qui annule les vestiges de l'alcali. On en refait, au besoin, certaines portions avec plus de succès que si l'on avait affaire à des estampes, en ce sens qu'on a pas à rétablir, à imiter servilement, des tailles de burin. Le mouillage prolongé dans la bassine, loin d'altérer ces dessins, leur donne au contraire plus de fixité; exceptons pourtant les esquisses très légères, dont le simple frôlement de l'eau agitée peut déformer les traits, ou même les effacer en partie.

Avant de mettre en portefeuille les dessins dont la trace est très fugitive, il est bon de les fixer; on y réussit en passant sur la surface un

blaireau doux trempé dans de l'eau, assez gommée pour que le crayon s'incorpore à l'épiderme du papier, mais pas assez pour communiquer à sa superficie l'apparence brillante d'un vernis. L'opération doit être faite vivement et avec légèreté. Si l'on étalait le liquide à plusieurs reprises, on risquerait d'entraîner des parties de crayon et d'écacher la finesse du trait. Le gommage achevé, on met en presse, le recto appuyé sur une surface polie.

On pourrait encore appliquer à la fixation des dessins le procédé d'encollage décrit à la fin du chapitre IX. J'ai vu quelquefois tremper, pour les fixer, des dessins au crayon noir dans l'eau de puits, eau tenant en dissolution des sels calcaires.

Je dois ajouter que beaucoup d'amateurs se garderaient bien d'user d'aucun de ces moyens; à leur avis, l'opération la plus délicatement exécutée nuit toujours à l'effet d'un dessin de maître, en ce qu'elle donne au trait une certaine crudité. Je ne suis pas juge compétent sur cette matière.

Quelques anciens dessinateurs se sont servis de simples pointes de plomb, purement

métalliques. De pareilles traces sur le papier n'ont pas l'inaltérabilité de la plombagine. L'acide azotique les attaquerait directement, et la plupart des acides décomposeraient leur surface oxydée par le contact de l'air. Ces crayons, que n'emploient plus nos artistes modernes, étaient, je crois, assez usités avant notre siècle. On traçait autrefois les contours des miniatures sur le parchemin avec des pointes de plomb ou d'autres métaux. Les esquisses de ce genre doivent être fort rares, cependant j'en ai vu plusieurs. J'en possède une dont le trait repassé à l'encre laisse çà et là entrevoir un tracé qui a le brillant argentin.

Il ne faudrait pas confondre, je le répète, les dessins dus à ces crayons avec ceux de nos artistes : presque tous les acides décomposeraient les premiers; l'eau de savon suffirait même pour en entraîner les parcelles métalliques. Je conseille donc à l'amateur, avant d'opérer sur les traits d'un ancien dessin, d'en étudier la nature, et, s'il y a doute, de faire quelques essais préalables.

Dessins photographiques sur papier. — Je n'ai pas trouvé jusqu'ici le temps de m'occuper

de photographie, ni par conséquent d'étudier la constitution assez compliquée de ces sortes de dessins modernes, de manière à pouvoir indiquer les moyens de les détacher sans altération, supposé la chose possible.

J'ai ouï prononcer une prédiction sinistre : tous les dessins photographiques sur papier courraient la chance de s'effacer spontanément au bout d'un certain nombre d'années, surtout exposés à la lumière, à l'agent même qui les a créés. Espérons qu'on remédiera au danger, s'il est réel. Ce qui est certain, c'est que les épreuves que je possède depuis six ans n'ont pas changé. Je sais encore par expérience que ces dessins disparaissent tout entiers dans une faible solution de chlorure de chaux.

Dessins sur papier à calque. — Une esquisse obtenue par voie de calque sur papier transparent ayant un fond très fragile, on tient souvent à la contre-coller sur un papier fort qui lui donne de la consistance. Rien n'est plus difficile à doubler que certains papiers à calque d'une minceur extrême et non encollés. L'humidité les met dans un état de froissement, de plissement, à peu près inextricable. Si, après

bien des tribulations, on parvient à les étendre et à les contre-coller, lorsqu'ils sont secs ils font horriblement onduler leurs feuilles de renfort.

Aujourd'hui, heureusement, on vend dans le commerce des papiers et même des toiles à calque, qui ont toutes les qualités requises pour le doublage. Ils se manient au sortir de l'eau, avec la plus grande facilité, et peuvent s'appliquer exactement, par le procédé dit à fond tendu, sur tout papier à pâte encollée.

On aura soin d'étaler au verso la colle de pâte bien uniformément, et de promener le pinceau toujours dans le même sens, sinon les traces de son passage se verraient en transparent et produiraient un effet peu agréable.

Quand on fait un calque en plusieurs feuilles sur papier diaphane, on préviendra le cas où ces divers morceaux devront, à l'état humide, se raccorder entre eux ; le point essentiel est qu'ils se rapprochent dans le même sens. Tous les papiers, et celui-ci notamment, se dilatant plus en un sens qu'en l'autre, il s'ensuit que les points de raccord ne seraient plus au même niveau. Avant de commencer un

calque, on devra donc s'assurer, par un essai, de la possibilité d'en bien raccorder les morceaux.

Miniatures anciennes sur vélin — Ces gouaches ornées de vives couleurs ne peuvent se nettoyer ni se redresser facilement. Les couleurs, dans les manuscrits soignés, adhèrent assez fortement au vélin et s'écroûtent difficilement; mais elles redoutent la moindre goutte d'eau et la majeure partie des agents chimiques usités; l'enlèvement d'une tache nécessite presque toujours la retouche du point détaché.

Les femmes du monde à qui l'on montre ces fraîches miniatures ont la manie d'y appliquer leurs doigts gracieusement effilés, mais toujours un peu moites. En *galant archéologue* (deux mots étonnés peut être de se trouver côte à côte), on devra les laisser faire, à moins qu'il n'y ait vraiment abus. Ces gouaches n'ont pas de mauvaises chances à encourir comme s'il s'agissait d'un pastel. J'ai vu plus d'un livre d'heures dont chaque miniature était recouverte d'une bande de satin; précaution superflue : elles se conservent intactes sans cet

appendice ; ce qui prouve la solidité de l'application de ces couleurs, solidité que j'ai niée à tort dans ma première édition.

Le redressage du vélin n'est pas fort aisé : je l'ai déjà fait remarquer page 183. Un pli léger, quand il ne tient pas à la nature inégale de cette membrane, disparaît par la mise en presse; on devra mouiller légèrement le verso, puis poser le recto sur un marbre bien poli, net et parfaitement sec, sinon une partie du coloris y resterait peut-être adhérente. On peut repasser au fer de très petites pièces, mais avec beaucoup de précaution : car, si ce fer était un peu trop chaud, le vélin se crisperait en tous sens et les couleurs s'érailleraient.

Si l'on veut doubler une miniature isolée, ce ne peut être que par le procédé *à fond tendu* (page 155). On lui choisira pour soutien un papier fort (ou, si l'on préfère, une feuille de parchemin), qu'on mouillera et qu'on fixera par les bords sur une planche. La colle gélatineuse peu fluide et seulement tiède doit ici remplacer la colle de pâte; le verso de la miniature humecté à l'éponge en sera rapidement enduit, puis appliqué vivement sur la feuille de dou-

blage bien tendue. On n'étirera pas le vélin, de crainte d'en écrouter les couleurs ; on appuiera sur le recto, mais légèrement, et avec l'intermédiaire de plusieurs feuilles de papier joseph, ou encore on passera sur ces feuilles un rouleau couvert de drap. On laissera ensuite le tout sécher lentement à l'ombre pendant plusieurs jours.

Si plus tard on désirait dédoubler la miniature, pour la garder à l'état simple et bien redressée, il suffirait peut-être de glisser une mince lame entre les deux feuillets, pour les désunir; seulement il resterait au verso une couche de colle desséchée.

La retouche d'une miniature sur vélin exige à la fois de l'art et du goût pour l'imitation. Le blanc en écaille est le fond de toutes les couleurs, et une certaine matière argileuse d'une dureté remarquable sert de base aux initiales et aux ornements en or bruni. Cette matière est incorporée au vélin avec cette ténacité qui fait adhérer à la brique le ciment romain. Je n'ai fait aucun essai sur la réparation de l'or bruni; je sais seulement qu'on lui donne pour soutien une sorte de

pâte (1) qui durcit assez avec le temps pour qu'on puisse polir à l'aide d'un brunissoir l'or en feuille qu'on y applique.

De précieuses miniatures intercalées dans des manuscrits de toutes sortes se détériorent de jour en jour dans nos bibliothèques publiques et nos dépôts d'archives. Celui qui pourrait les sauver de la ruine rendrait un immense service à l'art et à l'histoire ; je souhaite donc vivement la venue prochaine du messie de ces monuments historiques.

(1) Telle serait sans doute celle ayant pour base de l'argile ou de la craie broyée avec une colle de peau alunée.

XII

DE LA CONSERVATION DES ESTAMPES (1).

Le présent chapitre a pour but (qu'on me passe l'expression) l'*hygiène* des estampes. Si, depuis qu'il en existe, chaque possesseur avait

(1) M. Ch. Le Blanc, dans son *Manuel de l'Amateur d'estampes* (ouvrage en cours de publication), doit traiter de la manière de conserver les estampes. J'ignore s'il s'est déjà occupé de cette question, et quel sens il donne au mot *conserver*. Je me borne ici à réimprimer le chapitre de l'édition de 1846, en y ajoutant quelques nouvelles observations.

eu le désir et connu les moyens de les conserver, le présent livre serait inutile, et il n'y aurait de gravures rares que celles tirées à très petit nombre d'épreuves. Mais leur rareté a le plus souvent eu pour cause la destruction due à la sottise, à la négligence ou à l'ignorance des moyens préservateurs.

Je doute que nos descendants, dans deux siècles d'ici, supposé qu'ils aient hérité de l'estime que notre génération accorde à ces souvenirs du passé, puissent s'exempter de restaurer la plupart des livres, gravures ou lithographies sortis de nos presses depuis 1825. A partir environ de cette époque, nos papiers cotonneux, blanchis au chlore et fabriqués à l'aune, offrent en général peu de chances de durée. Parmi nos estampes, celles tirées sur papier dit *de Chine* survivront presque seules; encore ce papier n'est-il pas toujours de bonne qualité. Les amateurs de l'avenir devront en transporter les épreuves sur un fond plus consistant. Il est à croire, au reste, que le papier reprendra tôt ou tard sa solidité primitive. Depuis quelques années, nos éditeurs de livres sérieux (tels que MM. P. Jannet, Aubry et au-

tres) ont senti la nécessité d'employer des papiers vergés d'une pâte nerveuse et capable de braver le temps.

Je souhaite que mes conseils au sujet des vieilles estampes aient assez d'influence pour contribuer à la conservation, pendant une durée de quelques siècles, de celles, gravées de nos jours, qui auront échappé en petit nombre à la destruction.

L'excellence du papier est donc la condition principale; mais il en est une seconde tout aussi importante. Règle générale : les livres et les estampes doivent être conservés dans des salles toujours sèches et modérément chauffées. L'humidité moisit les papiers; l'excès de chaleur favorise le développement des vers qui s'attachent aux livres, et dont les germes sont sans doute déposés dans les colles et les peaux des reliures. C'est un fléau que n'ont pas à redouter les estampes, non réunies en recueils reliés, mais simplement conservées au moyen de l'encadrement et des portefeuilles.

Encadrement. — J'ai peu de chose à dire de l'encadrement. C'est un art industriel très répandu et perfectionné, du moins quant à

l'apparence extérieure. Les moindres vitriers savent tendre les gravures par le procédé dit *collage à l'anglaise*, consistant à en rabattre les bords au verso du carton. (Voyez p. 160.)

L'emploi, dans l'encadrement, d'un carton bien fabriqué, est, à mon avis, la condition essentielle. La saleté du carton contribue sans aucun doute à la détérioration des estampes, surtout lorsqu'il est en contact avec leur verso et sous l'influence d'une atmosphère humide. Le carton de pâte, le seul à peu près qu'on emploie pour l'encadrement comme pour la reliure, contient souvent des débris de chiffons de toutes couleurs et des parcelles de fer oxydé auxquelles sont dues en partie ces taches roussâtres (signalées page 87), si difficiles quelquefois à enlever. On devrait faire usage dans l'encadrement d'un carton imperméable, ou tout au moins interposer entre sa surface et l'estampe une feuille de nature soit résineuse, soit métallique. Les jours qui existent entre l'intérieur du cadre et le carton devraient être recouverts d'un papier pareillement imperméable ou d'une feuille d'étain. Les bandes légères qui relient la vitre à la feuil-

lure du cadre exigeraient les mêmes conditions.

Une estampe bien sèche, qu'on aurait ainsi emboîtée par un temps également sec, n'aurait plus rien à redouter de l'influence de l'air; mais, en dépit de tous ces soins, un autre ennemi conspirerait encore, sinon à sa perte, du moins à l'altération des traits du burin : le soleil, la lumière diffuse même, finit, dit-on, par détériorer, par faire tourner au gris, le noir si éclatant de l'encre d'impression. Je n'ai jamais vu prendre nulle part la précaution de construire, pour les estampes de haut prix, des cadres à vantaux dans le genre des anciens triptyques. Si le fait de l'altération est bien positif (je n'en sais rien par ma propre expérience), et si l'administration de la Bibliothèque impériale en est convaincue, ce système fort simple pourrait être, à peu de frais, appliqué à la conservation des chefs-d'œuvre de maîtres actuellement exposés sous cadres; on n'ouvrirait les vantaux que les deux jours publics de la semaine.

Je dirai en passant que les cadres de bois dorés se nettoient au moyen d'une éponge

très douce qu'on promène avec rapidité et à grande eau, une seule fois, sur la dorure. On entraîne ainsi la poussière et une partie des fientes de mouches. Quant aux cadres de sapin, acajou ou palissandre, assez usités de nos jours, on les nettoie comme les meubles fabriqués des mêmes bois. On les décrasse au blanc d'Espagne, puis, quand ils sont bien secs, on les frotte avec un morceau de flanelle légèrement imbibé d'huile de lin cuite; ils recouvrent de cette manière tout leur lustre.

Collections et *Portefeuilles*. — Un véritable ami (ou, si l'on veut, amant) des belles estampes, sacrifiant la gloriole de les étaler à tous les yeux, les conserve en feuilles, à l'ombre, en lieu sec, dans des cartons dits à *serviettes*, posés à plat sur les tablettes d'une armoire vitrée; il les place, en un mot, dans toutes les conditions les plus favorables à une existence indéfinie.

La collection la mieux ordonnée que je connaisse est celle composée de pièces historiques de M. Hennin; il emploie pour les réparer la colle la plus pure, les liquides les moins violents; il ne passe pas son temps à leur don-

ner de fausses marges ; un papier fort et fabriqué exprès fournit tout à la fois à ses gravures des fonds de soutien et des simulacres de marges. Il les fixe *à charnières* sur le papier de support, c'est-à-dire que, sur un seul de leurs côtés, elles sont munies, de distance en distance, de petites pièces de forme carrée qui, collées à leur tour sur le fond, les maintiennent suffisamment et servent à prévenir la déchirure de l'estampe dans le cas où l'on voudrait la transposer.

Mon système diffère sur ce point de celui de M. Hennin. Je fixe légèrement à la gomme le bord supérieur de l'estampe dans toute sa longueur, et non par intervalles ; grâce à cette disposition on évite, quand on parcourt la collection, d'engager ses doigts entre l'estampe et le papier de soutien, ce qui occasionne souvent des déchirures.

Les gravures ainsi rattachées d'un seul côté à la feuille de soutien ne peuvent l'être convenablement que dans un sens ; qu'il y ait une seule ou plusieurs pièces appliquées sur le même fond, il faut que le bord de chacune d'elles pende librement et regarde le dos inté-

rieur du carton ; fixée d'une autre manière, une gravure s'affaisse ou se plisse, si le papier n'est pas très fort, toutes les fois qu'on feuillette le carton.

Les feuillets de soutien seront d'une force moyenne : trop faibles, ils se déforment ou supportent mal les estampes; trop épais, ils surchargent inutilement le recueil. Leur dimension doit être uniforme et un peu moins grande que celle du portefeuille. La tranche sera coupée nettement et à l'équerre. Quant à la couleur de la pâte, c'est une affaire de goût. Il est des amateurs qui préfèrent le gris ou le chocolat clair; d'autres, le jaune-bistre, qui se raccorde avec la teinte enfumée des anciens papiers. Pour mon compte, je choisis la teinte légèrement azurée ; il me semble qu'elle communique aux vieilles estampes plus de ton et de vigueur. En tout cas, quelque nuance qu'on adopte, on évitera celles trop foncées, qui forment un contraste choquant et de mauvais goût.

Chaque feuille de soutien doit être isolée complétement : une collection bien entendue n'est pas une suite de registres, mais un as-

semblage mobile de feuillets, qu'on a la faculté de grossir à volonté, de transposer, d'intercaler, d'extraire de leur rang, afin d'examiner les pièces à loisir.

Le papier joseph doit être exclu d'une collection; ce n'est qu'un chiffon toujours flottant, se roulant, se plissant de cent manières, qui ne conserve rien, pas même les dessins, surtout quand ils sont fixés. L'application de ce léger papier soyeux convient aux gravures intercalées dans un livre pour s'opposer au maculage; mais, quand le livre est relié depuis longtemps, le mieux est de le supprimer.

Ainsi, règle générale : les gravures fixées sur un feuillet de support isolé doivent, si l'on veut éviter le froissement et les déchirures, être libres du côté du fond du carton, de sorte que la charnière soit en sens inverse de celle d'un livre. Quant aux estampes qui, vu leur grande dimension, ne peuvent se conserver d'une seule pièce, on les pliera avec soin, observant que la partie libre soit pendante s'il est possible, et que les plis soient toujours intérieurs, c'est-à-dire formés du côté du recto, la méthode contraire n'aboutissant qu'à

user les tailles du burin à l'endroit plié.

Il est d'autres procédés qui conservent tout aussi bien les estampes, mais ils sont plus longs à mettre en pratique. Tantôt on les colle à la gomme et des quatre côtés sur un feuillet, tantôt on en engage, sans rien coller, les quatre coins (lorsqu'elle a beaucoup de marge) dans de petites fentes pratiquées au canif et obliquement sur la surface du papier de support.

Les collections de la Bibliothèque impériale, toujours exposées aux tentatives des pillards, sont autrement disposées. Les gravures sont souvent collées en plein, à la colle de pâte, sur un papier grisâtre fort épais et offrant une marge assez large pour préserver l'estampe de l'encrassement qui résulte d'un fréquent *feuilletage*. Ces collections sont reliées; c'est un inconvénient qui, malgré l'addition d'un assez grand nombre de feuillets d'attente, s'oppose à l'intercalation indéfinie de nouvelles pièces destinées à compléter les recueils; de sorte qu'il devient nécessaire, au bout d'un certain temps, de former des volumes supplémentaires. Ce système est peu com-

mode pour les recherches, mais on est forcé d'y recourir pour plusieurs raisons qu'il est aisé de comprendre.

Collage à jour. — Quelques amateurs fixent *à jour* (le plus souvent à la gomme ou à la colle à bouche) les dessins ou estampes sur les feuillets de soutien. Voici le procédé le plus simple : on tranche les bords de la pièce avec netteté et parallèlement au témoin (trace du cuivre), en lui conservant le plus de marge possible ; puis on l'applique sur le fond qu'on lui destine, bien au milieu. On trace alors sur ce fond, en suivant le contour de la pièce, une légère ligne avec une pointe ou un crayon ; ensuite on évide le feuillet de soutien selon cette ligne, mais ayant soin de laisser à l'intérieur du jour un excédant de papier d'environ deux millimètres. C'est cette portion ménagée en deçà du trait qui recevra les bords du verso de l'estampe.

Si l'on avait la patience d'amincir au grattoir la place où les papiers se superposent, le fond s'identifierait si bien à l'estampe qu'on le prendrait pour la marge naturelle, supposé que la teinte fût bien semblable.

Le collage à jour convient donc surtout aux estampes qui ont perdu leurs marges sous les ciseaux d'un Vandale avant d'arriver entre les mains de l'amateur. Je me garderais bien de donner le conseil de les rogner tant soit peu à dessein; n'oublions pas qu'une marge naturelle, pour les estampes comme aussi pour les livres, est une condition de leur haute valeur. Une estampe rognée en deçà de la trace du cuivre, à plus forte raison en deçà de la ligne de contour, perd beaucoup de son prix, parce qu'on peut supposer qu'elle est privée d'un texte intéressant, d'une signature d'artiste, ou enfin de remarques qui aident à constater l'état de l'épreuve et l'époque du tirage. Quelques iconophiles respectent jusqu'aux bavures qui la limitent. Ces bavures du papier (nommées aussi *témoins* par les bibliophiles) font les délices des amateurs d'éditions elzeviriennes.

Le collage *à jour* est surtout applicable au *remmargement* de feuillets de livres, quand on veut, par exemple, relier un in-12 avec un in-4, et obtenir une rognure de niveau égal. Je le mets aussi en pratique pour la conservation en recueil des gouaches anciennes sur vélin. Je les

fixe à jour sur un papier fort ou sur parchemin, mais en sens inverse, de telle sorte que ce soit le papier de soutien qui fasse saillie sur la gouache, en empiétant sur les bords de deux centimètres. Cette saillie lui forme une sorte de rempart protecteur contre le frottement, et la garantit du contact d'une vitre si elle est encadrée, de la pièce qui la précède si elle est conservée en portefeuille. Cette sorte de mince châssis peut être assimilée à ceux de carton dits *passe-partout*, usités en vue, je crois, du même avantage, dans l'encadrement.

A Vienne et à Munich, les estampes des collections qui font partie des bibliothèques publiques sont généralement collées en plein sur des cartons lisses, dont la surface est presque toujours ondulée, parce qu'ils sont formés de plusieurs feuilles ; mieux vaudrait un papier très fort et fabriqué d'un seul jet de pâte. Ces cartons sont renfermés dans des boites d'acajou, mode peu propice à la conservation des gravures, et surtout à la rapidité des recherches. Il faut une patience vraiment allemande pour trouver une pièce, à la condition de transvaser un à un tous ces cartons, puis de les re-

mettre en ordre avec exactitude. Un portefeuille bien conditionné est de beaucoup préférable, car des estampes qu'on remue évitent mieux le frottement dans la position verticale qu'à plat.

Portefeuilles, etc. — Un portefeuille pour estampes doit être formé d'un carton raide et peu épais, et ne contenir qu'un nombre limité de pièces; sinon elles se froissent, se déforment par le bas, se dépassent à l'envi les unes des autres, et ne peuvent aisément se remettre en place quand on les isole de la collection.

Les portefeuilles doivent être rangés à plat, chacun sur sa tablette, dans l'armoire qui les renferme. Il faut, pour les feuilleter à l'aise, les établir sur des chevalets qui s'entrebâillent sous un angle plus ou moins ouvert. On les garnira de *serviettes*, autrement dit de toiles d'un tissu serré, fixées sur trois côtés, et se repliant à l'intérieur du carton. Ces toiles, qu'on peut remplacer par des peaux plus ou moins riches, s'opposent à l'introduction de la poussière et des rayons lumineux tout aussi parfaitement, si elles sont bien ajustées et

bien rejointes entre elles, que les boîtes allemandes.

On a fabriqué aussi des portefeuilles formant boîtes, c'est-à-dire que les trois côtés de chaque plat sont munis, vers les bords, de bandes de carton ou de bois en retour d'équerre avec le plat. Ces bandes, destinées à recouvrir les tranches des estampes réunies, s'emboîtent, quand on ferme le portefeuille, les unes dans les autres. Voici l'inconvénient de ce système : les bandes supérieures (celles opposées au dos du portefeuille) empêchent de feuilleter aisément le recueil. Il faudrait qu'elles pussent se rabattre à l'intérieur à l'aide de charnières, mais cette disposition ôterait toute solidité à l'appareil.

Je vais décrire ici un meuble d'iconophile que j'ai, il y a quelques années, grossièrement fabriqué pour mon usage, et que je me promets de faire exécuter sur un modèle soigné par un habile ébéniste. Qu'on se figure un grand coffre rectiligne de la forme et à peu près de la dimension d'une commode, destiné à contenir et à préserver de la poussière cinq ou six immenses cartons placés debout et toujours

ouverts. Quand le dessus du meuble, fixé d'un côté par des charnières, est dressé contre le mur, on peut visiter ses cartons sur place, y chercher et en extraire telle pièce dont on a besoin.

Voici le perfectionnement que j'y ajouterai : pour permettre aux cartons de s'entrebâiller sous un angle plus large, le devant du coffre sera mobile; il jouera à sa base sur des charnières, et au sommet s'inclinera du côté du dehors au moyen de quarts de cercle en cuivre engagés dans les profils des faces latérales. Ce meuble, exécuté avec un certain luxe, contribuerait à la décoration d'un cabinet, et serait assurément apprécié des amateurs. Pour lui donner un certain cachet, je compte faire figurer sur le devant une pile factice de huit ou dix in-folios posés à plat et séparés par des profils simulés de tablettes. Sur les dos maroquinés on lira des titres indiquant la nature des pièces que contiennent les cartons placés verticalement à l'intérieur. Comme il est nécessaire que le fond du coffre soit assez exhaussé, afin que les cartons soient à portée de la main, on pourrait, dans le bas, établir un tiroir des-

tiné à serrer des atlas ou des recueils reliés.

Manière de rouler les estampes. — Un véritable iconophile doit songer à la conservation de ses estampes, dès le moment même qu'il entre en possession de nouvelles pièces. Quand il vient d'en faire l'acquisition, il est le plus souvent obligé de les rouler. C'est naturellement le verso de l'estampe qui doit former l'extérieur du rouleau ; mais s'il arrivait qu'elle fût contre-collée à plein ou seulement fixée par les coins sur un papier de support, dont on ne pourrait la détacher sans risquer des écorchures, on la roulerait en sens inverse : c'est le moyen d'éviter qu'elle ne se plisse. Il est essentiel, en ce dernier cas surtout, de couvrir le rouleau d'une *chemise* ou feuille d'enveloppe, qui le préserve de la transpiration de la main, et en prévienne la chute sur un pavé boueux.

Quand il s'agit de réunir plusieurs estampes de diverses dimensions, il faut les ranger d'un côté sur la même ligne, puis les rouler toutes à la fois ; elles s'enlacent les unes dans les autres, et aucune ne peut s'échapper. On se gardera d'ajouter isolément une ou plusieurs piè-

ces autour d'un rouleau déjà formé : car, à moins qu'on ne recouvre le tout d'un papier bien replié aux extrémités, on risquerait de perdre sans s'en apercevoir les estampes qui forment *noyau*.

XIII

**RESTAURATION ET RELIURE PROVISOIRE
DES LIVRES RARES.**

Ce chapitre intéressera principalement les bibliophiles de la province, qui, ne pouvant, éloignés qu'ils sont des grandes villes, avoir recours à un habile relieur, auraient à cœur de donner à un bouquin rare un certain air de fraîcheur et de dignité joint à une solidité conservatrice.

Tout ce qui concerne le blanchiment des feuillets, l'enlèvement des taches, etc., se trou-

ve décrit dans les chapitres qui précèdent. Il s'agit ici des livres à partir du moment où les feuillets décousus, isolés, détachés, restaurés et redressés au fer ou à la presse, exigent, pour reformer un volume, un assemblage nouveau.

Quand on voit sur table, dans les ventes publiques, un livre rare grossièrement cousu, ignoblement *embasané* et surtout fort mal rogné, je veux dire beaucoup trop ou tout de travers, il est permis d'affirmer qu'il a passé, à une certaine époque, entre les mains d'un papetier-cartonnier de province, ou encore d'un de nos relieurs parisiens de dernier ordre, qui s'est avisé d'affubler un monument typographique contemporain de Louis XII de manière à lui ôter les dix-neuf vingtièmes de son prix.

Je ne connais pas de vandales d'une espèce pire, plus commune et plus irresponsable, que les gâcheurs de livres en question. Mais on concevra bientôt comment ils sont poussés, en dépit quelquefois d'un bon goût naturel, à se livrer à de pareils ravages. On leur offre, après une discussion en règle, 75 centimes, plus ou moins, pour un travail qui, traité avec soin, devrait être payé, on en sera convaincu en li-

sant ce chapitre, huit à dix fois davantage. Aussi la punition obligée, inévitable, infligée à cette lésinerie, est-elle la dépréciation presque totale du livre à eux confié par un bibliophile bonhomme, qui, de gaieté de cœur, a condamné son vieil ami à une reliure de 75 centimes tout compris.

Le papetier-relieur de province, avec ses immondes cartonnages déjetés, recroquevillés, grimaçants sous une basane encore barbue et mouchetée de pâtés d'encre, forme le digne pendant du petit vitrier barbouilleur en dorures à qui un iconophile encore novice a confié naïvement la réparation d'un rare Albert Durer, et tous deux marchent de pair avec l'architecte mutilateur qu'une aveugle décision attache aux flancs d'une majestueuse cathédrale. Cette trinité redoutable, ennemie née des vieux souvenirs gravés sur pierre ou sur papier, en a gâché ou détruit, sans y mettre aucune malice, au moins les trois quarts. Puissent ces conseils tardifs sauver encore quelques débris !

Le plus irrémédiable des attentats que puisse commettre le relieur de petite ville,

c'est la rognure des marges. Un simple projet d'économie d'un centime sur la dimension de son carton lui donne l'idée de mutiler un charmant in-4° gothique jusqu'à la limite du cadre d'impression. Encore doit-on crier trois fois *Noël!* quand l'extrémité des lignes n'a pas été rasée sur quelques points. Ceux qui ont appris quelque part, ou deviné par instinct, qu'une marge est bonne à quelque chose, consentent à la conserver, mais la taillent avec une inégalité si choquante que la victime ne fait que tomber de Charybde en Scylla. Le plus grand mérite d'un livre rare est, sans contredit, une marge non rognée, ou, tout au moins, peu et très régulièrement rognée en tous sens. Mais, pour obtenir une heureuse régularité, il ne suffit pas de couper en masse les tranches à l'équerre; on peut, avec ce zèle pour la symétrie, enlever même jusqu'à des portions du texte. On conçoit, en effet, que le point essentiel, c'est de refaire, avant d'égaliser la tranche, le pliage de chaque feuillet; travail long, minutieux, qui ne doit pas se payer par centimes, mais par francs. Je m'occuperai bientôt de cette opération importante.

1° *Déreliure des bouquins.* — Je dirai d'abord, revenant un peu sur mes pas, qu'il suffit pour défaire un vieux livre de rejeter le carton au dehors, de couper avec soin les cordes horizontales qui servent de pivot à la charnière de chaque cahier. Le carton se sépare d'abord; on procède alors à l'isolement des cahiers. Comme on n'y peut parvenir à sec, sans avaries, on s'y prendra comme il suit : on coupera toutes les ficelles tendues le long du pli intérieur de chaque cahier, puis on mettra tremper pendant quelques heures le livre entier dans l'eau chaude, laquelle, dissolvant la colle-forte dont le dos est imprégné, rend l'opération de l'isolement bien plus facile. Le premier feuillet double marqué d'une lettre et formant la tête de chaque cahier est celui qui retient le plus de colle mêlée de débris de ficelle et de cuir; on doit l'en débarrasser avec soin (1). Celui-ci isolé, les autres se désuni-

(1) Quand il s'agit de disjoindre, pour les relier, les cahiers d'une brochure moderne, on ne prend pas toutes ces précautions, vu que le dos de chaque cahier n'est imprégné que d'une légère couche de colle de pâte.

ront sans peine, et, quand tous les feuillets seront séparés les uns des autres, on les plongera dans un nouveau bain froid pendant douze ou vingt-quatre heures.

Au sortir de l'eau, on ôtera, s'il en est besoin, les taches par les procédés indiqués aux chapitres IV, V et VI, puis on fera sécher chaque double feuillet sur une corde tendue; enfin, quand ils seront bien secs et redressés, on passera au travail suivant.

2° *Alignement et rognure des marges.* — Si toutes les lignes du texte avaient été disposées par l'imprimeur sur chaque côté des feuillets de manière à coïncider complétement, on arriverait à obtenir, par la rognure, des marges d'une parfaite symétrie; malheureusement, dans les anciennes éditions, les lignes du recto et celles du verso sont souvent loin de se correspondre avec une précision mathématique; c'est un défaut irréparable, qu'on nomme une *mauvaise retiration*. Cependant il faut équarrir les marges et leur donner le

En certain cas, néanmoins, on ferait bien de passer à l'eau chaude le premier feuillet double de chaque cahier.

plus de régularité possible. Les amateurs possèdent rarement une presse à rogner : tant mieux pour le livre; il ne s'en portera pas plus mal, tout au contraire. Supposons donc l'exemplaire passablement gâché, et cherchons un remède.

Etalons d'abord tous les feuillets doubles sous nos yeux et examinons-les l'un après l'autre. Nous trouverons que la plupart ont été rognés de travers relativement au cadre qui limite le texte. Telle page offrira, je suppose, une marge de tête de deux centimètres, tandis que celle du bas n'en aura qu'un et demi; ce qui produit un très mauvais effet, car la marge inférieure doit avoir plus de blanc que celle du haut. Cette inégalité déplorable exerce sur la ligne perpendiculaire des marges latérales dites *de gouttière* (1) une déviation si funeste, qu'une portion des notes marginales sera ici intacte, là, entamée.

(1) Ainsi nommées parce qu'elles aboutissent à la tranche longitudinale du livre, tranche qui affecte une forme cintrée, du moins quand le dos est arrondi. La marge opposée se nomme marge de fond.

Ces défauts si choquants n'empêcheront pas que la superficie totale du feuillet double ne puisse être trouvée taillée à l'équerre : il faut donc attribuer nécessairement l'irrégularité à l'opération du pliage, mal pratiquée dès le principe. C'est en effet par cette négligence originelle que pèche la reliure dans la plupart des vieux livres. Les feuilles sont, en général, de nos jours, pliées avec plus de soin.

Quelquefois aussi des feuillets pliés avec attention offrent des marges très mal équarries, parce qu'une presse à rogner dirigée par un idiot ou par une main trop pressée (en raison des 75 centimes qu'elle reçoit par volume) a donné à tout le livre la forme d'un quadrilatère irrégulier, au lieu de celle d'un rectangle parfait. Aussi pourquoi un bibliophile s'avise-t-il de glisser un précieux volume dans une fournée de paroissiens de pacotille qu'on gâche à la douzaine, moyennant 75 centimes, y compris le carton, la basane velue, l'or en feuille et le magnifique jaune-serin des tranches ?

Quand un livre rare a été traité avec un pareil sans-façon, il n'est plus possible de lui rendre une tournure supportable ; et, à moins

qu'il ne renferme un texte intéressant au plus haut degré, il sera toujours vendu à vil prix.

En examinant un à un les feuillets doubles, on finira, s'il y a vraiment encore un peu d'étoffe, par adopter, pour la dimension générale des marges, une sorte de moyen terme de rognure qui dissimule en partie cette difformité. Les marges trop rognées seront destinées, après la disparition des traces de la couleur plus ou moins éclatante qui, à travers la tranche, a bavé sur les bords (voyez le chapitre *Décoloriage*), à former retrait dans la masse du volume; celles qui dépassent la limite adoptée seront réduites suivant le projet d'alignement, mais on n'en retranchera que la portion strictement nécessaire. On pourrait même, si le livre est digne de tant de soins, élargir les marges des feuillets par trop mutilés au moyen de fragments d'un papier identique, s'il est possible, à celui du livre, pour la force, la teinte, le degré d'encollage et le sens des vergeures; et, s'il manquait du texte, on le rétablirait par le procédé indiqué page 168. En un mot, on prendra si bien ses mesures que la dimension moyenne des marges,

les unes élargies, les autres rognées, laisse encore au volume une apparence supportable.

Pour donner à chaque feuillet le plus de symétrie possible, on façonnera un patron, autrement dit un rectangle de carton coupé net à l'équerre, dans les proportions convenables. Ce carton sera mince, mais assez raide; on y pratiquera çà et là quelques découpures vers les bords, afin qu'appliqué sur le feuillet double, il laisse voir, de distance en distance, les limites du texte.

On pourrait aussi faire tailler un patron de verre, dont la transparence permettrait de juger mieux encore des distances à conserver sur chaque côté des marges. Un tracé horizontal sur le verre marquerait le niveau de la première ligne supérieure, celle qui sert de point de départ et détermine les lignes d'équarrissement des trois autres marges.

Le patron une fois taillé d'après une sage combinaison, on l'apposera successivement sur chaque feuillet double bien déployé. Le feuillet devra reposer sur un fond ferme et bien uni; puis on tracera autour du patron, tenu assujetti sur le feuillet, une ligne nette et fine,

au moyen d'une pointe métallique. Quand tous les feuillets auront reçu cette trace, on les rognera l'un après l'autre avec de longs ciseaux bien tranchants, en suivant le tracé avec précision, de sorte que leur réunion offrira une pile dont les côtés seront parfaitement nivelés. Je ne conseillerais pas d'opérer cette rognure au canif, même le mieux aiguisé, car les papiers fins et non encollés se plissent et s'écorchent, surtout aux endroits où la partie à supprimer est très étroite.

On comprend que, rognés ainsi, les feuillets doubles formeront, après avoir été pliés juste par leur axe central, une suite de pages à marges régulières ; aussi, quand on les feuilletera rapidement, l'œil ne pourra-t-il saisir aucun ressaut, au passage des chiffres de pagination. C'est ce *feuilletage* rapide qui indique de suite aux bibliophiles à quelle sorte de relieurs un bouquin a eu affaire ; c'est souvent ce simple examen qui les détermine à le couvrir de pièces d'or ou à le laisser adjuger à vil prix. La rognure soignée est, en effet, le point capital qui constitue la beauté d'un exemplaire. A une rognure manquée il n'y a point de remède, car

je n'indique ici qu'un simple palliatif. Et combien de malheureux livres gothiques ont subi cette honteuse, cette fatale mutilation! Combien d'in-4° ont été réduits à la dimension de l'in-8° ou même de l'in-12!

Le palliatif que je propose est, en réalité, le seul praticable; quant à l'irrégularité résultant d'une correspondance de texte inexacte (d'une mauvaise *retiration*), c'est, je le répète, un vice d'impression qui ne peut se rectifier, et les bibliophiles les plus intraitables sont bien obligés d'en accepter les conséquences.

Un livre ainsi rogné aux ciseaux, quelque soin qu'on y mette, n'offrira jamais une tranche unie comme celle due à une machine qui, tout à la fois, maintient en presse et opère la rognure; mais cette machine, pour bien fonctionner, doit, surtout quand il faut retrancher une portion de marge excessivement étroite, être parfaite et dirigée par un habile ouvrier. Voilà pourquoi j'en interdis l'usage.

Après tout, qu'importe cette sorte de rudesse dans la tranche? Une tranche bien unie, quand le volume est fermé, s'oppose assurément à

l'introduction de la poussière, comme à l'enfumage de l'extrémité des marges; mais qui empêche que le livre rogné aux ciseaux soit conservé dans un étui, à la manière des anciens paroissiens? D'ailleurs, une bibliothèque bien vitrée, exposée en un lieu sec, n'est-elle pas une tutelle bien suffisante? Pour moi, bibliophile sans prétention, je me contente d'aligner ainsi les marges, une tranche bien nette me semblant indispensable uniquement quand un volume est destiné, comme un dictionnaire, à un feuilletage continuel et rapide.

3° *Réparation des traces de coutures antérieures.* — Pour unir les cahiers, il faut que les feuillets déjà une ou deux fois recousus (ce cas est assez commun) n'offrent pas, à l'endroit du pli, une série de trous telle, qu'il en résulte une sorte de déchirure longitudinale. Il en est pourtant qui en sont réduits à cet état déplorable, notamment ceux en tête de chaque cahier. Ces avaries sont dues, en partie, à l'usage que faisaient les anciens relieurs d'aiguilles fort grossières, ou même de poinçons, pour percer les trous; aujourd'hui on emploie généralement des aiguilles fines et recourbées.

Si les anciens trous formaient, sur toute la ligne, une déchirure presque continue, les feuillets, une fois repliés, ne présenteraient à l'aiguille aucun point d'appui : il faut nécessairement remédier à cet obstacle. Une bande de papier fin et en même temps résistant, collée à la gomme sur la longueur du pli, est un moyen d'atteindre le but; mais, si tous les feuillets portent une semblable bande, qui doit se plier en deux, le dos du volume doublera presque d'épaisseur, tandis que le côté opposé restera flasque et sans compacité (1).

Commençons, avant tout, par plier exactement chaque feuillet : nous jugerons mieux quels sont ceux qui réclament une bande de renfort. Nous verrons d'abord que le repliage, en corrigeant l'inégalité de largeur des marges de fond, fait que les anciens trous ne se trouvent plus tous précisément dans l'axe du pli. Il arrive de là que, les fils pouvant passer par d'autres points, la couture va devenir plus pra-

(1) S'il s'agissait d'un livre rarissime, on pourrait essayer de réparer ces déchirures au moyen de pâte de papier. (Voyez p. 138.)

ticable. Néanmoins il y aura toujours plus d'un feuillet qui réclamera un nouveau point d'appui, parmi ceux principalement qui forment la tête de chaque cahier, surtout s'ils ont été décousus, isolés avec trop de précipitation, ou dépouillés, à l'état sec, des grumeaux de colle-forte. Les feuillets du centre, généralement moins fatigués, seront suffisamment maintenus par celui qui les renferme.

En supposant donc qu'on se borne à renforcer le premier feuillet, il en résultera toujours un peu plus d'épaisseur au dos que du côté de la tranche. Je ne sais si les habiles relieurs ont le talent de dissimuler ce défaut au moyen d'un battage adroitement ménagé ; pour moi, je ne connais qu'un palliatif, consistant à laisser au carton de recouvrement un peu plus d'épaisseur du côté de la *gouttière;* de cette manière le volume, posé à plat, paraît avoir une épaisseur homogène.

J'ai ouï parler d'une invention qu'on pourrait appliquer au cas où la totalité des feuillets serait à peu près divisée en deux par suite de coutures souvent renouvelées. Il consiste à rogner à la presse et de droit fil tous les cahiers

du côté du dos, comme s'il s'agissait de former, de ce côté, la tranche du livre. Les cahiers ainsi rasés au même niveau et maintenus en presse, on passe sur la tranche une couche de caoutchouc réduit à l'état visqueux par une huile essentielle que fournit le caoutchouc lui-même ; puis on recouvre cette sorte de colle d'une toile fine ou d'une peau très souple. Par malheur, ce procédé de reliure, signalé dans ma première édition, ne vaut rien, à ce qu'il paraît, car je n'en ai vu aucun produit figurer à l'Exposition universelle de 1855, et personne n'a pu m'en donner de nouvelles. On y a renoncé sans doute par cette raison que le caoutchouc ainsi appliqué perd promptement sa vertu élastique et agglutinative, en sorte que chaque feuillet finit par se détacher faute de soutien.

Aurons-nous recours au procédé chinois, qui consiste en une suite de points de couture, à fil redoublé, et plus ou moins espacés sur une partie de la marge de fond ? Ce genre de reliure, ne permettant au volume de s'ouvrir que sous un angle très resserré, n'est applicable qu'à des brochures minces et sans importance.

Une réparation plus longue, mais plus digne d'un volume rare réduit positivement à l'état de feuillets simples, consisterait à coller à jour (à la gomme), sur des cahiers d'un papier fort, chaque feuillet isolé, ainsi que je l'indique page 220.

4° *Couture ordinaire.* — La reliure des cahiers entre eux doit être exécutée avec une telle précision que nul ne dépasse l'autre en aucun sens. Rien de plus aisé que de coudre régulièrement un livre : c'est un travail de patience, et, avec un peu d'habitude, un volume de trente à quarante cahiers est assez promptement formé. Je ne sais s'il existe plusieurs procédés de couture. Celui que je vais expliquer me paraît simple et convenable pour obtenir une reliure provisoire et pourtant solide; je l'ai étudié uniquement par un examen attentif de la structure de plusieurs bouquins que j'ai disloqués.

L'appareil à coudre est si peu compliqué qu'il suffit de l'avoir entrevu une seule fois pour pouvoir en reproduire le modèle. Je décrirai celui que j'ai fabriqué pour mon propre usage.

Figurez-vous une caisse plate en sapin, dont le dessus a les proportions d'un tome in-folio, mais d'une dimension un peu plus grande en tous sens. Les flancs ou côtés ont au plus dix centimètres de hauteur. Cette caisse fort basse peut se passer de fond. A deux des encoignures s'élèvent, séparés par la longueur de la caisse, deux montants ou bandes de sapin, cloués à plat dans le profil du bois qui forme un des flancs longitudinaux, et chaque montant dépasse de vingt-cinq centimètres le dessus de cette boîte, que nous nommerons *plate-forme*. Les deux montants sont réunis par une traverse de chêne clouée sur la tranche de leur sommet; on a donc sous les yeux une sorte de châssis dressé verticalement, ou, si l'on préfère, le modèle en petit d'un support de balançoire. Vers la base du flanc longitudinal, que j'appellerai la face antérieure, on percera sur une même ligne une série de trous espacés d'un centimètre, destinés à recevoir des pitons à vis; sur le profil de la traverse on en percera d'autres en correspondance avec ceux du bas, et destinés au même usage.

Notre appareil est construit. Quand nous

aurons un volume à relier, jusqu'à l'in-folio inclusivement, nous visserons en haut et en bas 3, 4, 6 ou 8 pitons correspondants, espacés suivant l'exigence du format. Dans les pitons on passe une ficelle, et l'on en forme une sorte de lyre grossière. Ces ficelles, dont la tension doit être fort modérée, sont nommés nerfs ou *nervures;* elles sont destinées à servir de fiches, de broches, si l'on aime mieux, aux charnières de fil que nous attacherons à chaque feuillet du livre.

On peut sans grands frais se procurer un appareil moins embarrassant. Les montants et la traverse pourraient, soit s'abaisser comme l'anse mobile de certains paniers, soit se démonter et se placer dans un long tiroir établi sur l'un des côtés. On utiliserait ce tiroir en y rangeant les divers accessoires nécessaires à la couture.

La ficelle destinée à jouer le rôle de nervures doit être assez fine, à peine tordue et composé d'un chanvre neuf long et tenace. Au reste la ficelle commune est assez solide; l'essentiel est qu'elle soit d'un diamètre régulier. Chaque brin, vu la disposition des pitons infé-

rieurs, s'étendra, en bas comme en haut, au delà du dos du volume à relier. Cet excédant est destiné, quand les cordes seront coupées après la couture des cahiers, à rattacher au volume les deux cartons qui doivent en former la couverture.

Maintenant, supposons qu'il s'agit de relier un in-4° : on tendra six nervures espacées à peu près ainsi $\overline{\,.\,.\,}$ puis on placera sur la plate-forme tous les cahiers, superposés et bien alignés, les dos touchant les nervures. En tête du premier cahier et à la suite du dernier devront se trouver deux (ou au moins un) feuillets doubles d'un papier semblable ou à peu près à celui du livre : on comprendra bientôt l'utilité de ces feuillets supplémentaires.

La pile de cahiers ainsi disposée, et pressée par un poids assez lourd, on indiquera, sur l'ensemble des dos réunis, au moyen d'un trait de crayon vertical, l'endroit précis où passeront les nervures et où seront formées les charnières de fil de chaque cahier. Ce tracé fait, on retire le volume. On n'oubliera pas, s'il s'agit de recoudre un rare bouquin qui a déjà subi plusieurs reliures, de faire passer les

nervures, autant que possible, assez loin des anciens trous.

Les relieurs, en général, ne se contentent pas d'un trait de crayon; ils pratiquent, à l'aide d'une scie, une entaille ou rainure destinée à loger le nerf. Je préfère le laisser en dehors, à découvert; il tient fort peu de place quand le chanvre est peu tordu, et l'on évite ainsi de multiplier, de ce côté, des avaries, des plaies déjà très nombreuses. Dans la plupart des anciennes reliures, le nerf forme à l'extérieur une forte saillie ronde, ou encore est remplacé par une lanière de cuir assez large, dont l'emploi nécessite quelques modifications dans la couture; mais nous adopterons exclusivement la ficelle, afin de simplifier l'opération. D'ailleurs, il n'est ici question que de reliures à *dos brisé*.

Pour procéder à la couture, on place d'abord sur la plate-forme un ou deux feuillets doubles de papier blanc, qui serviront à former les *gardes*. Le dos de ce premier cahier sera appuyé contre les nervures au point marqué au crayon. Alors, on prendra une aiguille assez longue, fine et recourbée comme une alé-

ne (1), puis on y passera un fil souple, fin et tenace tout à la fois; trop gros, il épaissirait inutilement le dos des cahiers. La soie, qu'on emploie assez souvent, me semble une matière trop glissante et peu susceptible de se nouer solidement. L'aiguillée ne doit pas être trop courte, il faudrait la renouveler sans cesse; ni trop longue, le fil s'embrouillerait, se romprait, contracterait des nœuds. Voici, je crois, des dimensions convenables : pour l'in-18, l'aiguillée aura 5 fois la longueur du dos, environ 85 centimètres; pour l'in-folio, 3 fois, ou à peu près 115 centimètres; pour les formats intermédiaires la longueur variera entre ces deux mesures extrêmes.

Le premier cahier, celui dit de garde, doit être solidement rattaché aux nerfs : on enroulera donc le fil de couture autour de la première nervure, soit de droite, soit de gauche (le choix est indifférent), et, pour le mieux

(1) Avec un peu d'habitude, on réussit en se servant d'une aiguille droite ordinaire. Bien que je ne parle ici que de la couture du cahier de garde, mes conseils s'appliquent aux cahiers suivants, en général plus épais.

fixer, on engagera l'aiguille dans l'épaisseur de son diamètre; puis, passant la main gauche derrière l'appareil, on ouvrira le cahier à angle droit, ayant soin, surtout quand il s'agit d'un cahier épais, de ne laisser en dehors aucun feuillet double, car cette négligence coûterait plus tard beaucoup de temps à réparer.

Le cahier étant donc maintenu ouvert, on engage l'aiguille dans le dos extérieur, à l'endroit marqué au crayon, puis on la retire du côté du pli intérieur. Plus les cahiers sont fournis, comme dans l'in-18, plus aussi les feuillets sont sujets à se déranger, à perdre l'alignement, ou à échapper au passage de l'aiguille, qui, si elle est mal maintenue, ne sort pas toujours précisément dans l'axe du pli, mais quelquefois sur la marge de fond; ce qui occasionne des déchirures, ou tout au moins empêche le fil de prendre son point d'appui. On pourrait percer d'avance les trous; mais comme ils seraient sujets à dévier de leur direction par le dérangement des feuillets, au moment où l'on ouvre le cahier, le mieux est d'engager et de retirer l'aiguille par voie de tâtonnement; avec un peu d'habitude on arrive

à la diriger bien et vite, sans être obligé d'en surveiller sans cesse la sortie à l'intérieur du pli. A la rigueur, on disposerait derrière l'appareil un miroir qui refléterait les évolutions de l'aiguille ; mais, je le répète, le procédé le plus expéditif s'acquiert par l'exercice.

Quand l'aiguille a traversé avec précision le pli intérieur, on en ramène la pointe, par un mouvement que règle la routine, vis-à-vis de la seconde nervure, puis on perce le papier. Quelquefois la pointe vient s'engager au milieu du nerf, ce qui n'offre aucun inconvénient pour le premier cahier, qui doit être solidement fixé ; mais, pour opérer sur les autres avec régularité, et se ménager la possibilité de les serrer plus tard, il faut que la pointe ne fasse qu'effleurer le nerf, sans le transpercer. Alors on tire sur le fil avec assez de force pour qu'il s'applique bien à l'espèce de rigole intérieure que forme le pli ; on l'y maintient de la main gauche, tandis que de la droite, après l'avoir enroulé autour de la nervure, on le repasse dans le même trou, ou du moins sur un point très voisin. L'essentiel c'est que l'aiguille ne traverse jamais le fil même qu'elle dirige,

car en ce cas elle ne pourrait plus avancer. En général il faut allonger droit et vivement l'aiguillée; sinon elle s'embarrasse dans ses propres spirales, il se forme des nœuds compliqués, et l'on perd beaucoup de temps à débrouiller ce chaos (1).

On continue de la même manière, et, lorsqu'on atteint la dernière nervure, on y enroule le fil, qu'on fait passer à travers le nerf (il s'agit ici des feuillets de garde), puis on l'arrête au moyen d'un nœud, précaution à observer quand on arrive à l'une ou l'autre extrémité de chaque cahier; mais ces nœuds doivent être peu serrés.

Les feuillets de garde cousus, on met sur la plate-forme le dernier cahier du volume (car on finit nécessairement par le titre), et on le relie de la même manière à la nervure, sauf qu'on commence par l'extrémité opposée relativement à la première opération, et ainsi de suite jusqu'à la couture totale. Avant de coudre un nou-

(1) Pour l'éviter, on est quelquefois obligé, surtout quand l'aiguillée est longue, de quitter le cahier, et d'interposer la main gauche entre les circonvolutions du fil qui revient sur lui-même.

veau cahier, on doit s'assurer si chaque feuillet est à sa place, si la lettre de chaque cahier est bien à son rang, car, le volume une fois cousu, on ne peut remédier à cette transposition qu'à condition de tout refaire. Un cahier oublié peut, à la rigueur, s'intercaler, pourvu que le dos du volume ne soit pas encore consolidé par une couche de colle-forte. Quant à quelques feuillets transposés dans un livre relié, il est possible de les remettre à leur place; j'en ai indiqué les moyens page 76. Lorsqu'on a affaire à un livre orné de vignettes ou de cartes, il faut songer, avant la couture, à les incorporer aux cahiers auxquels elles se rapportent, afin de coudre le tout à la fois.

Quand une aiguillée tire à sa fin, on la fixe solidement autour de l'un des nerfs; on rattache la nouvelle, soit au nerf, soit au bout qui dépasse celle qui précède, ayant soin que le nœud tienne bien et soit extérieur. Il est important de vérifier si les cahiers se relient à la nervure tous au même point; s'il arrivait que la trace de crayon fût effacée, il serait toujours facile de les superposer exactement à vue d'œil et de les maintenir dans cette position.

Lorsque tous les cahiers sont cousus, on les presse les uns contre les autres, on rapproche leurs charnières et l'on serre les nœuds qui attachent le dernier (le cahier de garde); puis l'on coupe les nervures, d'une part au niveau des pitons inférieurs, de l'autre au-dessus du livre, à une distance telle, qu'il reste cinq ou six centimètres de nervure excédante (1). Cette pile de cahiers ainsi réunis n'offre pas encore un tout solide : les charnières sont lâches, surtout vers le centre; les fils ont trop de jeu, l'ensemble n'est pas assez compact. On transportera le volume en cet état sur une table, qui le recevra à plat, de manière que le dos en dépasse le bord de deux millimètres; puis on alignera de nouveau les cahiers en tous sens, et l'on y superposera une planchette chargée d'un poids le

(1) Au lieu de couper de suite les nervures, quelquefois on les utilise, si l'espace le permet, pour la couture d'un second volume; mais, entre cette nouvelle pile de cahiers et celle déjà cousue, on devra placer plusieurs ais, d'une épaisseur collective d'au moins dix centimètres, afin qu'il reste à chaque volume des bouts de nervure suffisants pour y rattacher les cartons.

plus lourd possible, et appuyant sur toute la surface. Si l'on possédait une presse à vis, on pourrait l'utiliser en cette occasion.

Le volume ainsi bien comprimé, on applique sur le dos des cahiers une couche de colle-forte (Voyez la note page 184) assez épaisse pour ne pas pénétrer le papier. On remplit ordinairement de colle les intervalles ou sillons qui existent entre chaque cahier ; mais, pour ne pas accumuler la matière gélatineuse, qui peut dans l'avenir favoriser la production des vers, il vaut mieux remplir ces vides avec des brins de filasse et les bouts de fils qui dépassent.

Quelques relieurs ajoutent, dit-on, à leur colle, pour prévenir les vers, une pincée d'oxyde blanc d'arsenic, ou de tout autre poison énergique. Je ne sais si cette substance produit l'effet qu'on en attend; peut-être, mêlée à la colle, lui ôte-t-elle un peu de sa ténacité. Du reste, les vers ne s'attaquent guère qu'à des livres accumulés dans un local humide et abandonné.

Pour mieux encore rattacher entre eux tous les cahiers, on appliquera tout aussitôt sur la colle une toile fine ou une peau souple; puis, sans rien déranger, on laissera sécher, pendant

24 ou 48 heures, le volume sous une presse à vis, si l'on en possède une, ou simplement sous un ais chargé de poids.

5° *Cartonnage et parcheminage.* — Pour achever cette reliure sans prétention, on taillera deux cartons (nommés plats) de moyenne épaisseur, qui déborderont un peu les trois tranches du volume ; on amincira à la lime et l'on battra au marteau le côté qui doit se rattacher aux nervures, mais on laissera aux bords opposés toute leur épaisseur. Le renforcement des plats, du côté de la gouttière, peut même passer pour une compensation nécessaire dans le cas où le dos du volume serait épaissi par des bandes de soutien appliquées sur les plis de nombreux feuillets.

Pour relier les nervures aux plats, on les y engage, de telle sorte qu'introduites par l'orifice extérieur de trous pratiqués dans le carton (à un centimètre environ du bord), elles ressortent du côté opposé, celui qui touche la garde. C'est sur la face intérieure du plat qu'on rabattra l'excédant de nervure ; on l'éparpillera sur le carton, imprégné, à cet endroit, d'un peu de colle-forte. Cet éparpillement évite une trop

forte saillie, et fixe plus solidement l'extrémité du nerf, puisqu'il s'étend en éventail sur une plus grande surface. On évitera d'étirer trop la nervure, et d'encoller la partie qui, destinée à former charnière, doit conserver sa souplesse. On passe quelquefois le nerf en sens inverse, c'est-à-dire de l'intérieur du carton au recto, où on le fixe, à moins qu'on ne le fasse rentrer à l'intérieur par le second trou. La première méthode est plus simple, et laisse, je crois, au livre relié plus de facilité à s'ouvrir. Quelque procédé qu'on adopte, on devra aplatir au marteau le bourrelet formé autour du trou ; on consolide ainsi le point d'attache, et l'on aplanit la surface du plat. Au reste, malgré tous ces soins, nos livres n'auront jamais cette flexibilité parfaite qui est le cachet des bons relieurs.

Comme ces reliures provisoires n'ont rien à démêler avec le luxe, je ne parlerai pas ici de l'art d'amincir (1), d'appliquer et de dorer les

(1) C'est un contre-sens, à mon avis, d'amincir les peaux précisément à l'endroit où la reliure fatigue le plus : conséquence du goût des bibliophiles, qui préfèrent en général l'élégance à la solidité.

maroquins. Cette dernière opération exige, pour être bien exécutée, une sorte de talent artistique. Je me contente, en attendant que la fantaisie me vienne de faire revêtir mon livre plus richement, de dissimuler le carton sous une simple toile brune assez fine, sous un vieux parchemin plus ou moins épais, ou enfin (c'est là mon plus grand luxe) sous une soie mince et souple, moirée, ou émaillée de dessins aux vives couleurs, telles qu'en fournissent les reliures chinoises. Mais le plus souvent c'est de parchemin que je me sers, puisque je recherche la solidité avant tout : c'est donc par la manière de l'appliquer que je terminerai ce chapitre.

La feuille de parchemin, d'une dimension en rapport avec celle des plats, plus celle du dos, excédera la surface totale, en tous sens, d'au moins deux centimètres; un tracé au crayon indiquera la place précise que doit occuper chaque partie du volume. On donnera au parchemin, en l'exposant à la vapeur d'eau, ou autrement, une moiteur telle, qu'il ne puisse, en séchant, se rétrécir à l'excès, mais contracte assez de flexibilité pour se replier sans

peine. Il ne doit pas adhérer aux nervures du dos, mais à une mince bande de carton qui les couvre sans y être collée, et forme un *dos brisé* (1). Cette bande aura en largeur l'épaisseur du livre ; on la reliera aux plats au moyen de papier joseph. Il serait bon de la doubler d'avance, à l'intérieur, d'un papier fort et collé à l'état humide ; on compenserait ainsi la traction que le parchemin doit exercer quand il sera sec sur le dos à l'extérieur. On étalera ensuite sur la bande une couche de colle forte convenablement fluide ; et, dirigé par la ligne de crayon, on placera le dos du volume au milieu du parchemin étendu ; puis, on encollera successivement l'un et l'autre plat, qu'on appliquera sur la peau. Alors, fermant le livre, on effacera avec la paume de la main les rides et les boursouflures produites par des bulles d'air, en même temps qu'on étirera modérément

(1) Il n'est pas ici question des dos bombés, qui se façonnent avec une pièce de bois concave, opération qui entraîne la forme en *gouttière* de la tranche longitudinale du livre. On ne donne cette forme en général qu'aux volumes rognés à la presse ; ils n'en sont que plus solides.

la peau vers les bords. Cette opération achevée, on mettra de la colle sur les bords intérieurs du carton, du côté de la gouttière, et l'on rabattra les portions excédantes du parchemin, qui s'y fixeront.

Tout aussitôt, après avoir au besoin remouillé la peau, on la repliera sur le verso des plats, du côté des haute et basse marges, et tout à la fois, à l'intérieur du dos brisé, mais là avec certaines précautions nécessitées par la disposition de cette partie du livre. La colle forte ne saurait s'étendre régulièrement à l'intérieur de la bande : le mieux serait peut-être de s'en passer. En même temps qu'on rabattra le parchemin sur les plats, bien encollés d'avance, on engagera entre le dos du livre et le dos brisé la portion de peau qui doit s'y loger, et qui, on le conçoit, ne peut dépasser la première nervure ; on la raccourcirait si elle était trop longue.

Dans ma première édition, je conseillais de pratiquer des entailles dans le parchemin, à l'endroit où le dos forme équerre avec les plats quand le volume est fermé ; aujourd'hui, je supprime ces entailles. On se donnera un peu

plus de peine, mais la reliure aura plus d'ensemble et de solidité.

On pourra, tandis que le parchemin est encore moite, former une sorte de bourrelet, destiné à protéger le dos brisé contre la poussière. Ce bourrelet, nommé *coiffe*, servait, dans les vieilles reliures en vélin, à recouvrir la tranchefile, à laquelle se rattache le signet; il était formé quelquefois à l'aide d'un bout de corde sur lequel on le moulait.

On s'occupera ensuite de façonner les coins. On leur donnera plus de tournure et de régularité au moyen de quelques taillades dont la pratique indiquera l'opportunité. Du reste, pour compléter ces explications, je n'ai rien de mieux à faire que de renvoyer l'amateur à l'inspection d'un bouquin bien parcheminé. Le point essentiel à observer dans toutes ces opérations successives, c'est de conserver au parchemin un état de moiteur, de souplesse convenable, et de le remanier jusqu'à ce qu'il adhère bien partout et recouvre le carton sans grimacer sur aucun point. On s'arrangera, bien entendu, pour l'appliquer de telle sorte que sa surface la plus unie et la plus luisante, celle dite la

fleur ou côté du poil, soit exposée aux regards.

Pour terminer, on humectera les feuillets de garde contigus aux plats, de manière que le papier se dilate bien (1), et après en avoir imprégné de colle de pâte toute la surface, on les fera adhérer au carton; ils cacheront ainsi la limite des replis du parchemin, et exerceront une tension intérieure qui contrebalancera celle du dehors.

Si l'on craignait que cette tension fût insuffisante, on pourrait, avant de coller les gardes, appliquer sur le carton, à la colle forte, un carré du même parchemin (préalablement humecté): il en résulterait qu'au sortir de la presse, l'équilibre étant rétabli, la couverture ne grimacerait en aucune façon (2).

Le collage des gardes terminé, on laisse sé-

(1) Ces feuillets seront un peu plus courts sur les trois sens que ceux du livre, sinon, vu l'effet de la dilatation, ils dépasseraient le niveau des tranches.

(2) Je crois que les anciens relieurs ne collaient les gardes que plus tard, quand le parchemin et les plats étaient bien secs; c'est peut-être la méthode la plus convenable. Le parfait collage des gardes est une opération difficile dans les reliures soignées.

cher aux trois quarts le volume entrebâillé et placé debout. Une heure après, les plats seront déjetés, généralement en dehors; pour les redresser on mettra le volume soit sous la vis d'une presse, soit entre deux ais de bois serrés par un poids de dix à douze kilogrammes. Dès le lendemain, si la température est favorable, on retirera son volume bien sec, bien aplati et assez bien tourné, en attendant une reliure plus savante. En tête du dos brisé on inscrira le titre (sur un fond de teinte carminée, si l'on tient à le mieux faire ressortir); au bas, on ajoutera la date de l'édition.

On voit des bouquins parcheminés à sec; ce sont, en réalité, des brochures de l'ancien temps. En ce cas, le carton est très mince, ainsi que la couverture, dont les plis sont façonnés, je le suppose, sans le secours de l'humidité. Le tout est rattaché au corps du livre par des cordonnets de parchemin, qui sont les nervures mêmes. La garde seule est collée; le livre se ferme au moyen de cordons de cuir souple. Quelquefois la peau, repliée en retour d'équerre, couvre les tranches. Tous les bibliophiles ont vu ou possèdent des échantillons

de ce genre de reliure provisoire : il leur suffira de les examiner quelque temps pour les comprendre; mais en imiter le solide *négligé* n'est pas chose facile.

Il existe aussi des reliures des XVI° et XVII° siècles, formées d'un parchemin très épais, tantôt lisse comme la porcelaine, tantôt rugueux comme la peau de truie, qui peut-être en est la base. Cette sorte de cuir corné unit la souplesse à la solidité, et l'on se demande comment on parvenait à maîtriser à ce point une matière si rebelle. Ces reliures, particulièrement exécutées en Hollande, sont celles de toutes qui ont le mieux résisté au temps et à l'usure. Ma reliure provisoire est bien mesquine, comparée à un tel modèle, dont les échantillons sont aujourd'hui recherchés; néanmoins, elle pourra braver encore des siècles, surtout si l'on y ajoute un étui ; et, comme les marges auront été rognées régulièrement et le moins possible, il sera toujours temps plus tard de porter le volume au Bauzonnet de l'époque, qui, s'il y a vraiment assez d'étoffe, pourra le remanier et en faire un *bijou* de bibliothèque.

On a plus d'une fois essayé de remplacer, dans la reliure, les peaux et le carton; on a substitué au cuir et au parchemin la toile, la soie et le velours; au carton, le bois, l'ivoire, la corne, etc. J'ai souvenance d'avoir vu, vers 1825, des livres revêtus, cuirassés, si l'on préfère, sur le dos et sur les plats, de feuilles de ferblanc, moirées à l'aide d'un acide, puis peintes et vernies, le tout ajusté, je crois, au moyen de fils de fer ou de laiton. Cette disgracieuse quincaillerie, qui promettait aux livres une sorte d'immortalité (matérielle), n'a pas obtenu le moindre succès, vu qu'elle leur donnait la tournure vulgaire d'une boîte à serrer des allumettes.

De nos jours on couvre les paroissiens de luxe et les livres de mariage d'épaisses plaques d'ivoire sculptées en relief, du moins d'un côté; les bibliophiles se garderaient bien de placer ces rugueuses carapaces côte à côte avec leurs précieux maroquins, dont elles écorcheraient les surfaces, où l'or pétille en capricieuses arabesques.

Peut-être un jour tirera-t-on parti pour la reliure du caoutchouc ou du gutta-percha,

deux matières sujettes à se ramollir et à se déformer sous l'influence d'une chaleur peu intense. Il est à espérer qu'un industriel parviendra à les incorporer à une composition qui en retiendra les qualités précieuses : la souplesse et la résistance au frottement.

Je signalerai, p. 277, quelques ouvrages sur la reliure bons à consulter. J'y renvoie le lecteur, et je termine cet *essai* en renouvelant le souhait (déjà exprimé dans ma préface) qu'un praticien plus éclairé que moi, qu'un savant complet, et non pas un tiers de savant comme je le suis, entreprenne, sur le sujet que je viens de traiter tant bien que mal, un travail bien supérieur au mien, surtout sous le rapport important des questions chimiques.

NOTE

SUR L'EMPLOI ET LES PRIX DES SUBSTANCES CHIMIQUES INDIQUÉES.

Dans la crainte que mes efforts pour conserver les estampes n'aboutissent trop souvent à leur perte, vu le grand nombre d'amateurs peu familiarisés avec les manipulations chimiques, je crois devoir renouveler ici des observations faites çà et là dans le cours du présent ouvrage.

On ne saurait employer les substances chimiques avec trop de circonspection, si l'on veut éviter tout danger pour soi-même aussi bien que pour les estampes. On aura une chambre spécialement réservée pour ces sortes d'opérations; une cuisine peut, au besoin, servir de laboratoire. On fera usage, sans précipita-

tion, des acides et des alcalis puissants; une seule goutte de ces liquides corrosifs qui atteindrait l'œil de l'opérateur occasionnerait une douleur des plus vives et peut-être la perte de cet organe. Les acides sulfurique, chlorhydrique, azotique et autres, dépolissent avec énergie le marbre et la plupart des métaux usuels, carbonisent le bois, décolorent et désorganisent les étoffes de soie, de laine, de toile et de coton. La potasse et l'ammoniaque attaquent les vernis et beaucoup de matières animales ou végétales, et décomposent un grand nombre de couleurs. Le chlore à l'état de gaz ou de solution, ainsi que les chlorures alcalins, produisent des effets analogues. L'alcool, les éthers et les huiles essentielles offrent des risques d'incendie si on les chauffe sans précautions. Il faut se méfier des exhalaisons de presque toutes ces substances, et s'exposer le moins longtemps possible à celles du chlore, de la térébenthine, de l'ammoniaque, de l'acide sulfureux et de la benzine.

Passons au danger que courent les estampes. Les acides faibles et d'une sapidité supportable, extraits des végétaux, comme le vinaigre, le jus de citron, etc., n'altèrent pas sensiblement, même à chaud, le papier ni le noir d'impression (1); mais les acides énergiques cités ci-dessus, à l'état trop concentré, désorganisent promptement les papiers et les parchemins; il faut

(1) Il y a exception pour l'acide oxalique, qu'on extrait de l'oseille. (*Voyez la note de la page* 74.)

DES SUBSTANCES CHIMIQUES INDIQUÉES. 269

donc les employer mêlés à une quantité d'eau plus ou moins considérable, suivant les circonstances, les faire agir le moins de temps possible, et soumettre à un lavage prolongé les estampes qui en ont été imprégnées. Les alcalis purs exercent également des ravages fâcheux, surtout sur le noir d'impression; on s'en servira donc avec beaucoup de réserve.

Au reste, je le répète, les effets des acides et des alcalis se neutralisent réciproquement. Une goutte d'acide versée sur du papier ou sur une étoffe ne causera qu'un léger dommage si on peut la couvrir sur-le-champ d'une goutte d'ammoniaque, qui se combine avec elle et en arrête l'action délétère. Quand le remède n'est pas sous la main, une aspersion d'eau pure atténue un peu le danger, mais ne l'annule pas. Les sels alcalins, tels que les carbonates de soude, etc., préviennent aussi le dégât produit par les acides violents; en certains cas même on devra les employer de préférence aux alcalis purs.

Pour se procurer les substances que j'indique à l'état de pureté (condition essentielle, mais difficile à obtenir dans les petites villes), on s'adressera aux premiers fabricants de produits chimiques : c'est un conseil d'économie. Les pharmaciens les débitent sans doute à l'état de pureté, mais en général bien au-dessus des prix courants. Quant aux marchands de couleurs en bâtiments, ils vendent de l'essence, des acides, des alcalis, etc., fort convenables pour les diverses industries auxquelles ces produits s'adressent; mais, pour nous, ces substances seront ou trop faibles, et agiront

imparfaitement, ou pas assez purifiées, et déposeront souvent sur nos estampes de nouvelles taches, au lieu d'enlever celles qui les maculent.

Je conseille de prendre les acides à un état assez concentré, sans l'être au dernier degré, car ils deviendraient trop dangereux à manier, et coûteraient beaucoup plus cher, sans utilité pour l'usage auquel nous les destinons; l'essentiel, c'est qu'ils soient tout à fait exempts de matières étrangères. Même remarque au sujet des alcalis et des sels alcalins. On les mêlera à tel ou tel volume d'eau, par quantités progressives, jusqu'à ce qu'ils produisent l'effet désiré.

Les flacons doivent être fermés de bouchons de verre usés à l'émeri. Le liége, en bien des cas, s'altère vite ou s'oppose mal à l'évaporation; il suffit cependant quand il s'agit de matières nullement volatiles, telles que les solutions d'alun, de potasse, etc.

On peut quelquefois mettre en réserve pour une autre occasion des liquides qui ont agi peu de temps, par exemple l'eau acidulée, l'alcool, les solutions alcalines, etc.; mais, quand il s'agit de restaurer une estampe capitale, il vaut mieux, négligeant l'économie, employer des substances qui n'aient jamais servi.

Je vais ici, comme dans la première édition, donner un aperçu des prix-courants (à l'époque de février 1858) des substances chimiques les plus usuelles dont il a été question dans cet ouvrage. Je citerai le tarif de la maison des frères Rousseau (rue de l'Ecole-de-Médecine), connue pour la perfection de ses produits. Toutefois mon but n'est pas de faire de la réclame industrielle;

je ne prétends pas imposer au lecteur ma confiance personnelle, et je suis loin de nier qu'il existe d'autres maisons aussi recommandables. J'inscris ici la valeur de chaque substance par *kilogramme*, mais en faisant observer, après information prise, que toute fraction de ce poids, même fort minime, est à un taux proportionnel à l'unité. Ainsi cent grammes d'acide oxalique, acide coté 5 fr. le kilo, coûteront 50 c. Les substances ci-dessous indiquées sont purgées de toute matière étrangère, mais non toujours à l'état maximum de concentration, état qui entraînerait souvent des prix beaucoup plus élevés, sans nous offrir des avantages proportionnés à ce prix.

	fr. c.
Acide *chlorhydrique* (autrefois dit *muriatique*, esprit de sel, et, il y a encore quelques années, *hydrochlorique*).	2 50
— *azotique* (eau-forte du commerce, ci-devant *nitrique*, esprit de nitre).	2 50
— *sulfurique* (huile de vitriol du commerce).	2 50
— *sulfureux*, liquide.	1 50
— *oxalique* (en cristaux blancs).	5 »
(Le sel d'oseille ou *bioxalate de potasse* vaut le même prix.)	
— *gallique* (cristaux jaunâtres en forme d'aiguilles soyeuses).	35 »
(Le prix de cet acide est élevé, mais il est à noter qu'il est d'une légèreté excessive.)	
Chlore dissous dans l'eau.	1 »
Chlorure de chaux en poudre (ordinaire).	1 »

	fr.	c.
Potasse caustique préparée à la chaux. . .	4	»
(Préparée à l'alcool, elle coûte 25 fr. Celle que j'indique peut suffire.)		
Ammoniaque (ou alcali volatil).	3	»
Ether sulfurique rectifié.	7	»
Alcool à 40°.	4	»
Essence de térébenthine.	2	»
Benzine.	4	»
Alun.	»	50
Carbonate de soude.	»	50

Eau oxygénée (bioxyde d'hydrogène). — Cette substance ne se trouve pas toute préparée. Dans le *supplément* à ma 1re édition, j'ai, par malentendu, annoncé le prix de ce liquide à raison de 5 à 8 fr. le litre, suivant le degré de saturation. Au tarif actuel il coûte 5 fr. les *cent grammes*.

Toutes les autres substances indiquées, telles que l'eau de Javelle, les colles gélatineuses, l'amidon, etc., se trouvent à l'état convenable chez les marchands de couleurs.

LISTE

D'OUVRAGES A CONSULTER

(Non compris les Traités généraux de Chimie)

1732. — *Dictionnaire économique*, par Noël Chomel ; 2 vol. in-fol. — On indique dans cet ouvrage des procédés pour ôter les taches sur les livres ou estampes, procédés à mon avis peu efficaces, et souvent absurdes : en 1732, la chimie n'existait pas.

1751. — *Catalogue des Estampes gravées d'après Rubens..... avec un secret pour blanchir les Estampes et en ôter les taches d'huile*, par R. Hecquet, graveur. Paris, in-12. Dans un appendice de 89 lignes, qui précède le Privilége, l'auteur nous révèle ce secret, con-

sistant dans l'emploi de l'eau bouillante combiné avec l'action des rayons solaires. Il prétend avoir, par son procédé, assez analogue à celui décrit p. 59, effacé sur une estampe, au bout de huit jours, une tache *invétérée*, provenant d'huile à l'usage des peintres.

1779. — *Traité des Archives, dans lequel on enseigne le moyen de faire revivre les anciennes écritures*, par Mariée. *Paris*, in-8.

1787. — *Mémoires de l'Académie des Sciences*. — On trouve dans le volume de cette année des observations sur l'acide muriatique oxygéné (chlore liquide) appliqué au blanchiment des estampes, par Chaptal : observations réimprimées, je crois, dans les *Annales de Chimie*, t. 39, p. 137.

1801. — *Essai sur le blanchiment des papiers*, par O'Reilly; in-8. — A la page 110, on traite du nettoiement des estampes par le procédé de Chaptal, à l'aide de l'acide muriatique gazeux.

1802. — *Recherches chimiques sur l'encre, les causes de son altérabilité et les moyens d'y remédier*, etc., par C. N. Alexandre Haldat (professeur de chimie à l'Ecole centrale de la Meurthe). *Nancy*, nivôse an XI (1802), in-8 de 45 pages. J'ai cité plusieurs fragments de cet opuscule.

On pourra consulter aussi le *Manuel du fabricant d'encres* pour l'écriture et l'imprimerie, par MM. de Champour et Malepeyre (Collection Roret).

1806. — *Chimie appliquée aux arts*, par Chaptal; 4 vol. in-8. Au tome III de la 2e édition, qui est de 1807, on traite de l'art de blanchir les estampes ; au

tome IV, p. 274, il est question de l'encre à écrire; *ibid.*, p. 390, des encres des imprimeurs et des graveurs. Le catalogue Roret indique du même ouvrage une édition in-8 en un seul volume, avec additions par M. Guillery.

1808. — *Principes chimiques de l'art du teinturier*, par Chaptal; in-8. — Je pense que cet ouvrage peut fournir quelques idées sur la matière qui nous occupe.

1809 (ou 1819). — *Manuel pratique de l'art du dégraisseur*, par L.-Séb. Le Normand, professeur, membre de la Société d'encouragement pour l'industrie nationale; in-12, 2ᵉ édition. — J'ai cité dans le présent *Essai* quelques passages de cet ouvrage.

1812. — *Essai sur l'histoire du parchemin et du vélin*. Paris, in-8, sans nom d'auteur.

1821. — *Procédés pour nettoyer les estampes*, indiqués dans la 5ᵉ partie du *Manuel des amateurs d'estampes*, par J. C. L. M. *Paris*, Foucault, in-12. Ouvrage portant le n° 1243 du catalogue de vente de Jules Goddé, peintre, faite en décembre 1850. Je retrouve à l'instant ce titre, qui m'avait échappé, vu son insertion dans un ouvrage général, et je regrette de n'avoir pas eu le loisir de consulter le livre, qui, selon une note du *Bulletin du bouquiniste* de février 1858, fut vendu relié 6 fr.

1834. — *Mémoire sur les faux en écriture et les moyens de les reconnaître et de les prévenir*, par A. Chevalier. *Paris*, in-8 de 43 pages.

1834. *Manuel du blanchiment*, etc., par M. Julia de Fontenelle. *Paris*, Roret, 2 vol. in-18. — Je ne con-

naissais pas cet ouvrage à l'époque (1846) où je publiai la première édition de mon livre. Le premier volume (dont je n'ai vu que la table) contient des observations sur les chlorures et l'eau de Javelle, sur le blanchiment des estampes, sur les dessins tachés, sur les différents bleus, etc. Le tome II, que j'ai lu, renferme quelques passages concernant la restauration du papier avarié, l'enlèvement des taches d'encre, de rouille et de graisse.

1844. — *Annexe au mémoire sur les papiers de sûreté présentés à M. Lacave-Laplagne, ministre des finances*, par Louis Tissier, etc. *Paris*, chez l'auteur, gr. in-8. — Je possède cette brochure, mais non le *Mémoire* dont elle est le complément. On y trouve des détails sur les encres typographiques.

1855. — *Chimie des couleurs pour la peinture à l'eau et à l'huile*, etc., par M. J. Lefort. *Paris*, Victor Masson, in-12. Cet ouvrage, que j'ai acquis, indique la composition chimique de la plupart des couleurs à la gomme, et quelquefois, mais assez rarement, les moyens de les décomposer. J'y ai puisé des renseignements pour mon chapitre sur le décoloriage.

Je mentionnerai ici le titre d'un ouvrage que je n'ai point vu, et qui a paru chez Roret il y a, je pense, déjà longtemps : *Manuel du coloriste, contenant le mélange et l'emploi des couleurs, ainsi que les différents travaux de l'enluminure*, par MM. Perrot, Blanchard et Thillaye.

On consultera encore les ouvrages suivants, dont j'ignore les dates de publication : — *Eléments de l'art*

de la teinture, avec une Description de l'art du blanchiment par l'acide muriatique oxygéné, par Berthollet. 2ᵉ édition. — *Journal de pharmacie*. — *Annales de chimie*. — *Manuel du fabricant de papiers*, faisant partie de la collection Roret.

Un artiste peintre m'a signalé un ouvrage italien intitulé : *Notizie storiche degli intagliatori*, par Grandinelli, comme contenant, au tome III, p. 331 et suivantes, des procédés pour le nettoyage des estampes. Je ne sais à quelle époque il a paru.

Je citerai, au sujet de la reliure des livres, les neuf ouvrages suivants :

1818. — *Art du relieur*, par N. Dudin. Nouvelle édition, publiée par J. E. Bertrand. *Paris*, Moronval, in-4.

1824. — *Notice sur la lithographie*, 2ᵉ édition, suivie d'un *Essai sur la reliure et le blanchiment des livres et gravures*, par F. Mairet, relieur et imprimeur lithographe à Châtillon-sur-Seine; petit in-8. — Je possède ce livre assez rare. Ce qu'il nous apprend sur l'enlèvement des taches et sur la reliure est d'une médiocre importance, mais il contient quelques alinéas curieux au sujet du report sur pierre des anciennes estampes.

1827. — *La Reliure*, poëme en six chants, par Lesné. *Paris*, gr. in-8.

1827. — *Epître à Simier père sur l'exposition de 1823*, par le même. *Paris*, gr. in-8.

1834. — *Lettre d'un relieur français aux principaux imprimeurs, libraires, relieurs et bibliophiles de l'Europe*, par le même. *Paris*, in-8.

1834. — *Mémoire présenté au jury d'exposition de 1834 sur les cartonnages conservateurs*, par le même. Paris, in-8.

1834. — *Essai historique et archéologique sur la reliure des livres*, etc. par Gabriel Peignot. Dijon, in-8, avec planches.

1855. — *Considérations générales sur la reliure des livres*. — Extrait du *Rapport* de M. R. Merlin sur la XXVIe classe des produits de l'Exposition universelle de 1855. — Ces observations sur la reliure ont été réimprimées dans les *Variétés* du journal *Le Courrier de la Librairie*, du 17 janvier 1857. L'article est intéressant et assez développé. Dans un numéro de date postérieure du même journal est un autre article tiré du même *Rapport*, concernant la reliure des registres.

On trouve dans la collection Roret un *Manuel du relieur* rédigé par M. Sébastien Le Normand et M. R. Je ne l'ai pas consulté, mais j'y renvoie les amateurs.

J'ai inscrit sur cette liste, nécessairement très incomplète, tous les titres que m'a offerts le hasard. Il m'eût fallu, pour la doubler, consacrer à des recherches un temps que réclament d'autres travaux, auxquels je me suis voué si exclusivement que jamais, c'est probable, je ne publierai de nouvelle édition du présent livre.

DES DIVERS SYSTÈMES DE REPRODUCTION
DES VIEILLES ESTAMPES.

Autrefois, pour reproduire une estampe, on avait recours à un moyen fort simple, mais peu expéditif. On prenait le calque des contours et de chaque taille; on décalquait ce dessin, par une méthode quelconque, sur une plaque de cuivre; puis on en burinait tous les traits, imitant le mieux possible le style de la gravure originale. Goltzius et Antoine Wierix ont si exactement regravé de cette manière certaines eaux-fortes d'Albert Durer que les iconophiles exercés ont besoin de toute leur sagacité pour distinguer les copies des originaux.

Plus d'une estampe a été reproduite au XVII° siècle, en plus petit que l'original, au moyen d'un calque dû au *compas de mathématique*, instrument qui, simplifié dans sa forme, se nomme aujourd'hui *pantographe* (1). J'ignore si, à la même époque, on eut l'idée d'opérer cette réduction en calquant l'image de l'estampe réfractée dans une chambre noire, appareil déjà connu et usité.

De nos jours on a multiplié par le simple calque un assez grand nombre d'anciennes estampes. Pour citer un exemple, M. Méryon, artiste de talent en même temps qu'imitateur habile des divers styles de gravure, nous a laissé des copies très satisfaisantes de pièces de Zeeman, de Silvestre et d'Androuët Ducerceau; mais il était réservé à notre siècle, fertile en inventions de tout genre, de chercher et de

(1) On peut reproduire les modèles en plus grand avec le même instrument employé en sens inverse, c'est-à-dire en fixant la pointe à calquer à la place destinée au crayon, et *vice versa*. Les copies agrandies de certaines vues, qu'on trouve dans la *Topographia Galliæ* de Zeiler, ont peut-être été obtenues par ce procédé, assez difficile du reste à mettre en pratique.

trouver des moyens plus prompts et plus précis pour produire de véritables *fac-simile*, des copies à peu près identiques aux originaux.

Je vais résumer en quelques pages tous les systèmes mis en pratique.

REPORT SUR PIERRE D'ANCIENNES ESTAMPES. — Les premières tentatives de reproduction des estampes par le noir même de l'original remontent à l'époque des premiers essais lithographiques. En janvier 1818 parut une *Notice sur la lithographie* par F. Mairet, relieur et imprimeur-lithographe à Châtillon-sur-Seine. La seconde édition (augmentée d'un *Essai sur la reliure*) est de 1824. J'en vais extraire l'exposition du procédé qui nous occupe. M. Mairet explique, page 59, « l'impression par trans-« position sur pierre », système basé sur la difficulté de sécher vite de l'encre grasse, et qui permet d'obtenir, par voie d'application sur pierre, soit la contre-épreuve d'un dessin tracé avec cette encre sur papier gommé (ce qu'on nomme aujourd'hui *autographie*), soit celle d'une épreuve lithographique, fraîchement tirée sur le papier ordinaire apprêté d'une certaine façon. Vient ensuite (page 62) le passage

le plus intéressant pour nous ; je vais le réimprimer en entier.

« Il n'est pas impossible de transporter sur
« la pierre d'*anciennes* gravures devenues rares,
« et que l'on désirerait multiplier. Quoique les
« traces sèches des anciennes gravures ne
« semblent guère propres à donner une nou-
« velle impression, on peut cependant les en
« rendre susceptibles en les humectant de nou-
« veau. Quelques essais nous ont prouvé qu'il
« n'était pas impossible d'en reproduire ainsi,
« en les colorant de nouveau avec une encre
« typographique ordinaire. Il faut d'abord hu-
« mecter le papier avec des acides étendus
« d'eau qui en attaquent la colle et les rendent
« plus perméables à ce dernier liquide : on
« empêche en même temps le papier de rece-
« voir l'encre du rouleau ; mais, pour que
« l'encre de ce rouleau ne se mêle point avec
« les acides, on passe sur la planche une lé-
« gère couche de gomme arabique, que l'on a
« soin d'étendre avant de tirer les épreuves :
« le noir de la gravure devient aussi plus sus-
« ceptible de recevoir la couleur du rouleau,
« et par conséquent de pouvoir donner plus

« facilement une contre-épreuve. L'estampe
« étant suffisamment noircie, on transporte
« la gravure sur la pierre ; il ne s'agit plus en-
« suite que d'opérer la pression. Si toutes les
« opérations ont été bien conduites, on obtient
« une contre-épreuve *assez exacte.*

« On peut encore obtenir des contre-épreuves
« par un procédé peu différent, et cela en re-
« couvrant la gravure avec de l'amidon cuit
« dans l'eau seulement. Avant de faire usage
« de l'amidon, il faut, lorsqu'il est coagulé, le
« mêler avec de l'acide sulfurique en y ajou-
« tant un peu de soude, puis avec l'encre typo-
« graphique ordinaire. Alors le blanc du pa-
« pier, défendu par l'amidon qu'on y a mis
« précédemment, ne reçoit point le noir de
« l'encre, tandis que les traits de la gravure
« s'en colorent. On enlève ensuite avec soin,
« et avec une éponge, l'amidon qui avait collé
« la gravure ; cette opération terminée, on
« porte la gravure sur la pierre, et l'on opère
« la pression.

« Les deux opérations que nous venons de
« décrire réussissent le plus ordinairement ;
« mais elles sont *très difficiles à exécuter.* Il

« est facile de juger avec quelle précaution il
« est nécessaire d'agir pour parvenir au ré-
« sultat qu'on se propose : M. Darcet a, du
« reste, assez bien réussi, surtout pour obtenir
« une contre-épreuve d'une gravure *ancienne*,
« en employant le lait pur ou l'eau de savon.
« Une cause célèbre a prouvé depuis peu com-
« bien ces moyens étaient sûrs et faciles. Ce-
« pendant le point le plus difficile dans l'art
« de transporter sur la pierre une gravure an-
« cienne est d'en rendre l'encre assez colorée
« pour donner une impression. Au reste,
« quand les gravures sont *peu anciennes*, on
« peut bien les contre-éprouver sur la pierre,
« soit par le moyen du lait pur, soit simple-
« ment avec l'eau de savon, ainsi que l'ont
« pratiqué MM. Darcet et Choron pour la contre-
« épreuve de la musique. »

Ce procédé, décrit ici peut-être un peu va-
guement, a été depuis perfectionné ; mais la
réussite n'a jamais été complète, parce que,
je crois, la couche de noir qui constitue les
tailles des vieilles estampes est rarement ho-
mogène, et presque dépourvue, sur certains
points, de substance huileuse ; or, sur ces

points trop secs, l'encre lithographique ne peut être absorbée au passage du rouleau. La plupart des iconophiles n'oseraient destiner une pièce précieuse à ce rôle de pierre lithographique. Si l'opération est bien menée, l'estampe n'a aucun risque à courir; mais, si le noir d'impression, par suite d'une négligence quelconque, venait à en envahir les blancs, on pourrait la regarder à peu près comme perdue.

Le succès est donc l'exception. La plupart des échantillons de reports d'estampes gravées sur bois ou sur métal que j'ai vus çà et là n'avaient pas, il s'en faut de beaucoup, la netteté des originaux. Une partie des tailles n'avaient pris qu'imparfaitement le noir du rouleau, pour telle ou telle cause, et plus d'une lacune avait été remplie à la main : c'est assez dire combien de telles copies risquent d'être défectueuses. Ensuite, beaucoup d'estampes répugnent à ce procédé. On a réussi assez bien à décalquer ainsi des gravures sur bois, quelques estampes sur cuivre du temps de Louis XV et certaines pages de vieux livres; mais les eaux-fortes d'Albert Durer, de Callot et de

Silvestre n'ont jamais pu, que je sache, se prêter à ce mode de reproduction.

Je possède quelques spécimens de feuillets gothiques et d'estampes sur bois multipliés à l'aide du report par MM. Thierry, Delarue et Dupont frères. J'ai cité dans mon *Histoire de la gravure en France* les essais en ce genre de M. Boyer, ex-pharmacien à Nîmes, associé avec M. Massias. Il m'a montré, en 1845 ou 1846, plusieurs vignettes contemporaines de Louis XV reproduites avec assez de bonheur; je dois ajouter, toutefois, que je n'ai pas vu les originaux en regard des copies.

Depuis cette époque je n'ai plus entendu parler de M. Boyer, qui devait se rendre en Belgique, après avoir échoué dans sa tentative pour obtenir de la chambre des députés une récompense nationale en échange de la révélation de son procédé, plus ou moins analogue, je pense, à celui dont je viens d'exposer le principe.

Le nom le plus populaire qui se rattache à l'invention est assurément celui des deux frères Dupont, qui ont eu le courage de reproduire un in-folio de plus de 600 pages, imprimé sur

2 colonnes : je veux parler du tome XIII du *Recueil des historiens de France* par dom Martin Bouquet. Ce volume figurait, comme échantillon en grand de *litho-typographie*, à l'Exposition de l'industrie de 1849, et se vendait 150 ou 180 francs. On avait employé, sinon sacrifié, à sa composition, un des exemplaires originaux de ce XIIIe tome, échappés en très petit nombre à l'incendie, je crois, de la bibliothèque Saint-Germain-des-Prés, arrivé en août 1794. En parcourant le volume j'ai remarqué un grand nombre de lettres refaites après coup, ce qui prouve que l'opération est souvent incertaine. En outre, ces caractères contrépreuvés n'ont pas la netteté de ceux du livre original, lesquels eux-mêmes sont loin d'égaler les produits des fonderies typographiques de notre époque.

On distribuait aux visiteurs de l'Exposition une page imprimée qui donnait ce renseignement : « M. Tabary, ancien bouquiniste (rue « Guénégaud), a eu l'heureuse idée de faire « reproduire (en 1847) ce volume par le pro- « cédé litho-typographique de MM. Paul et « Auguste Dupont. Par ce moyen des frais

« considérables ont été évités, etc. » Au bas était cette note : « Il suffit, pour reproduire « un imprimé quelconque par le procédé litho- « typographique, de se procurer un seul exem- « plaire de l'ouvrage ; chaque feuille est sou- « mise alternativement à une *préparation chi-* « *mique* et décalquée sur pierre lithographi- « que. Le tirage peut s'en opérer ensuite à « 2,000 exemplaires et plus, avec une *telle* « *précision* dans la forme des caractères, vi- « gnettes et ornements, qu'il est *difficile* de « distinguer la feuille reproduite par la litho- « typographie de l'original imprimé. » Exa- gération de prospectus, qui n'empêche pas qu'un si gros volume reporté en entier sur pierre ne soit un curieux tour de force litho- graphique.

Je signalerai encore un opuscule de 1635, reproduit par les mêmes à Périgueux en 1841. C'est un petit in-8 de 82 pages et de 18 lignes à la page, intitulé : *Histoire de l'incomparable administration de Romieu*, etc. A la fin, on lit : *Reproduit par le procédé litho-typogra- phique Dupont*, 1841 ; et plus bas, en très petits caractères : *Périgueux, lithogr. Dupont.*

Le titre de l'original est gravé sur cuivre et entouré d'un cartouche à enroulements bizarres. Il paraît reproduit avec assez de bonheur; toutefois, ce *fac-simile* accuse une épreuve usée ou mal venue. Peut-être la gravure du modèle était-elle d'un tirage défectueux. Quant aux caractères de tout le livre, italiques ou romains, et notes marginales, ils sont assurément lisibles, mais peu agréables à l'œil, vu leur bavochure; beaucoup de lettres, en outre, m'ont paru retouchées. Ensuite je ferai observer que cette copie est peut-être le premier exemple d'un livre reproduit en entier par voie de report sur pierre, et qu'on a rencontré, sans aucun doute, de grandes difficultés en raison de l'hétérogénéité de l'encre employée dans les anciennes impressions.

Cette invention ingénieuse, sinon féconde en résultats, semble avoir été oubliée depuis l'époque surtout où l'on appliqua la photographie sur papier à la reproduction des gravures. Ce fut en 1839 que la litho-typographie commença à attirer l'attention du public, à l'Exposition industrielle de cette année. *La Presse* contient à ce sujet des articles en date des 17

et 21 juin. Dans le premier on lit : « En quel-
« ques secondes chaque page, chaque gravure,
« se trouve décalquée avec une exactitude
« *rigoureuse*, et le tirage peut commencer im-
« médiatement à des nombres très considéra-
« bles. Ce qu'il y a de remarquable, c'est que
« les feuilles originales *ne s'altèrent pas*, et
« qu'elles peuvent être remises en volume
« après avoir ainsi fourni l'élément nécessaire
« à leur reproduction *recto* et *verso*, etc. »

Dans l'article du 21 juin, il est question de l'intérêt que Louis-Philippe portait à cette invention ; on signale la reproduction d'une tête gravée sur bois par Albert Durer en 1527, dont le décalque était *parfait*. Le roi en demanda une épreuve pour sa collection de portraits du Palais-Royal, et félicita MM. Dupont
« sur une découverte grâce à laquelle il n'y
« aura plus d'estampes ni de livres *rares* ».
Ensuite apparaît, en compagnie des princesses et du baron Thénard, la reine, qui « s'est beau-
« coup égayée sur le désappointement des
« *bibliomanes* qui verront leurs éditions uni-
« ques se reproduire par centaines et avec
« une *désespérante identité* ». On peut juger

aujourd'hui combien ces éloges et ces prédictions étaient exagérés (1).

Avant d'aborder les procédés de reproduction qui ont pour agent la lumière, avec ou sans l'aide de la chambre noire, et pour ne rien omettre, je mentionnerai un article du *Moniteur des Connaissances utiles*, dont je copie le texte dans l'*Athenœum français*, qui l'a répété dans son numéro du 7 avril 1855. « Prenez de bon savon, que vous couperez
« par petits morceaux que vous ferez fondre
« dans de l'eau-de-vie sur un peu de feu; vous
« y mettrez environ 16 grammes de savon sur
« un quart de litre d'eau-de-vie; puis, avec
« une plume ou un petit pinceau plat très doux,
« dit queue de morue, vous en frotterez dou-
« cement le livre que vous voulez copier, feuil-
« le par feuille, en mettant entre chaque
« feuille une feuille de papier blanc; vous re-
« fermerez le livre bien exactement, après quoi
« vous le mettrez dans une presse, de laquelle

(1) Voir sur le même sujet un article de la *Gazette des Tribunaux* du 4 juillet 1839, et un autre de *La Quotidienne* en date du 1er août.

« vous le retirerez une demi-heure après, et
« vous trouverez toutes vos feuilles de papier
« blanc imprimées *parfaitement*. Il y a, il est
« vrai, un inconvénient, car il faudra les lire
« de droite à gauche, au lieu qu'on lit de
« gauche à droite; mais on pourra y remédier
« facilement en présentant les feuilles copiées
« devant un miroir. Si on ajoute au mélange
« un peu de sel de nitre avec le savon et l'eau-
« de-vie, cela n'en viendra que mieux. La
« soude dans l'eau fait le même effet, — *une*
« *once* dans un verre d'eau. Pour copier une
« gravure, prenez de l'eau d'alun et de savon,
« mouillez-en une toile ou un papier que vous
« appliquerez sur l'estampe, mettez le tout
« sous presse, et vous aurez une assez belle
« copie de l'estampe. »

Ce procédé, supposé praticable, n'est pas en tout cas fort utile, car il ne procure de l'original qu'une copie à l'envers, non susceptible d'être multipliée. Néanmoins, s'il était prouvé que les originaux n'en souffrissent pas (ce qui me paraît peu probable, surtout quand on emploie la soude), on pourrait s'en servir en certaines circonstances, par exemple si l'on

voulait se dispenser de copier dans un livre un long article. L'emploi d'un papier très fin ou diaphane permettrait, au besoin, de lire à l'endroit avec facilité.

REPRODUCTION DES ESTAMPES PAR L'ACTION SOLAIRE. — Cette invention a produit déjà bien des merveilles, et, à mon avis, nous en promet bien d'autres. Les premiers essais dans cette voie sont, sans aucun doute, ceux tentés vers 1813 par M. Nicéphore Niepce; essais dont je parlerai plus loin. Toutefois il n'est pas précisément sûr qu'il fût à cette époque seul à s'occuper de ces recherches. Le *Moniteur universel* du 3 avril 1857 contient cette note reproduite d'après *La Presse de la Jeunesse :*
« On a découvert et mis sous les yeux des
« membres de la Société de photographie des
« gravures extrêmement curieuses, dont la
« date remonte à 1819, et qui semblent avoir
« une certaine analogie avec les épreuves pho-
« tographiques. Ces gravures, au nombre de
« trois, prouvent qu'il suffisait de présenter à
« l'auteur une planche quelconque pour qu'il
« en tirât, en très peu de temps, des *fac-si-*
« *mile* diminués ou agrandis. Dans ces trois

« gravures, représentant un même oiseau avec
« des dimensions différentes, on remarque la
« similitude la plus parfaite, la plus mathé-
« mathique, et la même finesse de détails. On
« dit que l'auteur de ces reproductions les avait
« mises à l'Exposition des produits de l'in-
« dustrie, en 1819, et qu'il est mort sans ré-
« véler le procédé dont il se servait pour les
« obtenir. »

Assurément ce récit est trop vague pour établir un fait incontestable. En 1819 il y avait déjà environ six ans que M. J. N. Niepce se livrait à ses expériences; s'agirait-il par hasard d'une de ses productions? Peut-être trouverait-on à ce sujet quelques renseignements dans le journal *La Lumière*, que je n'ai pas eu le loisir de consulter. Quoi qu'il en soit, je vais passer outre, et, pour suivre l'ordre chronologique non pas des premiers essais particuliers, mais de la publicité des découvertes, je commencerai par exposer brièvement le procédé de Daguerre, révélé au public en 1839, et je le considérerai sous le point de vue spécial de son application à la reproduction des estampes par elles-mêmes.

Procédé de M. Daguerre. — Supposons une estampe étalée à nu (1) sur un mur, qu'éclaire un rayon ou un reflet de soleil. En face de cette estampe est placée une chambre noire, dont l'objectif amène sur une glace dépolie l'image réfractée et très nette de l'estampe, image plus ou moins réduite, ou de grandeur naturelle si l'objectif est assez puissant et l'instrument assez large et suffisamment éloigné du mur. Passons maintenant à l'opération.

On soumet (dans un cabinet obscur, éclairé artificiellement) une plaque de cuivre argentée et bien polie à la vapeur d'iode, laquelle, se combinant avec la surface, y forme une pellicule d'*iodure d'argent*; on l'expose ensuite à la vapeur d'une solution de brôme qui favorise et accélère l'action de l'iode.

La plaque, ainsi préparée, à l'abri de la lumière solaire, est devenue très sensible à l'ac-

(1) Ou encadrée, pourvu que la vitre ne soit pas éclairée de manière à produire le miroitage. J'ai vu un habile praticien (M. Arthur Forgeais) photographier sur papier collodionné une ancienne charte placée sous verre. Il est essentiel que le verre soit exempt de tout défaut qui ferait tache.

tion de cette lumière, soit directe soit réfléchie; l'aspect de sa superficie est d'un jaune mat violacé. On la glisse au fond de la chambre noire, au point où l'image réfractée de l'estampe s'est formée nettement sur la glace dépolie : en d'autres termes, on la substitue à cette glace. Si l'on découvre alors l'objectif, l'image renversée de l'estampe fixée au mur se projette sur la plaque. Les parties vivement éclairées, les blancs, les intervalles des hachures, décomposent bientôt, c'est-à-dire noircissent, l'iodure d'argent (1); l'image des parties noires ou des tailles du burin forme écran et ne produit aucun effet.

L'opération terminée, après dix, vingt, trente secondes, plus ou moins, selon le degré d'intensité de la lumière que concentre le foyer de l'objectif, on retire (dans l'obscurité, bien entendu) la plaque, sur laquelle rien n'apparaît

(1) Le chimiste suédois Scheele découvrit en 1665 la propriété que possèdent le *chlorure d'argent* et autres sels du même métal de noircir à la lumière ; il appelait ce chlorure *argent corné*. Il est étonnant que personne avant Daguerre n'ait songé à tirer parti de cette propriété, qui est une des bases de la photographie.

encore, puis on la soumet à la vapeur mercurielle qui se dégage d'une cuve chauffée à 40 degrés centigrades. Des gouttelettes de mercure d'une ténuité extrême se condensent seulement sur les portions impressionnées de la plaque. Les blancs de l'estampe sont accusés par un glacis mercuriel, et les tailles par une pellicule d'iode et de brôme que le mercure n'a pas modifiée. La couche d'iodure d'argent non attaquée est entraînée par une solution d'hyposulfite de soude versée sur la plaque ; alors le métal, découvert à cet endroit, brille de son éclat naturel.

Ainsi que le fait remarquer M. Boulongne, l'épreuve est négative ; les tailles sont en réalité traduites en blanc ; mais, comme le mercure amalgamé est plus pâle que l'argent poli, il y a transformation, pour l'apparence du moins. L'estampe daguerréotypée paraît donc semblable à l'original reproduit, sauf le renversement des détails : en effet, les objets de gauche sont à droite, et *vice versa*. On peut remédier à ce défaut au moyen d'un miroir plan, qui redresse l'image avant sa projection sur la plaque ; mais, la lumière réfléchie perdant au

moins un tiers de son intensité, l'opération sera moins rapide. Serait-il permis à la science de combiner un système d'objectifs qui redressât directement l'image sans l'intermédiaire d'un miroir, d'un prisme ou d'un second objectif? Je ne le pense pas.

La reproduction de l'estampe offre, au sortir de la chambre noire, deux autres inconvénients : elle miroite à l'œil, qui a de la peine à la saisir, et n'a aucune fixité, car l'amalgame d'argent est très fugace. Heureusement M. Fiseau trouva, dès l'origine de l'invention, le moyen de fixer l'image et tout à la fois d'atténuer le miroitage. Il suffit de verser sur la plaque chauffée une solution de chlorure d'or mêlé d'hyposulfite de soude. L'épreuve se couvre à l'instant d'une couche d'or excessivement légère, qui d'une part s'amalgame avec le mercure, qu'elle fixe, et d'autre part assombrit le poli de l'argent. (1)

(1) Ceux qui voudront avoir des détails plus précis sur le mécanisme de chaque procédé photographique décrit dans ce chapitre devront consulter les nombreux traités modernes publiés à la *Librairie centrale des*

Reste un défaut inhérent à la nature même des images sur plaque : on ne peut les incorporer à une collection d'estampes. Réussirait-on à substituer sans désavantage à la plaque une feuille d'argent très mince, appliquée comme le papier de chine sur un feuillet de soutien? Peut-être un tel fond ne se prêterait-il pas aux apprêts délicats que doit subir la plaque de cuivre argentée. J'ignore si l'on a fait en ce genre d'heureux essais.

Occupons-nous maintenant d'un mode de reproduction photographique qui satisfera beaucoup mieux que le précédent les iconophiles : car ses produits, ayant pour base le papier, ne sont pas sujets au miroitage et peuvent se conserver en portefeuilles.

Reproduction d'estampes sur papier photographique. — Les fac-simile d'estampes dus à l'action que le soleil exerce sur des papiers diversement préparés sont aujourd'hui assez répandus; on en voit dans le commerce de

Sciences (rue de Seine-Saint-Germain), les ouvrages spéciaux sur les inventions modernes, et surtout le journal *La Lumière.*

fort remarquables, soit réduits soit de grandeur naturelle. Les prix de ces épreuves sont encore assez élevés, parce que chacune d'elles ne s'obtient que grâce aux soins tout particuliers des photographes ; mais un temps viendra où l'on s'en procurera de parfaites à bon marché. Passons en revue tous les systèmes désignés aujourd'hui sous la dénomination commune d'*héliographie*.

Je devrais peut-être citer tout d'abord celui de M. Nicéphore Niepce, qui, bien avant les essais de Daguerre, le mettait en pratique, dans le but spécial de reproduire des estampes ; mais je n'en parlerai qu'à la fin de ce chapitre, parce qu'il rentre dans les procédés destinés à fournir non pas de simples copies d'estampes, mais bien des planches toutes prêtes à recevoir le noir d'impression.

Dois-je regretter de ne pas avoir sous la main un ouvrage (dont le nom d'auteur m'échappe) intitulé : *Autophotographie, ou Méthode de reproduction par la lumière des dessins, gravures*, etc. ; in-8 (1847)? Ce traité nous eût peut-être éclairés. Je me console en songeant que sa date déjà éloignée le rejette

sans doute, vu les progrès incessants de l'héliographie, au rang des ouvrages arriérés. J'extrairai donc mes renseignements de plusieurs articles que j'ai lus à des époques plus récentes dans le *Moniteur universel* ou ailleurs.

Dès 1834, vers le temps où Daguerre faisait ses essais sur plaque, un Anglais, M. Fox-Talbot, trouvait de son côté des moyens analogues, moins parfaits à la vérité, mais plus maniables et plus féconds en résultats. Tandis que M. Daguerre iodurait des plaques argentées, M. Talbot, usant d'un sel d'argent tout préparé, en étalait sur du papier une couche mêlée d'acide gallique; cette mixture offrait un aspect mat et jaunâtre; il la nommait *gallonitrate d'argent.* Ce papier sensibilisé recevait l'image d'une estampe réfractée par l'objectif d'une chambre noire. La lumière solaire impressionnait le sel d'argent, autrement dit le noircissait, partout où l'image offrait des clairs, et n'agissait pas aux endroits occupés par les tailles.

Je prends ici encore pour exemple, et pour simplifier, une gravure au burin ou à l'eauforte dont les ombres et les demi-teintes con-

sistent en des faisceaux ou des réseaux de hachures plus ou moins serrés. S'il s'agissait d'une aquatinte, on conçoit que l'action solaire aurait sur ses diverses parties une influence en rapport avec la gamme de tons comprise entre les clairs et les ombres extrêmes.

Pour faire apparaître l'image, encore latente après l'opération du soleil, M. Talbot passait une seconde fois son papier au gallo-nitrate d'argent, puis le chauffait doucement au feu; l'image alors devenait visible; il possédait une épreuve négative sur laquelles les blancs ou entre-tailles étaient accusés en noir.

Comme la surface du papier est loin d'avoir le poli d'une plaque d'argent, ces empreintes manquaient de finesse dans les menus détails, mais offraient en compensation deux avantages sur le procédé Daguerre; on pouvait 1° les mettre en portefeuille, 2° les convertir en clichés propres à fournir des épreuves droites à un nombre pour ainsi dire illimité. Pour leur donner cette dernière qualité, il suffisait d'en rendre le papier transparent au moyen de cire vierge. Derrière une épreuve négative ainsi *diaphanéisée*, il appliquait un autre papier

impressionnable, et, plaçant le tout dans un châssis, l'exposait au soleil. La nouvelle feuille recevait une sorte de décalque, de contre-épreuve de l'image négative; les noirs et les blancs, cette fois, correspondaient aux tailles et entre-tailles de l'estampe, et les objets occupaient leur position naturelle : l'épreuve, en un mot, était positive.

Tel est le procédé primitif de M. Talbot. M. Blanquard-Evrart, de Lille, grâce à des modifications ingénieuses, l'a porté à la perfection. Les noms de MM. Bayard, Bisson frères et autres, se rattachent également avec honneur à cette branche de la photographie; ils lui ont fait faire des progrès étonnants, surtout sous le rapport de la préparation du du papier destiné à recevoir les empreintes, soit négatives, soit positives. On a obtenu des papiers à surfaces très lisses, par l'emploi successif de la cire (1), de la gélatine, de l'albumine, puis enfin du collodion ou fulmi-

(1) M. H. de la Blanchère a perfectionné l'art d'obtenir des épreuves négatives sur papier ciré. Voir le *Moniteur universel* du 8 novembre 1856.

coton dissous dans la benzine (voir les traités de photographie pour les détails de ces apprêts). Le papier préparé avec cette dernière substance lutte de poli avec la plaque daguerrienne ; néanmoins le papier sensible ayant pour base la gélatine n'est pas à oublier : c'est grâce à son emploi que M. Baldus, peintre photographe, et M. Benjamin Delessert, ont reproduit avec succès des pièces capitales d'anciens maîtres, les unes par l'entremise de la chambre noire, les autres directement avec les planches originales apprêtées d'une certaine manière. L'invention a aussi été améliorée sous le rapport des substances employées à la sensibilisation du papier ; on a substitué au gallo-nitrate le chlorure d'argent, dont on dissout les portions non influencées par un lavage à l'eau pure suivi d'un bain d'hyposulfite de soude.

Revenons à M. Fox Talbot. Sa méthode primitive de reproduction d'estampes exigeait l'emploi de la chambre noire ; leur image, réfractée et projetée sur un papier sensible, lui fournissait des réductions de l'original à l'échelle désirée ; mais il tarda peu à se passer

du secours de l'optique. Il lui vint une idée analogue à celle que M. Nicéphore Niepce mit en pratique, de son côté, comme nous le dirons plus tard : il imagina de reproduire les estampes par elles-mêmes. Il en rendait le papier transparent à l'aide de cire vierge en poudre qu'il étendait au verso et qu'il liquéfiait en y passant, je crois, un fer chaud sur toute la surface (1). Puis il en appliquait le recto contre une feuille de papier sensibilisé par un sel d'argent. Le noir des tailles interceptant la lumière, le papier restait blanc à cet endroit; partout ailleurs le sel d'argent tournait au noir et se fixait. Les parties non impressionnées étaient dissoutes dans un bain d'eau distillée contenant de l'hyposulfite de soude. Cette contre-épreuve était susceptible, après avoir été elle-même diaphanéisée, de servir de cliché pour un tirage sans limites d'épreuves po-

(1) Une estampe dont le verso serait imprimé ou gravé ne se prêterait pas à cette méthode. Je compte trouver un jour et indiquer aux amateurs le moyen de diviser en deux placards les estampes de ce genre. (Voir ma dissertation à ce sujet, page 330.)

sitives, de même grandeur que l'original, épreuves dont il renforçait les traits au moyen d'une solution d'acide gallique ou de protosulfate de fer.

Ici les iconophiles vont m'arrêter. L'estampe originale ne souffre-t-elle pas de cet apprêt, et surtout du contact des substances, telles que la benzine ou la térébenthine, destinées à en enlever les traces? Je crois en conscience qu'elle n'encourt aucun danger, pourvu que la cire soit très pure et qu'il en soit de même du liquide destiné à la dissoudre; mais on devra rejeter l'emploi de la stéarine, ou graisse saponifiée, qui laisserait sur les tailles (voy. page 70) une sorte de glacis blanchâtre.

Le procédé ci-dessus expliqué, qui varie selon la méthode particulière de chaque praticien, est appelé à rendre bien des services à l'art; mais les produits n'en sont pas encore en général assez parfaits pour satisfaire l'amateur délicat; les tailles de la gravure ne sont pas accusées avec la fermeté, la netteté, de l'original, et les magnifiques *fac-simile* d'estampes de MM. Baldus, Blanquart-Evrard et Benjamin Delessert n'ont été obtenus que grâce

à de nombreuses modifications apportées au procédé primitif.

Héliographie sur verre. — Le plus ingénieux perfectionnement du système Talbot est sans contredit celui dû à M. Niepce de Saint-Victor, neveu de Nicéphore Niepce. Il imagina de substituer au papier le verre, cette matière si polie, si diaphane. Il étala sur une glace d'abord une couche de gélatine, puis ensuite de collodion ; il recouvrait l'une ou l'autre de ces substances d'une pellicule de sel d'argent, et faisait apparaître l'image au moyen de l'acide gallique ou pyrogallique. C'est par l'usage de la glace collodionnée et de la chambre noire que MM. Le Gray, Bisson frères, Moulin, Mantes et Riffaut sont arrivés à obtenir des négatifs capables de fournir de précieuses copies positives d'anciennes eaux-fortes. M. Blanquart-Evrard à Lille, et M. Lachevardière à Paris, ont les premiers, ai-je lu, illustré des livres (notamment le *Voyage en Egypte* de M. Maxime du Camp) de dessins héliographiques dus aux mêmes procédés. En 1855 M. Martens s'est procuré, par l'emploi du verre albuminé à sec, les clichés de ses admirables

panoramas du Mont-Blanc; il mêlait à l'albumine de l'iodure d'ammonium. C'est aussi à l'aide de l'héliographie sur verre que M. Ferrier a produit ses épreuves doubles si remarquables, à l'usage du stéréoscope, instrument qui commence à se populariser.

Un article du *Moniteur universel*, du 23 décembre 1857, signale la nouvelle méthode de M. Leborgne, qui sensibilise le verre collodionné avec un liquide ainsi composé : 200 grammes d'eau distillée, 20 grammes d'acétate d'argent et 16 grammes de nitrate de plomb. Il développe l'image à l'aide d'une solution très faible d'acide gallique. « Les « glaces ainsi sensibilisées, dit l'article, peu- « vent se conserver longtemps sans perdre « leurs propriétés, ce qui permet d'opérer à « sec. »

L'héliographie sur verre appliquée à la reproduction des estampes est de tous les systèmes le plus parfait, soit qu'on superpose à la glace sensibilisée une estampe en nature rendue transparente, soit qu'on y projette son image réfractée. Ce dernier mode mérite, à mon avis, la préférence, parce qu'il four-

nit des réductions précises dans les proportions désirées, et, au besoin, des négatifs de la dimension de l'original Il s'agit, dans ce dernier cas, d'avoir une chambre noire assez vaste, pourvue d'un objectif à long foyer et de large ouverture : c'est assez dire qu'on est entraîné à des frais importants ; mais, si l'on se contente de copies réduites, on peut opérer avec un daguerréotype d'un diamètre courant et d'un prix modique.

Une dernière observation. La pureté de la glace, l'homogénéité de sa substance et de son épaisseur, sont les conditions essentielles de la perfection des négatifs. Plus la glace sera mince et à surfaces bien parallèles, plus, à mon avis, ce cliché donnera de belles épreuves positives sur verre ou sur papier. Si la lumière, avant d'impressionner le sel d'argent, avait à traverser une glace trop ou inégalement épaisse, et parsemée de stries, bulles d'air, etc., elle subirait nécessairement des réfractions irrégulières, des aberrations préjudiciables à la netteté des tailles. Si encore sa surface s'appliquait mal sur certains points du papier positif, les tailles de l'estampe seraient,

à ces endroits, confuses, mal terminées, comme les contours des ombres.

Qu'on me permette ici une courte digression :
M. Guiraudet, imprimeur du présent livre, a connu un libraire de Paris (feu M. Galliot) qui renouvelait le papier d'une estampe comme un réparateur de tableaux remplace la toile d'une vieille peinture. Il collait, je ne sais avec quelle matière, peut-être le collodion, le recto d'une estampe sur une glace, qui en retenait les tailles; puis il en détruisait le papier, soit en l'écorchant, soit plutôt, à mon avis, en le décomposant à l'aide d'un acide assez fort, auquel peut résister le noir d'impression. Le papier anéanti, il appliquait une nouvelle feuille sur les tailles, qui y adhéraient grâce à un procédé quelconque; enfin il détachait le tout de la surface vitreuse par un moyen qui m'est également inconnu.

Il est à regretter que M. Galliot ait emporté son secret dans la tombe. Sa méthode, supposé qu'elle fût infaillible et sans graves inconvénients (ce dont je doute), eût rendu de grands services : 1° aux iconophiles : elle leur eût permis de renouveler le fond

d'une estampe moisie et les eût dispensés de suer sang et eau à la recherche de remèdes propres à détruire certaines taches incurables; 2° elle eût fourni aux photographes un moyen nouveau de préparer des clichés héliographiques. Il serait sans doute possible de retrouver ce procédé, ou tout autre analogue.

DE LA GRAVURE HÉLIOGRAPHIQUE. — Nous allons voir maintenant la lumière préparer le travail le plus difficile, le plus long, du graveur à l'eau-forte. La première idée de cet art, aussi expéditif que merveilleux, appartient tout entière à Joseph Nicéphore Niepce. Ici ce nom doit briller de tout son éclat; un jour peut-être, grâce aux savants efforts du neveu qui porte et honore le même nom, il éclipsera celui de Daguerre.

Dès 1813, selon M. A. Boulongne, M. Nicéphore Niepce, préoccupé de l'invention de la lithographie, récemment connue en France (1), conçut le projet de substituer une

(1) Il est à noter que l'invention de la lithographie en a, dès son origine, engendré deux autres tout aussi remarquables : la litho-typographie et l'héliographie.

mince plaque métallique à une lourde pierre. Cette idée lui en suggéra une autre : trouver le moyen de fixer sur cette plaque les images de la chambre noire. Ses premiers essais eurent pour but de reproduire des estampes par le procédé dont la description va suivre.

Il connaissait la propriété que possède le bitume de Judée, matière noirâtre, de blanchir quand on l'expose pendant un certain temps à la lumière du soleil, directe ou réfléchie. Partant de ce principe, il étala d'une manière quelconque, sur une plaque d'étain, une couche de ce bitume. D'autre part il vernit au verso une estampe, afin de lui communiquer un certain degré de transparence; puis il appliqua ce côté verni, dès qu'il fut sec, sur sa plaque préparée. La lumière, passant à travers les parties claires ou entre-tailles de l'estampe, blanchit le bitume et en même temps le fixa sur le métal. Les parties noires ou tailles, au contraire, interceptant les rayons lumineux, le bitume, sur ces points, ne fut ni influencé ni fixé sur l'étain.

Après *dix heures* d'exposition au soleil, l'opération était achevée. M. Niepce trempait

sa plaque dans un bain d'essence de lavande et de pétrole, laquelle dissolvait le bitume aux endroits non impressionnés, protégés par le noir, tandis qu'elle n'avait aucune action sur les portions atteintes et fixées par la lumière, celles correspondantes aux blancs de l'estampe. Le brillant du métal représentait donc l'empreinte exacte des tailles; c'était un *fac-simile* direct, une reproduction dans le sens naturel, une copie positive.

Comme ces empreintes étaient fort pâles, M. J. N. Niepce essaya, mais en vain, de leur donner de la vigueur en soumettant le métal aux vapeurs iodiques ou sulfureuses. Plus tard il fixa, par le même procédé, des images de paysages en nature, réfractées par la chambre noire, images nécessairement à l'envers, et, défaut bien autrement choquant, tout à fait confuses, vu que pendant une exposition de plusieurs heures au soleil les ombres des objets réels se déplacent à chaque instant. Ce fut peut-être la vue de ces images renversées qui lui inspira l'heureuse idée dont il va être question.

On va me demander sans doute à quoi pouvaient servir ces empreintes d'estampes. A

peu de chose, au premier coup d'œil; mais M. Niepce allait trouver moyen d'en tirer bon parti. Ne possédait-il pas, en effet, grâce à cette simple opération, une planche toute vernie avec un sujet tout tracé, n'attendant plus que la morsure de l'eau-forte ? Il lui suffisait, pour reproduire le modèle à grand nombre d'épreuves, d'appliquer son estampe sur sa plaque d'étain ou de cuivre, enduite de bitume, de manière à en avoir une empreinte retournée, qui, creusée à l'eau-forte, donnât, au tirage, des épreuves droites. Il parvint à obtenir ainsi quelques *fac-simile* d'estampes.

Plus tard, en 1827, M. Niepce rencontra M. Daguerre chez M. Charles Chevalier, fils de l'ingénieur-opticien Vincent, très habile constructeur de chambres noires; dès lors il associa ses expériences à celles du fondateur du Diorama, et abandonna, à ce qu'il paraît, ses essais au bitume, pour chercher avec son associé l'art de fixer les images de la chambre noire sur plaques d'argent iodurées. En 1839, quelques années après le décès à *Châlons* de M. Niepce, M. Daguerre, resté seul possesseur du secret commun, le divulgua à l'Europe et

fut récompensé par la chambre des députés au nom de la nation (1). Depuis cette époque le nom de Niepce fut, il est vrai, associé à celui de Daguerre; mais bientôt le public l'oublia à peu près, ainsi que son procédé personnel, qui avait pour base l'action de la lumière sur le bitume. M. Niepce neveu songea dès lors à perfectionner ce procédé et à le faire prévaloir même sur celui qui porte le nom de Daguerre; peut-être est-il permis de dire qu'il y a réussi. Il reprit donc les essais imparfaits de son oncle et en tira des résultats si féconds que la méthode de M. Daguerre sera bientôt reléguée, c'est probable, parmi ces inventions ingénieuses qu'on admire, mais qu'on met en pratique rarement et par exception.

Voici comment M. Niepce de Saint-Victor fit faire des pas de géants au procédé de son oncle, encore en quelque sorte à l'état d'embryon à l'époque où fut révélée la brillante découverte de Daguerre. Il emploie aujourd'hui une plaque d'acier; après quelques apprêts pré-

(1) M. Charles Chevalier, opticien, possédait depuis 1827 un échantillon, sur plaque d'argent, des essais de

liminaires (voir les traités photographiques), il y verse un vernis liquide composé de — cent grammes de benzine, — six de bitume de Judée, — un de cire jaune (vernis qu'on doit conserver dans un flacon à parois opaques); puis il fait sécher ce vernis en chauffant la plaque, qu'il met à l'abri de la lumière et de l'humidité.

Sur cette plaque ainsi enduite il applique soit le recto d'une estampe en nature rendue diaphane, soit son image obtenue à la chambre noire, sur verre albuminé ou collodionné et chargé d'un sel d'argent. Il expose le tout non plus pendant dix *heures*, mais pendant dix *minutes*, au soleil, ou une heure à la lumière diffuse. Si la durée de l'exposition se prolongeait trop, l'image deviendrait visible avant l'opération du dissolvant, lequel ne produirait plus son effet. Ce dissolvant, composé de trois parties d'huile de naphte rectifiée et d'une partie de benzine, enlève avec énergie les portions du glacis bitumineux que les tailles

M. Niepce; cet échantillon est aujourd'hui aux archives de l'Institut. (*Rapport à la Société d'encouragement* par M. le baron Séguier, 11 mars 1840.)

de l'estampe ont préservées de l'action fixatrice de la lumière.

M. Niepce emploie, pour creuser les traits représentés par les portions, mises à nu, de sa plaque d'acier, le liquide suivant : acide azotique (à 36 degrés), une partie en volume ; eau distillée, huit parties ; alcool (à 36 degrés), deux parties. Je passerai sous silence les apprêts assez compliqués qu'il fait subir ensuite à sa planche pour la rendre plus sensible à la morsure de l'acide azotique, employé alors sans mélange.

Notons qu'au moment même où j'indique ces détails d'après divers articles du *Moniteur universel*, les procédés usités l'an passé sont peut-être déjà surannés, car chacun des photographes qui s'en servent y ajoute les perfectionnements que lui inspirent ses propres recherches. J'ai voulu seulement donner une idée générale du mécanisme de l'opération. M. Benjamin Delessert a entrepris de reproduire par ce système de gravure les principales eaux-fortes d'Albert Durer. MM. Mantes et Riffaut s'occupent de l'œuvre de Rembrandt, en apportant dans la pratique du procédé certaines

modifications dont ils ont le secret. J'ai lu qu'ils se servent d'épreuves négatives obtenues à la chambre noire, sur glaces collodionnées, d'après les images des originaux.

Inappréciable conséquence de l'ingénieuse découverte de M. Nicéphore Niepce ! On possède une planche couverte d'un vernis inattaquable aux acides et d'une esquisse qu'a tracée la lumière, une planche tout à fait assimilable à celle de cuivre vernissé sur laquelle le graveur doit tracer patiemment à la pointe les contours et les ombres d'un dessin. Ici, ce dessin, dû à l'action du soleil, est d'une précision étonnante, d'un fini parfait dans tous ses détails. Pour en faire une planche à tirer, il suffit de creuser, à l'aide d'un acide, le métal dénudé, et il n'y a plus qu'à passer le rouleau chargé de noir d'impression pour obtenir des milliers d'épreuves d'une copie très exacte. Il reste encore, en certains cas, un travail à faire pour arriver à la perfection : un artiste devra retoucher, renforcer certains traits, pour les disposer à recevoir plus d'encre ; c'est, au reste, une opération qu'exige le plus souvent toute gravure à l'eau-forte.

Tel est, de tous les systèmes inventés pour fac-similiser les vieilles estampes, celui qui promet le plus. Le défaut de tous les autres, c'est d'offrir des traits sans reliefs, d'un noir trop mat et d'un ton uniforme, comme l'ombre d'un corps projetée sur un mur. Avec celui de M. Niepce il est permis de reproduire non plus seulement les traits de la copie, mais aussi, en creusant plus ici que là, les tons renforcés de l'original, avantage inhérent aux seules épreuves produites par voie d'impression. Seulement il faut le concours d'un artiste; mais, quel mal après tout que l'action mécanique cède pour quelques instants la place au talent que dirige le cerveau, à l'inspiration du génie?

Il existe encore plusieurs procédés analogues, mais bien inférieurs à celui-ci, pour se procurer des planches à graver au rouleau, soit en creux, soit en relief. M. le docteur Donné eut le premier l'idée de disposer une plaque *daguerrienne* de telle sorte qu'elle pût être creusée à l'eau-forte et servir de planche à tirer. Il attaquait à l'acide azotique les parties brillantes de la plaque, là où l'argent était à nu, tandis que les portions mates, fixées par le mer-

cure, n'éprouvaient aucune altération ; malheureusement, vu le peu de profondeur de la morsure de l'acide, il ne tirait que des épreuves *très imparfaites.* M. Fiseau appela à l'aide de ce système la puissance galvanoplastique ; mais je n'entrerai dans aucun détail sur cette application, puisque, en définitive, elle n'a donné que des produits encore peu satisfaisants.

M. Grove, Anglais, tenta également d'appliquer l'électricité aux images daguerriennes, pour obtenir des planches à tirer. Les résultats s'étant réduits à des essais ingénieux, mais sans portée, il est inutile de nous occuper plus longtemps de son procédé.

M. Fox Talbot, l'inventeur de la photographie sur papier, entreprit aussi de convertir en une planche à graver une plaque d'acier, sur laquelle il étalait une couche de gélatine tenant en dissolution du bichromate de potasse (sel rouge impressionnable à la lumière); puis il y appliquait un dessin photographique sur papier transparent. Mais le gaz que dégageait l'action de l'acide azotique troublait l'enduit gélatineux et s'opposait à la réussite. Toutes ces tentatives, mentionnées par M. Boulongne, sont

uniquement curieuses à constater, comme témoignage de l'ardeur qui anime, de nos jours, les amateurs de photographie.

Un article du *Moniteur universel* du 20 mars 1855 signale la découverte suivante, due à MM. Salmon et Garnier, de Chartres, qui nomment leur procédé *gravure-photographie*. On a évité le nom d'*héliographie* « parce que la *lumière*, « et non le *soleil*, y joue un rôle très impor- « tant. » En effet, toutes les opérations s'exécutent à l'ombre.

« Ce procédé, écrit le rédacteur, est d'une « simplicité telle que tout le monde peut l'exé- « cuter ; il permet de reproduire à peu de frais, « en quelques minutes, et avec toute la fidélité « désirable, toute espèce de lithographies, « gravures, écritures, dessins à la plume, au « crayon noir ou à la mine de plomb, même « des photographies. Grâce à ce procédé, on « peut faire de tout cela une planche sur « cuivre durable et solide pouvant être tirée « à la presse lithographique, typographique, « etc. »

Esquissons en peu de mots le mécanisme du système : on expose pendant quelques se-

condes une estampe, placée au fond d'une boîte, à la vapeur de l'iode, qui se porte sur les tailles; puis on l'applique sur la surface polie d'une plaque de laiton, où l'iode se dépose. On passe sur cette plaque une légère couche de mercure, qui agit sur tous les points atteints par l'iode et respecte les autres; puis on étend, au rouleau, de l'encre typographique, qui s'attache seulement aux endroits exempts de mercure, c'est-à-dire aux vides qui séparent les tailles; ces tailles ressortent donc en blanc sur le fond noirci par l'encre grasse. Pour pouvoir les creuser, on dissoudra le mercure qu'elles retiennent au moyen d'une solution de nitrate d'argent, additionnée d'acide azotique. Le métal, partout où les tailles ont laissé une empreinte, se trouve ainsi à nu et même déjà légèrement entamé. Veut-on obtenir une eauforte, on ajoute de l'acide; le noir d'impression joue alors le rôle d'un vernis, auquel on donne plus de consistance en le saupoudrant de résine pulvérisée, qui l'épaissit et le solidifie. Désire-t-on convertir cette plaque en pierre lithographique, on a recours à de nouvelles opérations, que j'omettrai, et dont la principale

consiste à couvrir d'une couche ferrugineuse les tailles de la contre-épreuve de l'estampe, etc. Enfin il y a moyen de faire de cette planche un véritable cliché en relief : il suffit de déposer une couche d'or sur les tailles, après quoi on fait mordre l'acide azotique sur le cuivre dénudé, etc., etc.

A mon avis, une invention qui a la prétention de se prêter à tant de transformations est par cela même dépourvue de cette simplicité qui seule mène à de bons résultats dans la pratique. Je renvoie à l'article indiqué ceux qu'intéresserait cette découverte compliquée, dont on ne parle plus. Si elle est réellement née viable, le temps en révélera les progrès; mais j'ai bien peur, puisqu'elle ne donne plus signe de vie, qu'elle n'ait fait *fiasco*.

Je ne sais non plus où en est aujourd'hui un autre mode de reproduction d'estampes ainsi indiqué dans un article du *Moniteur universel* du 18 janvier 1854 : « On se sert d'une pierre « lithographique ordinaire, sur laquelle on « verse une dissolution éthérée de bitume de « Judée. On applique dessus une épreuve pho- « tographique négative quelconque, en la pres-

« sant sur la pierre pendant un temps excessi-
« vement variable, puisqu'il peut être depuis
« dix minutes jusqu'à quatre et même cinq
« heures. On lave ensuite la pierre avec de
« l'éther pur, qui s'évapore bientôt et laisse la
« figure convenablement marquée avec ses
« ombres et ses creux, de telle façon qu'on
« peut encrer et faire le tirage comme pour les
« lithographies ordinaires. »

Pour me résumer, je crois que les plus parfaites reproductions d'anciennes estampes seront obtenues à l'aide d'empreintes négatives déposées par la chambre noire sur glace collodionnée, puis multipliées par le mode de gravure héliographique inventé par Nicéphore Niepce et perfectionné tant par son neveu que par nos plus habiles photographes. Ce dernier procédé, quand il aura atteint son maximum de perfection, sera probablement le seul adopté dans la pratique pour la reproduction, à prix modéré, non-seulement des belles pièces des anciens maîtres, mais encore de livres rarissimes (1). Il est à espérer que les épreuves se-

(1) Je compte un jour m'exercer à reproduire un

ront fixées de manière à subsister indéfiniment, bien qu'on ait, à tort ou à raison, prédit le contraire.

Le 16 novembre 1857, on a fait à l'Académie des Sciences un rapport sur un mémoire de M. Niepce de Saint-Victor, dont j'extrairai (d'après le *Moniteur* du 18) quelques passages intéressants pour les iconophiles.

« On expose aux rayons directs du soleil,
« pendant un quart d'heure au moins, une
« gravure qui a été tenue plusieurs jours dans
« l'obscurité... On applique ensuite cette gra-
« vure sur un papier photographique très sen-
« sible, et, après vingt-quatre heures de con-
« tact dans l'obscurité, on obtient en noir une
« reproduction des blancs de la gravure.....
« L'auteur a obtenu ainsi des intensités d'im-
« pression qui lui font espérer que peut-être
« on arrivera, en opérant sur des papiers très
« sensibles (comme sur le papier préparé

opuscule gothique par la voie de l'héliographie sur glace collodionnée, combinée avec la méthode de gravure de M. Niepce. Le point difficile sera de parvenir à bien *registrer* les recto et verso de chaque feuillet.

« à l'iodure d'argent, par exemple, ou sur une
« couche de *collodium* sec ou d'albumine), et
« en développant l'image avec l'acide gallique
« ou pyrogallique, à obtenir des épreuves as-
« sez vigoureuses pour pouvoir en former un
« cliché ; ce serait un nouveau moyen de re-
« production des gravures..... Une gravure
« colorée de plusieurs couleurs se reproduit
« très inégalement, c'est-à-dire que les cou-
« leurs impriment leur image avec des inten-
« sités différentes, variables selon leur nature
« chimique. Quelques-unes laissent une im-
« pression très visible, tandis que d'autres ne
« colorent pas ou presque pas le papier sensi-
« ble. Il en est de même des caractères impri-
« més avec diverses encres : l'encre grasse
« d'impression en relief ou en taille-douce,
« l'encre ordinaire formée d'une solution de
« noix de galle et de sulfate de fer, ne don-
« nent pas d'images, tandis que certaines
« encres anglaises en donnent d'assez net-
« tes..... »

Au moment où cette feuille va être mise
sous presse, le *Moniteur universel* du 3 mars
1858 nous révèle dans ses *Variétés* un nou-

veau mode de reproduction d'estampes, au moyen de la vapeur du phosphore, qui a la propriété de se condenser sur les tailles sans agir sur les blancs. C'est encore à M. Niepce qu'on doit cette découverte. Je me bornerai à citer une phrase de son Mémoire présenté à l'*Académie des Sciences* par M. Chevreul le lundi 1^{er} mars.

« On expose la gravure à copier aux vapeurs
« du phosphore brûlant lentement dans l'air;
« les noirs seuls s'imprègnent de vapeurs phos-
« phorées; on l'applique sur une feuille de
« papier sensible préparée au chlorure d'ar-
« gent; après un quart d'heure de contact, la
« gravure est représentée sur le papier par un
« dessin formé de phosphure d'argent, lequel,
« quand il est suffisamment vigoureux, résiste
« à l'action des agents chimiques étendus
« d'eau ou dilués. »

Je renvoie au numéro du journal signalé l'amateur qui voudrait se mettre au courant de tous les détails de l'opération.

Voilà deux nouvelles découvertes bien inattendues, qui vont grandir encore en Europe un nom déjà si populaire. Nous verrons

par la suite quelles conséquences en découleront pour l'art qui fait le sujet de ce long chapitre.

Presque tous les systèmes ci-dessus décrits sont également applicables à la reproduction des dessins à la plume ou aux divers crayons; mais il est à noter que, si le trait en est très léger, c'est-à-dire tracé avec une encre peu opaque ou un crayon d'une teinte peu prononcée, ils fournissent des empreintes fort pâles et à peine visibles (à moins qu'il n'y ait moyen de les renforcer), vu que l'action de la lumière a été imparfaitement interceptée. Le noir d'impression au contraire, peu perméable à ce fluide, offre des épreuves bien plus vigoureuses. Les aquarelles se reproduisent quelquefois assez heureusement à l'aide de la chambre noire. M. Arthur Forgeais m'a donné une remarquable copie héliographique d'un dessin de ce genre représentant la démolition des maisons du pont Notre-Dame. On peut également réussir à reproduire par voie de réfraction certaines peintures à l'huile, pourvu qu'elles n'aient pas trop tourné au noir.

Ce chapitre n'est après tout qu'un simple résumé, une compilation succincte, si l'on préfère, de nombreux articles publiés dans plusieurs journaux. N'ayant jamais eu le temps d'éprouver moi-même les procédés indiqués, je ne puis répondre de leurs résultats, annoncés *de confiance*. J'ai rédigé cet exposé à titre de sujet intéressant pour les iconophiles; mais à ceux qui voudraient mettre ces théories en pratique je conseillerais de consulter les ouvrages spéciaux et très détaillés, et de prendre quelques leçons chez un professeur de photographie; là seulement ils pourront s'initier aux trucs du métier, à ces petits secrets qu'aucun livre ne révèle, et qui sont la condition *sine qua non* d'une parfaite réussite.

SUR LA POSSIBILITÉ DE DÉDOUBLER UN FEUILLET SIMPLE.

Il s'agit de diviser en deux placards, pour en opérer la reproduction (par la méthode citée pages 305 et 312), soit un feuillet de livre, soit une lettre écrite des deux côtés, soit une estampe dont le verso serait chargé d'une impression quelconque. La possibilité d'une telle opération n'est pas une chimère : elle a été effectuée avec un plein succès par M. W. Baldwin à Londres, et à Paris, un imprimeur en taille-douce, réparateur d'estampes, M. A.

Pierron, a mis à l'Exposition universelle de 1855 plusieurs échantillons de gravures dédoublées.

Je regrette de ne pouvoir livrer aux amateurs ce secret qui n'est pas en ma possession, mais je leur ferai part de quelques observations propres peut-être à les mettre sur la voie; de l'hypothèse raisonnée à la pratique sûre, il y a quelquefois un court intervalle à franchir. En attendant que je sois en mesure d'indiquer des moyens infaillibles que de nombreuses expériences doivent seules me révéler, je vais développer des idées théoriques qui, si je ne me fais illusion, feront toucher de près à la solution du problème.

Notons d'abord que, si l'on n'a aucune raison de conserver intact le verso du papier à dédoubler, on peut se borner à enlever avec régularité au grattoir cette surface incommode; c'est un travail de patience. Pour y réussir sans encourir de mauvaises chances, voici ce qu'on fera. Le recto ou côté à ménager sera exactement appliqué au moyen d'une colle quelconque sur un fond uni de bois, de marbre, etc. On opérera soit à sec, soit en humec-

tant le verso, assez légèrement pour que la colle qui fixe le recto ne puisse se ramollir. La superficie enlevée, ce qui n'est difficile que si le papier est très mince, on laissera sécher l'estampe sur le fond, on aplanira la surface écorchée avec de la peau de chien marin, puis on fera tremper le tout dans l'eau chaude, l'alcool, etc., selon la substance qui aura servi de colle ; cette dernière opération ne peut causer aucun embarras sérieux.

Mais, si l'on tient positivement à séparer la feuille en deux placards égaux et sans déchirures, le travail est tout autre, et je crois qu'il ne peut s'effectuer sans le secours de certains appareils d'une grande précision. Au premier coup d'œil, bien des amateurs jugeront sans doute la chose impossible ; pourtant on y a réussi, puisque j'en ai vu des échantillons. M. Hennin, le savant collectionneur d'estampes historiques, possédait une rare gravure (un portrait d'Henri IV) au verso de laquelle était un texte imprimé, dont les caractères majuscules, apparaissant sur la face opposée, nuisaient beaucoup à l'effet du burin. Il la fit remettre à Londres à M. W. Baldwin (employé dans

la maison de commerce d'estampes de P. Colnaghi), qui la lui renvoya divisée en deux placards, sans la moindre écorchure (1). M. Baldwin écrivit à M. Hennin que son estampe avait été *tranchée* ou, je crois, *sciée en deux*, explication destinée peut-être à dérouter les amateurs sur le procédé réel.

Sur quels principes peut reposer la réussite de l'opération? Voilà l'énigme à deviner. Partons de ce raisonnement : quand un effort est exercé sur une matière solide quelconque dans le but de la diviser, c'est toujours la partie la plus faible, la plus molle, ou celle qui n'est pas maintenue, qui cédera.

Or, dans une feuille de papier, on peut considérer les deux surfaces planes exposées à l'air comme les couches les plus fermes de la

(1) M. Hennin cite ce fait au tome I de ses *Monuments de l'histoire de France*, page 215. J'ai ouï dire qu'en 1848, M. Baldwin était parvenu à dédoubler des banknotes; la Banque d'Angleterre lui offrit une récompense pour qu'il ne divulguât pas un secret qui pouvait, en des mains déloyales, lui être préjudiciable. M. Pouillet se serait intéressé à ce tour de force et le signalerait je ne sais en quel ouvrage ou mémoire.

masse, et la couche intermédiaire, dans toute son étendue, comme la plus faible : ainsi d'une tranche de pain rassis, d'un morceau de ouate à surface lustrée, d'une pierre calcaire durcie par l'action de l'air. Un feuillet de papier présente un si mince profil qu'on ne peut le dédoubler faute de prise, faute d'espace pour introduire une lame ou une scie entre ses deux faces, comme on ferait à l'égard d'une planche de sapin épaisse de trois centimètres. Pour réussir on devra, je crois, recourir à des procédés analogues à ceux dont je vais donner la théorie.

Essayons d'abord du suivant : faisons adhérer la plus précieuse surface du feuillet à un fond de bois résistant, *très lisse* sans être poli. Quelle que soit la colle employée (j'ignore encore quelle est la plus convenable), elle devra être parfaitement pure, sans le moindre grumeau, d'une viscosité bien homogène, et telle qu'elle ne pénètre pas à l'intérieur du papier, mais s'attache *uniquement* à sa superficie. On fixera donc le recto sur tous les points avec un égal degré d'adhérence ; puis, une fois la dessiccation complète, on étendra sur le verso, exposé aux regards, une couche de la même

colle à l'aide d'un pinceau fin, ayant bien soin que chaque portion de la surface en reçoive la même quantité, et qu'aucune parcelle ne s'étende au delà du papier et n'empiète sur le fond de bois, qu'il est aisé de mettre à l'abri des atteintes du pinceau. Sur cette couche visqueuse on appliquera, à l'état de moiteur, soit une toile résistante, soit une peau bien unie; adoptons le parchemin. On s'arrangera pour que cette feuille déborde des quatre côtés les limites de l'estampe; ces portions excédantes et libres seront destinées à fournir de la prise.

Le tout bien sec, on essayera d'isoler la feuille de parchemin qui doit entraîner avec elle le verso du papier à dédoubler. Un des côtés excédants du parchemin devra être saisi dans toute sa largeur et tiré lentement avec un effort identique sur tous les points. Je citerai ici une opération délicate, que j'ai vu pratiquer à Naples pour dérouler un rouleau de papyrus incinéré. Une bande de baudruche se relie à de nombreux fragments de la même peau, adhérents à la surface raboteuse et très inégale du rouleau de cendre; on attache à cette bande un rang serré de cordons de soie fixés,

par l'autre extrémité, à un cylindre supérieur qu'on fait tourner avec une lenteur extrême. La baudruche, collée dans les moindres replis qui rident la surface du rouleau, se déploie peu à peu, entraînant les diverses couches de cendre, vestiges impalpables des spirales qui formaient le rouleau; après quelques *mois* le tour de patience est accompli.

Un procédé analogue, appliqué au dédoublage de notre feuillet, réunirait-il toutes les conditions de réussite? Je le crois, pourvu toutefois que le papier soumis à l'expérience ne fût pas d'une fabrication par trop grossière. Si le collage des deux superficies a été pratiqué avec une précision parfaite, surtout vers les bords (ce qui est le point difficile), il me semble que le parchemin, tiré avec une régularité mécanique, entraînera, avec la surface du verso, juste la moitié de la couche intermédiaire du papier, laquelle est ici la partie faible, celle qui doit céder. Plus le feuillet à dédoubler aura d'étendue, plus nécessairement l'opération exigera de précautions. Si chaque point des deux surfaces n'adhérait pas complétement au fond de soutien, soit qu'il y eût

des intermittences dans le collage, soit qu'il se trouvât des ordures dans la pâte du feuillet, il se formerait des déchirures ; mais le papier, supposé bien collé et bien égal dans sa contexture, se dédoublerait, ce me semble, en deux tranches de même épaisseur, comme si l'on avait affaire à une carte à jouer formée de deux feuillets distincts.

Le dédoublement une fois accompli, le reste de l'opération ne serait plus qu'une bagatelle : il suffirait, pour détacher les deux minces placards, de tremper bois et peau dans l'eau chaude si la colle y est soluble ou dans l'alcool si elle est d'une nature résineuse, etc.

Réussirait-on mieux en fixant entre deux tablettes de bois le feuillet au moyen de collodion ou d'un vernis, et laissant le tout tremper pendant plusieurs jours? Par l'effet de la capillarité, l'eau *peut-être* s'infiltrerait par degrés à travers le milieu du feuillet et en ramollirait la couche intermédiaire sans atteindre les deux superficies, qui, protégées contre l'action de l'eau, deviendraient des parties résistantes par rapport à la couche centrale, ramollie par l'humidité. Je l'avoue, je ne saurais

concevoir, pour résoudre le problème, un procédé où la colle et l'humidité ne joueraient aucun rôle.

J'ai entendu parler d'une machine destinée à diviser les peaux d'agneaux en couches fort minces. Une lame très affilée et d'une épaisseur presque nulle entame, m'a-t-on assuré, le profil de la peau, maintenue entre deux cylindres fortement serrés l'un contre l'autre, lesquels, tournant en sens contraire, entraînent la double tranche formée par l'action continue de la lame. Ce mode de dédoublage serait sans doute applicable à des feuillets de vélin. Du reste, le renseignement est fort vague : je n'ai pu voir ni l'appareil, ni même un dessin qui le représentât; néanmoins, il m'a inspiré une idée *peut-être* réalisable. Le point le plus difficile est sans contredit de commencer l'entaille sur toute la ligne, et au milieu même du profil d'un feuillet. Y parviendrait-on par l'emploi de ces lames extrêmement minces dont se servent les amateurs d'expériences microscopiques pour obtenir des tranches de bois d'une excessive ténuité? Il m'est impossible de croire qu'une telle lame ait de la prise

même sur un papier d'une moyenne épaisseur.

En définitive, voici comment je compte m'y prendre pour commencer le dédoublage. Un des bords (du côté le plus étroit) étant enduit de part et d'autre d'une colle quelconque, d'une viscosité convenable et homogène, je l'engagerai entre deux planchettes de bois dur et uni, sorte d'étau à mâchoires très larges. Quand le feuillet engagé sera bien sec, je tâcherai d'écarter les deux planchettes uniformément sur toute la ligne. Si tous les apprêts ont été faits avec soin et si la colle étalée sur chaque surface n'a pu se réunir à travers le papier, il me semble que chaque planchette ou mâchoire d'étau, en se séparant, entraînera précisément la moitié de l'épaisseur du feuillet. Ce résultat obtenu, rien ensuite de plus aisé, je le répète, que de détacher du bois les portions collées.

Le bord du feuillet une fois dédoublé à une profondeur de quelques millimètres, on l'engagerait entre deux cylindres de bois bien uni, et l'on collerait chaque portion isolée sur un des cylindres. Le tout bien sec, on serrerait fortement les cylindres l'un contre l'autre à

l'aide d'un ressort, puis on les tournerait avec une manivelle dans le sens où leurs surfaces courbes semblent se fuir. Il est probable que, le feuillet étant ainsi disposé avec un commencement d'entaille, la division en deux placards s'opérerait régulièrement même à sec, grâce à l'écartement uniforme des cylindres et à la pression qui maintient les portions engagées du feuillet à mesure qu'elles s'approchent de la ligne tangente du double cylindre.

Telle est la théorie, vraie ou erronée, que je compte mettre en pratique pour résoudre un problème que d'autres ont résolu. Ces idées sont-elles de pures chimères? Ont-elles au contraire assez de fond pour que, grâce à certaines modifications qu'inspire toujours la pratique, on obtienne le résultat désiré? Je l'ignore complétement. Celui qui voudra me prévenir dans ces essais en est parfaitement libre, puisque je n'ai développé qu'une théorie, et n'ai point pris, comme on dit en style industriel, « un *brevet S. G. D. G.* ».

FIN.

TABLE DES CHAPITRES

Avant-propos.	v
Préface de la première édition.	1
I. Dédoublage et redressage des estampes	5
II. Blanchiment des estampes.	21
III. Considérations générales sur l'enlèvement des taches	35
IV. Des taches d'huile et de graisse.	49
V. Enlèvement des taches de diverses natures.	69
VI. Décoloriage des estampes.	96
VII. Réparation des déchirures, lacunes, etc.	132
VIII. Doublage des estampes.	149
IX. Raccord du noir d'impression, etc. — Encollage du papier	166
X. Des estampes tirées sur divers tissus. — Réparation du parchemin.	176
XI. Restauration des dessins de toutes sortes.	194
XII. De la conservation des estampes.	209

XIII. Restauration et reliure provisoire des li-
vres rares 227
Note sur l'emploi et les prix des substances chi-
miques indiquées. 267
Liste d'ouvrages à consulter. 273
Des divers systèmes de reproduction des vieilles
estampes. 279
Sur la possibilité de dédoubler un feuillet simple. 330

TABLE ANALYTIQUE DES MATIÈRES

Acides (Emploi et danger des), 268.
Alcalis (Emploi des), 268.
Aquarelles (Réparation des), 196 et suiv.
Argent en coquille, 103.
Bain-marie (Chauffage au), 55.
Bassines, 7 et suiv.
Benzine (Emploi de la), 65, 178, 182.
Blanches (Destruction des couleurs), 101.
Blanchiment des estampes, 21 et suiv. — partiel, 32, 47.
Bleues (Destruction des couleurs), 119.
Boue (Taches de), 72 et 73.
Brûlures (Taches provenant de), 90.
Brunes (Destruction des couleurs), 115.
Cadres en bois doré ou vernis (Nettoyage des), 213.
Calques (Papiers à), 164, 203.
Cambouis (Taches de), 99.

Caoutchouc liquéfié (Taches de), 71. — Son emploi dans la reliure, 241.

Chine (Estampes sur papier de), 176, 210.

Chlore (Solution de) appliquée au blanchiment, 23 à 32.

Chlorure de chaux en poudre, 26 et 27. (L'emploi de cette substance est souvent indiqué au chapitre *Décoloriage*.)

Cire à bougie (Taches de), 69. — Son emploi dans la photographie, 306.

Cire à cacheter (Taches de), 70.

Cobalt (Inaltérabilité du bleu de), 120.

Collage à jour, 219 et suiv.

Colles gélatineuses (Préparation des), 184, *note*, 254.

Colle de pâte ou glutineuse. — Comment on en débarrasse le papier, 17, 87. — Sa préparation, 151.

Collection d'estampes, 214 et suiv. — de la Bibliothèque impériale, 218.

Coloris bon à conserver, 96. — Nuisible à la gravure, 97.

Conservation des estampes, 209 et suiv.

Contre-collage, voyez *Doublage*.

Couleur (Estampes sur fonds de), 179.

Couleurs à l'eau. — Difficulté de reconnaître leur nature sur une estampe, 100. — Décomposition des —, voy. les mots *Blanches*, *Bleues*, etc. (Je n'ai pas cru devoir mentionner, dans cette table, les noms particuliers de chaque couleur de telle ou telle nuance.)

Couleurs mixtes (Décomposition des), 125.

Couleurs (Estampes imprimées en plusieurs), 98.

Couture des livres, 242 et suiv. — Appareil pour la —,

244. — Réparation des anciennes traces de —, 239 et suiv.
Crayons (Enlèvement des traces de), 81 et 82.
Déchirures (Réparation des), 134 et suiv. — à sec, 143.
Décoloriage des estampes, 96 et suiv.
Dédoublage des estampes, 6 et suiv. — d'un feuillet simple, 330 et suiv.
Déreliure des bouquins, 231.
Dessins à la plume (Restauration des), 194 et suiv.
Dessins aux divers crayons, 199 et suiv. — photographiques, 202.
Dilatation du papier, 164. — du papier à calque, 204.
Doublage des estampes sur fond libre, 150 et suiv. — sur fond tendu, 155 et suiv.
Eau acidulée, son emploi, 28.
Eau oxygénée (bi-oxyde d'hydrogène), 22, 103, 272.
Écorchures (Réparation des), 133, 174.
Encadrement des estampes, 211 et suiv. — dit à l'anglaise, 160.
Encollage du papier, 173 et suiv. — Moyen de juger du degré d' —, 150.
Encrassement des estampes, 91.
Encre noire usuelle (Taches d'), 73 et suiv. — sur parchemin, 188. — Ravivement de l' —, 190. (J'ai oublié de parler des encres bleues et violettes, aujourd'hui très usitées. On consultera les paragraphes relatifs à ces deux sortes de couleurs.)
Encre à marquer (nitrate d'argent), 83, 84.
Encre noire d'impression, 31. — de diverses couleurs, 180.

Encre de Chine (chimiquement insoluble), 78 et suiv.
Fécales (Taches de matières), 87.
Feuillets (Méthode pour isoler les), 76.
Fiel de bœuf, son emploi, 56.
Fixage des dessins au crayon, 175, 200, 201.
Fruits (Taches de), 84, 85.
Gallique (Acide), son emploi, 190 et suiv.
Gaz (Danger de quelques), 268.
Gomme arabique (Emploi de la) pour coller le papier à sec, 143 et suiv. — Pour fixer les dessins au crayon, 175.
Gouaches (Réparation des), 196 et suiv.
Goudron (Taches de), 71.
Graisse (Taches de), 50 et suiv.
Grattoirs convenables, 134.
Grises (Destruction des couleurs), 105.
Héliographique (Gravure), 311.
Huile (Taches d'). — récentes, 51. — anciennes, 56 et suiv. — Procédé indiqué en 1751, 273.
Insectes (Taches produites par divers), 86.
Jaunâtres (Taches) de diverses natures, 90.
Jaune d'œuf (Taches de), 71.
Jaunes (Destruction des couleurs), 110.
Javelle (Eau de), 30, 31.
Lacunes ou trous (Réparation des), 137 et suiv., 143.
Lames d'acier pour réparer les estampes, 12.
Livres rares (Restauration des), 225 à 265.
Maculage (Taches dites), 92.
Manuscrits sur parchemin (Nettoyage des), 187.
Marges simulées des estampes, 163, 170.

DES MATIÈRES. 347

Miniatures anciennes sur vélin, 205 et suiv.
Mixtes (Couleurs), 125.
Moisissure (Taches de), 89.
Mouches (Taches de fiente de), 85.
Mouillures (Taches dites), 93, 94.
Neutralisation des acides et des alcalis, 269.
Noir de fumée (Taches de), 80.
Noir d'impression, sa composition, 31. — Raccord du —, 166 et suiv.
Noires (Destruction des couleurs), 104 et suiv.
Oiseaux (Taches de fiente d'), 85.
Orangées (Destruction des couleurs), 114.
Or bruni appliqué sur vélin, 207. — en coquille, 114.
Oxalique (Acide), danger de son emploi, 74, *note*.
Pantographe (Emploi du), 280.
Papier moderne, en général peu solide, 210.
Papier (Pâte de), 138.
Parchemin (Gravures et livres sur), 180 et suiv.
Parcheminage des livres, 256.
Pastels, leur nature, 82, *note*. — Réparation des —, 197 et 198.
Peaux molles (Estampes sur), 180.
Pile de Volta (Emploi de la) conseillé : Avant-Propos, VI; 106, *note*.
Pinceaux pour le collage à la gomme, 145.
Pipettes, leur emploi, 45.
Piqûres de vers, 137.
Plis et rides (Réparation des), 136.
Plis antérieurs au tirage, 136, 161.
Plomb (Taches de sulfure de), 103.

Plombagine. Comment en effacer les traces, 81. — Quelle est sa nature, 199, *note*.
Poix (Taches de), 71.
Portefeuilles pour estampes, 214 et suiv. — Coffre à serrer les grands —, 223.
Poudres à détacher, 52 et suiv.
Presse (Mise en) des estampes, 18.
Prix-courant de quelques substances chimiques, 271.
Proto-chlorure d'étain, 112, *note*.
Prussiate de potasse (Emploi du), 193.
Pureté des substances chimiques (très essentielle), 269.
Raccord des teintes du papier, 33, 167. — des tailles, 139 et suiv.
Redressage des estampes, 17, 137.
Réglisse noire, son emploi, 33. — Taches de —, 84.
Remmargement des estampes, 163, 170. — des livres, 220.
Renouvellement du papier d'une estampe, 310.
Repassage au fer des estampes, 18.
Reproduction des estampes par report sur pierre, 281 et suiv. — par l'action solaire, 293 et suiv.
Résineuse (Taches de nature), 70.
Rognure des livres aux ciseaux, 236.
Rouges (Destruction des couleurs), 105 et suiv.
Rouille (Taches de), 88, 109, 112, *note*.
Rouler les estampes (Manière de), 225.
Rousseur (Taches de), 87.
Roussi (Réparation du linge), 91.
Sang (Taches de), 85.
Sépia (Nature de la), 116.

Siphon (Emploi du), 8.

Soie (Estampes tirées sur), 176 et suiv.

Soleil (Action du) sur les taches d'huile, 59, 274. — sur le noir des estampes, 213. — sur les sels d'argent, 296. — sur le bitume de Judée, 312.

Stéarine (Taches de), 70, 306.

Sulfureux (Acide), son emploi, 84.

Tabac (Taches de), 84.

Taches (Considérations générales sur les), chap. III.— Destruction des — sur un seul point, 42 et suiv.

Taille des gravures (Raccord des), 139, 166 et suiv.

Témoins des estampes. Manière de les simuler, 171.

Température la plus favorable à la réparation des estampes, 172.

Toiles (Estampes tirées sur), 178.

Transposition de feuillets, 76 et 77.

Trous, voy. *Lacunes.*

Urine (Taches d'), 87.

Vertes (Destruction des couleurs), 122.

Vin (Taches de), 85.

Violettes (Destruction des couleurs), 101, 122.

OUVRAGES DU MÊME AUTEUR

(Dont une partie en vente à la LIBRAIRIE CASTEL)

1837. — **Perruque et Noblesse**, roman in-8 de 396 pages (aucun mis en vente).

1846. — **Essai sur la restauration des estampes**, etc., in-8; avec supplément en déc. 1846. (1re édition épuisée depuis 1830.)

1848. — **Lettre au bibliophile Jacob sur le Cabinet des estampes...** gr. in-8 de 16 pages. (Restent quelques exempl.) 50 c.

Id. — **Voyage à l'île de Vazivoir**, contes d'enfants. In-32 tiré à 50. (Aucun en vente.)

Id. — **Joseph le Rigoriste**, facétie philosophique in-18, tirée à 70 (12 ex. en vente). 2 fr.

Id. — **La Châsse de Saint Cormoran**, esquisse de mœurs parisiennes au XVIe siècle, in-18 tiré à à 70. (12 ex. en vente.) 1 fr.

Id. — **Études sur Gilles Corrozet**, etc., in-8, 56 p., tiré à 100. (Restent 10 ex.). 3 fr.

Id. — **Le Mirouer du bibliophile parisien**, etc., facétie in-18 tirée à 160. (Epuisé.)

1849. — **Histoire artistique et archéologique de la gravure en France**, in-8 de 302 pages tiré à 300. (Restent quelques exemplaires.) 7 fr.

OUVRAGES DU MÊME AUTEUR.

1851. — **Etudes archéologiques sur les anciens plans de Paris**, in-4 tiré à 200 ex. Prix : 7 fr.
1852. — **Le povrtraict de l'iconophile parisien**, etc., in-18, tiré à 200. 1 fr. 50 c.
Id. — **L'Homme-oiseau, ou La manie du vol**, facétie-vaudeville in-18 tirée à 100. (Sera mis plus tard en vente.)
1853. — **Dissertations archéologiques sur les anciennes enceintes de Paris**, etc., in-4, 12 planches, tiré à 200. 15 fr.
1855. — **Des Télescopes.** Causeries familières. In-12 tiré à 300. 3 fr.
1855. — **Des petits chiens de dames...** In-32, tiré à 100. (Presque épuisé.) 3 fr.

Pour paraître dans le courant de 1858
à la même Librairie

Fantaisies multicolores. (Première série.)
Iconographie du vieux Paris. — Première partie : *Tableaux.*

www.ingramcontent.com/pod-product-compliance
Lightning Source LLC
Chambersburg PA
CBHW060603190426
43202CB00031BA/2217